The Fall of the Studio
Artists at Work

Wouter Davidts
& Kim Paice (eds.)

With contributions by
Wouter Davidts
Julia Gelshorn
MaryJo Marks
Kim Paice
Kirsten Swenson
Morgan Thomas
Philip Ursprung
Jon Wood

Antennae
Valiz, Amsterdam

The Fall of the Studio:
Artists at Work

Wouter Davidts & Kim Paice (eds.)

Introduction

Wouter Davidts
& Kim Paice

The artist's studio is in dire standing, or, at least, so many critics and artists would have one believe. In recent decades, this customary space used for artistic creation and production has been discussed widely, yet mostly in a casually negative form. Any praise is by definition considered to be ideologically suspect.[1] Indeed, ever since artists embarked upon the radical program of questioning and eventually overturning the traditional and conventional modes of production, circulation, and reception of artworks in the late 1960s, the studio has suffered a series of tragic blows. It became a prime target for critique, was declared to have *fallen*, and finally lost both its conventional prominence and mythical stature — its putative station as "imagination's chamber."[2] To many artists, the space not only accommodated, but, above all, represented a type of artistic practice, material production, and creative identity that they wished to supersede or avoid altogether. "Deliverance from the confines of the studio," wrote Robert Smithson in 1968, "frees the artist to a degree from the snares of craft and the bondage of creativity."[3] Just as the studio was experienced as a romantic straitjacket, an outdated and restrictive context for the development of new modes and strategies of making, distributing, presenting or experiencing art, the long-established mediums of painting and sculpture, which had traditionally been considered studio arts, were deemed passé, and likewise their tools and techniques seen to be irrelevant. New modes of production were developed and tested with seeming

urgency. Some artists simply stopped making works
themselves and began outsourcing the production of

1 Isabelle Graw, 'Atelier. Raum ohne Zeit; Vorwort', Texte Zur Kunst, 13,
 49, (2003), p. 5. This negative perception is certainly symptomatic of the
 persistent lacunae in critical scholarship on the artist's studio. In stark
 contrast to the spectacular increase of the field of critical museum studies,
 which has resulted in a wide range of publications, engaging disciplines
 as varied as art history, anthropology, sociology, and political science, the
 artist's studio has not yet received the full consideration that it deserves.
 The beginnings of the proposed consideration can be found in Caroline
 A. Jones's groundbreaking compendium about studio practices of key
 American artists, Machine in the Studio: Constructing the Postwar American
 Artist, Chicago and London: The University of Chicago Press, 1996. More
 recently, too, there has been a spate of exhibitions that have presented the
 artist's studio as a vital topic in contemporary art (at the Henry Moore
 Institute in 2002, the Stedelijk Museum in Amsterdam in 2006, the
 Kunst Akademie in Berlin in 2006, the Hugh Lane Museum in Dublin
 in 2006, and the Centre Pompidou in 2007). These shows have evaluated
 fundamental changes made in artmaking since the 1960s and also
 examined the means by which artists have questioned and reinvented the
 studio. For the respective catalogues, see Jon Wood (ed.), Close Encounters:
 The Sculptor's Studio in the Age of the Camera (exh. cat.), Leeds: Henry
 Moore Institute, 2002; Stedelijk Museum Bulletin, 2 (2006); Jens Hoffmann
 and Christina Kennedy (eds.), The Studio (exh. cat.), Dublin: Dublin City
 Gallery The Hugh Lane, 2006; and Didier Schulmann (ed.), Ateliers: L'artiste
 et ses lieux de création dans les collections de la Bibliothèque Kandinsky (exh.
 cat.), Paris: Editions du Centre Pompidou, 2007.
 In popular culture however, the studio still enjoys a high status. In January
 2007, British life-style magazine Wallpaper*, for example, ran a remarkable
 quiz-like article in the 'Art' section, entitled 'Private Viewing'. It showed
 photographs of a certain Gautier Deblonde, who travelled around the world
 to "capture the inner sanctum of artists." Readers were invited to "spot
 the clues" and "name the absent genius." The answers were printed in the
 last pages of the magazine. They revealed that photographs of the studios
 of such famous artists as Jeff Koons, Jasper Johns, Chuck Close, Rachel
 Whiteread, Luc Tuymans and Richard Serra had been included – some
 of which were easier to guess at than others. For more substantial and
 historical publications that have taken up the topic of the artist's studio as
 a photographical subject, we would like to single out Alexander Liberman,
 The Artist in his Studio, New York: Thames & Hudson, 1960; Lieven Nollet,
 Ateliers d'artistes (exh. cat), Antwerpen: MUHKA, 2001; and Dominique de
 Font-Réaulx, The Artist's Studio, Paris: Musée d'Orsay, 2005; Liza Kirwin
 and Joan Lord, Artists in their Studios: Images from the Smithsonian's
 Archives of American Art, New York: Harper Collins, 2008.
 For the historical use of the studio as a backdrop for fashion photography,
 we would like to refer readers to the study by visual artist Joke Robaard
 within the context of the Research Group of Visual Arts of the Academie
 voor Kunst en Vormgeving/St Joost, Avans Hogeschool, and published as
 Joke Robaard: Folders # 53, 54, 55, 56, edited by Joke Robaard, Camiel van
 Winkel, Jaap van Triest, 's-Hertogenbosch/Breda: Lectoraat Beeldende
 Kunst, Avans Hogeschool, AKClSt.Joost, 2008.
2 Michael Peppiatt and Alice Bellony-Rewald, Imagination's Chamber: Artists
 and Their Studios, Boston: New York Graphic Society, 1982.
3 Robert Smithson, 'A Sedimentation of the Mind: Earth Projects' (1968), in:
 Robert Smithson: The Collected Writings, edited by Jack D. Flam, Berkeley:
 University of California Press, 1996, pp. 100-113 (107).

works of all kinds and scales to engineering firms and industrial manufacturers. As Richard Serra recounted in 1985, when he started to produce large-scale steel sculptures in the late 1960s, he was forced outside of a private studio: "The studio has been replaced by urbanism and industry. Steel mills, shipyards, and fabrication plants have become my on-the-road extended studios."[4] Other artists tried to circumvent the conventional division between the site of production and reception that persists in the system of studio and gallery, and opted for site-specific work, either inside the gallery itself or on remote locations — hoping thereby to subvert the tried presentational techniques of art institutions and ultimately to short-circuit the commodification of art. In 1971, Daniel Buren decided to reverse the dominant way of doing things and no longer to force the artwork into a course of eternal nomadism.[5] He ended his seminal essay 'Fonction de l'atelier' with the radical statement that his decision to work in situ compelled him to leave the studio and to "abolish" it.[6] Desires to make monumental earthworks and ecological art led some artists to reclaim derelict sites for their work — as was the case for Agnes Denes, who declared a landfill in southern Manhattan to be her "studio."[7] The endeavour of taking exception with any notion of a preset spatial ontology of the studio was also clearly at issue in the conceptualist renunciation or suspension of the materiality of the art object. When an artwork comes into being and exists as a mere idea, its 'creator' is no longer in need of a separate, let

4

alone an especially assigned and equipped workplace at her or his disposal. As Lawrence Weiner's notorious "declaration of intent" bluntly indicated, neither the construction of the piece by the artist, its fabrication, nor its actual building was a guarantor of 'art'. The ultimate existence of a work depended on the presence of a someone at the receiving end: "Each being equal and consistent with the intent of the artist, the decision as to condition rests with the receiver upon the occasion of receivership."[8]

In recent decades, the desertion of the studio has become still more apparent and involved. In such films as *Trying to Find the Spiral Jetty* (1997) and *Section Cinema (Homage to Marcel Broodthaers)* (2002), Tacita Dean calmly positions the studio as one among other lost and phantasmatic objects, as her camera

4 Richard Serra, 'Extended Notes from Sight Point Road' (1985), in Richard Serra: Writings, Interviews, Chicago and London: University of Chicago Press, 1994, pp. 167-173 (168).
5 Daniel Buren, and Jens Hoffmann, 'The Function of the Studio Revisited: Daniel Buren in Conversation', in Jens Hoffmann and Christina Kennedy (eds.), The Studio, Dublin: Dublin City Gallery The Hugh Lane, 2006, p. 104.
6 Daniel Buren, 'Fonction de l'Atelier' (1971), in Daniel Buren: Les Écrits (1965-1990). Tome I: 1965-1976, edited by Daniel Buren and Jean-Marc Poinsot, Bordeaux: CAPC Musée d'art contemporain de Bordeaux, 1991, pp. 195-204.
7 Agnes Denes, 'Living Murals In the Land: Crossing Boundaries of Time and Space', Public Art Review, 17:1, 33 (Fall/Winter 2005), pp. 24-27 (25). Reflecting on her Wheatfield: A Confrontation (1982), she explained: "Wheatfield sprang up twenty feet from the Hudson, one block from Wall Street, flanked by the World Trade Center and the Statue of Liberty. At sunset the four-block site was my studio. Exhausted from the day's work, I'd look out at the rushing waters of the Hudson and the yellow stalks of wheat waving in the wind, savor the heavy smell of the field and the buzzing of dragon flies, surrounded by ladybugs, field mice, praying mantis. I was on an island of peace, just a block away from the heartbeat of the city and evening rush hour on West Street."
8 Lawrence Weiner, as quoted in Alexander Alberro, 'Reconsidering Conceptual Art, 1966-1977', in Alexander Alberro and Blake Stimson (eds.), Conceptual Art: A Critical Anthology, Cambridge, MA: The MIT Press, 1999, pp. xvi-xxxvii (xxii). This statement was first published in the catalogue for the exhibition January 5-31, 1969, New York: Seth Siegelaub, 1969, n.p.

languorously haunts Robert Smithson's *Spiral Jetty* (1969) or Marcel Broodthaers's studio in Dusseldorf. Furthermore, it is now rare for art to be produced in a single spot and by a sole individual. Rather it comes into being on myriad 'sites,' via both physical and virtual bases, and through the collaboration of different people with varied skills and backgrounds. For that matter, few artists can be said to reside in one place. Most operate in multiple locations around the globe and participate in a network of multiple artistic, institutional, and socio-political 'actors'.[9] As Philippe Parreno, a celebrated exponent of the nomadic existence, relational activity, and collaborative practice that has flourished since the 1990s, remarked in 2003: "I don't need one studio, but I do need a lot of studios." His ideal studio, he continued, "would be one place made of many different places, (...) made of different qualities and useful in different time frames."[10]

The dispersal of the artistic workplace across globalized networks has led to the widespread acknowledgment of the 'post-studio' era. We often speak of or read about inhabiting a moment in history that is *past* or *beyond* the studio. Indeed, the space has been deemed on many occasions to be *over*, and *done with*. In the contemporary scholarship about art, the nomenclature of the 'post-studio' has become utterly commonplace. In both theoretical and critical prose the terminology is used frequently. And yet it is still challenging to determine precisely when and with whom this manner of speaking about the

studio began. Although Smithson and Buren are often considered as the pioneering figures of 'post-studio' practices, neither one of them ever used the term, despite producing voluminous writings on this matter.[11] John Baldessari, who employed the term to describe a course he taught at the California Institute of the Arts, Valencia, in the early 1970s, does not recall where he took the term from — "perhaps from Carl Andre," he guessed, in an interview in 1992.[12] Andre indeed coined himself in an interview of 1970 as "the first of the post-studio artists," although he immediately hedged that the claim was "probably not true."[13]

The history of the origination of the idea of the 'post-studio' is apparently as uncertain as that of 'institutional critique'.[14] Although both terms have played a

9 For a broad discussion of the roles and significance of art's industrial fabrication, we refer readers to the October 2007 issue of Artforum on the theme of 'The Art of Production'.

10 Kate van den Boogert, Studio Visit: 'Alien' Philippe Parreno, in TATE, January / February 2003, pp. 48-53.

11 Caroline A. Jones has observed that Smithson "aspired to become the first post-studio artist," only later to acknowledge that, "[n]either 'post-studio' nor 'post-modern' were yet common in Smithson's lexicon, of course." See Jones, Machine in the Studio, p. 270. In the sequel to Brian O'Doherty's famous book of essays, Inside the White Cube: The Ideology of the Gallery Space (San Francisco: Lapis Press, 1976), it is quite revealing that the author does not use the term 'post-studio'. Rather, his succinct text reinvigorates our understanding of the importance and crucial role of the studio. See Brian O'Doherty, Studio and Cube: On the Relationship Between Where Art is Made and Where Art is Displayed, Buell Center/FORuM Project, New York, Columbia University, 2007.

12 Interview with John Baldessari, conducted by Christopher Knight at the artist's studio in Santa Monica, California, April 4, 1992; Smithsonian Archives of Modern Art; http://www.aaa.si.edu/collections/oralhistories/transcripts/baldes92.htm.

13 Carl Andre and Phyllis Tuchman, 'An interview with Carl Andre', Artforum, 8, 6 (June 1970), pp. 55-61 (55).

14 Andrea Fraser, 'From the Critique of Institutions to the Institution of Critique', Artforum, 44, 1 (September, 2005), pp. 278-283. In this brilliant essay, Fraser establishes that not a single one of the leading artists-protagonists of 'institutional critique' – including Smithson or Buren – had ever used the term.

crucial role in critics' and artists' parlance of the past four decades, there is no one person who can claim to be the sole author or exponent of either one. But in the case of the 'post-studio,' we should also consider the extent to which the term does justice to the current status and nature of the space(s) and place(s) of art production. Following four decades of the critical exploration of the institutional art regime and its paradigmatic spaces by artists, the studio curiously seems to be the only space of the so-called 'art nexus' that remains systematically endowed with the prefix 'post'. How often do we read or hear about a post-museum, post-gallery, or post-house-of-the-collector? Has the studio become the ultimate casualty of the neo-avant-garde's wishes to dismember the institutional apparatus?

Despite profound changes in the understandings and processes of artistic production in the 1960s, not everyone considered the studio to be obsolete. As early as 1968, Lucy R. Lippard and John Chandler, in their famous essay 'The Dematerialization of Art', recognized that the seeming evaporation of the art object in conceptualism could not be equated with a vanishing studio. On the contrary, with an explanation that is strikingly structuralist, Lippard and Chandler informed *Arts Magazine* readers of the notion that the studio was merely undergoing a functional, and not a fundamental, change: it was "again becoming a study."[15] Lippard and Chandler eluded taking up a funereal voice, and struck more

nuanced tones — albeit without examining the impli-
cations of their statements. Their assertions, however,
prompt us to consider the historical dimension of the
modern artist's studio, namely the relation between
the workplace of artists and scholars, represented by
the long-established historical model of the study. In
that sense, the term 'studio' signifies more than an
enclosed space for genius, creativity, or melancholia;
and this resonates with the postwar abandonment of
related notions of the author, and is aligned with the
discourse of the 'post-studio'. The historical use of
the term 'studio' sealed the gradual transformation
of the early-modern artist's workshop from a place of
manual practice to one of intellectual labor. It embod-
ied the gradual blurring of the distinction between
artistic and academic activities and thus could be said
to emblematize a virtual condition of personal ar-
tistic reflection or 'studious activity' that permeates
contemporary artistic ways of making.[16] In this re-
spect, Lippard and Chandler then seem to hint that if

15 Lucy R. Lippard and John Chandler, 'The Dematerialization of Art', Art
International, 12, 2 (February 1968), pp. 31-36, as reprinted in Alberro and
Stimson (eds.), Conceptual Art, pp. 46-50 (46).
16 For this understanding, we would like to refer readers to the brilliant
collection of essays by Christopher S. Wood, Walter S. Melion, H. Perry
Chapman and Marc Gotlieb, in Michael Wayne Cole and Mary Pardo (eds.),
Inventions of the Studio: Renaissance to Romanticism, Chapel Hill: University
of North Carolina Press, 2005. In the introduction, Cole and Pardo explain
that the current use of the English word 'studio' for the early-modern artist's
atelier is historically incorrect. In English the word 'studio' does not appear
in this meaning until well into the 19th century; in Italy, until far into the
17th century, people called the artist's atelier a bottega, or simply a stanza
(room). The Italian word studio (or studiolo) refers to the room, or even only
to the furniture of a scholar. Since the 15th century, artists have increasingly
often also had a studio, where they collected books and all sorts of
curiosities and to which they could withdraw for private artistic reflection,
away from the busy public workshop or bottega.

conceptual art grants us a new understanding of the role and significance of the studio, on the one hand, and of the nature and identity of the space, on the other, it does so neither by discarding the customary model of the studio, nor by inventing a new one altogether: it revisits the stakes of an existing, yet overlooked model of the studio.

An analogous argument and approach informs the present compendium of essays on the artist's studio. Instead of upholding the accepted wisdom or narrative that *the studio has fallen*, this book ambitiously questions many assumptions that underlie the popular and international discussions of the 'post-studio'. It traces the shifting nature and identity of the artist's studio in postwar art and art criticism, both in Europe and in the United States, and aims to achieve this by way of detailed analyses of seminal artists' practices. The contributors are concerned with artists who are, to be precise, *at work*. So, the essays gathered here are devoted to individual practitioners and their understanding and use of the place of work — not necessarily in order to frame their practices *in* the studio, rather to analyse their practices *of* the studio — across media and geographies. Thus, *The Fall of the Studio* deliberately focuses on the artist's studio as key trope, institutional construct, and critical theme in postwar art. While some of the artists discussed here are canonical figures of the second half of the 20th century, others maintain highly active careers at the beginning of the 21st. All of them, however, partake in the staging, re-

staging, performing, critiquing, and displaying of the space and place of the artist's studio, in one way or another. While the list of the artists who figure in this study is by no means exhaustive or even representative of possible rapports that artists have had with the studio since the 1950s, the collected essays, nevertheless, present a succinct palette of significant positions and approaches; and this variety allows us to broach key medium-related, gender, cultural, as well as socio-political issues that lend specificity to our understanding of the institution of the studio.[17] Its wealth lies in the acknowledgment of the discontinuities more so than the continuities in practices of the studio.

One proposition that permeates the following essays is that the rapport of postwar art and artists with the studio is in no way transparent, as seems to be implied by the overly broad term 'post-studio'. While some of the essays here demonstrate that artists most closely associated with the romance of the studio have a far more complicated relationship with the space and its aesthetic regime than is commonly accepted, other essays insist that protagonists of the 'post-studio' era do not maintain so radical a distance from the studio, as is often claimed — either by the artists themselves or by their critical advocates.

17 Admittedly, the present collection of essays remains hopelessly partial and does little to examine and frame the subject of the studio within such methodological perspectives as post-colonialism, multiculturalism, and contemporary identity politics. Yet this would have required a different approach than that of gathering the papers we received in our call for the College Art Association's Annual Conference, but one we will certainly take into account when, in all likelihood, we expand upon this compendium in the future.

In the first essay, Morgan Thomas discloses the complex 'figure' of the studio that can be discerned in the work of the celebrated painter Mark Rothko, who remains closely and yet problematically associated with Abstract Expressionism. Even though Rothko's work "has been framed as emblematic for the limitations of the studio as it functions in modernist art," Thomas argues, "[it] opens up the possibility of an alternative thinking of the studio." Contrary to the reading of the "closed nature" of the paintings as a direct token of the painter's isolated, romantic, and heroic use of his studio, Thomas wants us to consider them "in terms of an aesthetic of oscillating forces." Rothko's paintings, and in particular the later ones that were commissioned for specific sites, are defined, she explains, by a "complicated and often volatile two-way traffic between the studios and the real or imagined destination," a series of quasi-cinematic moves that, Thomas provocatively says, produce a "vertiginous effect," not unlike the one evoked by the dialectic of site and non-site in the work of Smithson.

Next, MaryJo Marks lays out the blunt and sophisticated understanding of the studio of Bruce Nauman, an artist who most famously wondered in the late 1960s what it meant to be an artist and possess a studio to do all kinds of things in — when consciously "not start[ing] out with some canvas." As Marks demonstrates, Nauman embarks upon a self-reflexive examination of "the form of strategic deprivation," or the "deliberate loss of conventions, materials, or rou-

12

tines that had formerly determined (...) what an artist does and practices doing in the studio," better known as "deskilling." To these ends, Nauman makes the most of the "conjunction of empty time" and "empty space" in his various studios. He turns away from conventional studio activities to the staging of multiple everyday activities — which he then documents either in photographs or on film — in his studio works of the late 1960s and finally records his vacant studio at night in *Mapping the Studio I (Fat Chance John Cage)* (2001), thereby revealing, as Marks convincingly asserts, that "mutually dependent, the art and the studio exist by virtue of the artist's mere presence, a minimal guarantor of their identity as they are of his."

The actual presence of the artist is further explored by Kirsten Swenson, who discusses Eva Hesse's self-portrayal in her studio, both *with* her work and *with* items that she collected and used in her studio. Examining the famous, and as-yet under-analyzed photographs of Hesse, literally posing with certain sculptures in her studio and taken by fashion photographer Hermann Landshoff in 1968, Swenson demonstrates how the artist herself intelligently and sensibly responded to "the phenomenological premises and tacit gender politics of minimalism," and also used her studio "for negotiating the diverse post-studio strategies" that prevailed in the New York art world of the late 1960s. Looking closely at one of the most-reproduced photographs of the series, in which Hesse lies on a chaise longue and is covered in a tangle of

rope, Swenson unravels the convoluted references that the artist advances through the conscious arrangement of work by artist friends such as Smithson and Sol LeWitt and reviews of Hesse's own latest exhibitions. The Landshoff photographs, Swenson points out, serve "as historically conscious depictions of the artist in her studio" that reveal the extent to which Hesse, who "notably maintained a more conventional studio-based practice" than many of her contemporaries, nevertheless "incorporated diverse extra-studio practices into the conceptual bedrock of her art."

In her essay on Robert Morris, Kim Paice starts by wondering why, although this well-known American artist is thought to be one of the artists responsible for the fall of the studio, he himself never wrote about studio practice as such. Throughout the 1960s, the artist maintained several studios in which he deconstructively expropriated the studio's margins, noise, and activity into photographic and performance works that, Paice contends, are in some ways "about displacing or ruining the artist's studio." Folded into the famous *Box with the Sound of its Own Making* (1961) and *Card File* (1963), as well as the ambitious *Continuous Project Altered Daily* (1969), she also recognizes the artist's desires "to increase public awareness" of the conceptualization of works while limiting "the symbolical presence of language, images and gestures" in them. Morris's early Neo-Dada objects, later minimal sculpture, and process-oriented installations all involved attempts to "expose the everyday as well as the

category of publicity," the creation of exchange value, and limits in artmaking. Decades later, these issues led him, curiously, to endow his collected writings with the supplemental title of his 1969 project. The fact of being at work and of maintaining a "workly" quality of work, whether in or outside the studio, Morris discerned, is valuable.

Daniel Buren, who is widely considered a key protagonist of the 'post-studio' generation, took a more definite decision in 1971. Writing his, by now, canonical essay on the function of the studio, the artist believed that his decision to work in situ had forced him not only to leave the studio, but also to declare it "extinct." Through a close reading of the 1971 essay, however, Wouter Davidts shows that Buren's particular farewell to the studio, while based upon a highly intricate and efficient analysis of the role and significance of the space, in a triad with the gallery and the museum, that is, is anything but ultimate. Buren's desire for a "true relationship" between the artwork and its place of creation — epitomized by the historical studio of Constantin Brancusi in Paris — inhibits him, Davidts argues, from accepting or exploiting "the loss that takes place within every exhibition." It is remarkable, Davidts observes, that the very condition of publicity that befalls every artwork, and which Buren has repeatedly analyzed in detail, seems to trouble him to such an extent that he feels obliged to abolish precisely the space of the studio. Even more so, since his solution is not to 'leave' the studio, but to

'incorporate' it — through "a complete identification between the studio, the world, and himself."

The artist's bodily encounter with the studio forms the core of Julia Gelshorn's essay on the negotiation of the studio as a gendered space in the art of several male artists in the late 1990s. The work of such diverse and controversial figures as Matthew Barney, Martin Kippenberger, Jason Rhoades, and Paul McCarthy, she argues, amounts to more than merely juvenile or pathetic veneration of the space of the studio, but in fact involves highly coded and self-conscious engagements with the latter's historical "masculine mystique" — in the aftermath of both feminist and post-feminist critiques of the studio's potential implications in the masculinity in art. Through a close reading of some of these artists' celebrated sculptures, performances, and large-scale installations, Gelshorn demonstrates how these works deliver a smart and ambiguous update of "the studio as a frame for the ritual display and formation of the artist's identity." Ultimately, she concludes with the admission that "attempts to undermine, subvert or renounce the myth of the studio, tend only to reveal that the annihilation of the studio is itself a counter-myth."

The question of mythification pervades Philip Ursprung's essay on the studio of Olafur Eliasson. Using his own experience of visiting Eliasson's studio, and having participated in debates and symposia that the artist organized there, and ultimately contributing to a book on the studio proper, Ursprung

16

sets out to uncover the undeniable appeal of Eliasson's whirling work space and task force of collaborators in his Berlin studio, formerly called *Olafur Eliasson Werkstatt & Buro (Olafur Eliasson Workshop & Office)*. He meticulously unravels Eliasson's posture as artist-cum-entrepreneur-cum-scientist by tracing the various assignations of the studio, to then expose the trailblazing enterprise that its system has made possible. The artist, explains Ursprung, "at once demystifies and remystifies the studio as a site of artistic production," since he "manages to appeal to both the romantic idea of the workplace and the administrative notion of the office." In this way, we learn that Eliasson has succeeded in launching the studio as a virtual brand, an attractive label of experimentation that all the products that it engenders are endowed with, all while creating a marvel that narcissistically mirrors and reproduces itself over and again.

In the final essay, Jon Wood embarks on a similar quest to grasp the role of an artist's studio, quizzically asking, "Where is the studio?" Deeply intrigued by Jan De Cock's site-specific wooden fiberboard sculptures, called *Denkmal*, Wood thoughtfully and evocatively traces the importance of the "rich, anxious and deeply contested tradition and legacy of the studio, and of the studio of the sculptor in particular," that is, first in 19th and 20th century literature, and then in the young artist's self-aware sculptural practice. A Jan De Cock *Denkmal*, Wood points out, presents itself to the visitors as a studio, "albeit an abandoned one," that

demonstrates a "subtle awareness of its [own] museological status and problematic posterity." These sculptural environments, he explains, bear the material residue of the manual work it took to produce them, and when they are displayed as "sculptural and architectural interventions" and accompanied by "staged installation photographs" of people frequenting them, the artist's sensitivity to "the theatre of the studio and art museum" allows us to grasp the studio both as a stage set with "off-screen sculptures" and as "material existence as archive and documentation."

In concluding, we would be remiss not to mention the debates about the artist's studio that are being waged today, in real institutions, for example, in ongoing discussions about 'research in the arts,' and in the practical spheres in which recent changes in the conception, goals, and functions of higher art education are occurring. Within these discussions, which are very lively in Europe and in the United States, about the different modes and modalities, and the goals and purposes of artistic production and creativity, the artist's studio remains *both* a crucial referent and reference point for future forms of practice and knowledge. Within the current exploration and evaluation of the scientific and/or academic value, potential, and significance of artistic work, the studio as the (private and/or personal) site of that work, remains to serve as a crucial subject.

Additionally, a discussion of the contemporary status and nature of the studio can add to the ongo-

ing debate in art schools around the world about the necessity and significance of providing art students with a proper workspace. In an era when students work ever more systematically on personal computers and laptops, questions arise as to what extent the architectural and institutional investment in separate and viable workspaces for all students remains valid, let alone crucial to preparing our students for professional practices. Our expectation is that this publication, which critically questions and evaluates the historical and contemporary modes and modalities of the artist's usage of studio space, finds concrete relevance in these contexts. We sincerely hope that this anthology puts to rest the many sweeping claims and prevailing misconceptions about the obsolescence of private workplaces in the era of global informaticization and mobility.

While many essays do indeed emphasize the calamitous status and heritage of the studio, they reveal, if anything, that the studio, up to this day, continues to emerge as a fabulous, hydra-headed monster that — like the museum — survives every radical attack. The present collection of essays is marked by the credence that one can not easily dispense with the condition of the studio. One is forced to deal with it through a critical engagement with its multiple historical legacies and with the different modes and modalities in which it has been used, displayed, represented or 'practiced' by artists. This endeavour paradoxically forces us to pay the studio a visit, over

and over again, or at least to consider those myriad spaces where artists are at work; an endeavour for which this book wishes to act as a thought-provoking exercise and an inspiring invitation.

Introduction

Studio Vertigo
Mark Rothko

Morgan Thomas

During the 1960s and 1970s, the artist's studio became an object of critical discussion as never before. Andy Warhol's Factory went into business. John Baldessari, following Carl Andre, took up the idea of "post-studio art" as a "catchall" for art that was neither "straight painting nor straight sculpture."[1] Daniel Buren analyzed the studio as a custom due for "extinction."[2] Robert Smithson wrote about the "fall of the studio" as a form of "deliverance."[3]

The hypothesis of a post-studio era, frequently taken to be the outcome of moves like these, depends on at least three interconnected formulations or framings. First, the studio is taken to be — is framed as — a frame, a division of inside from outside, an enclosure. Second, the studio, thus understood, is taken to be metonymic of the historical situation of Modernism, and Modernist painting and sculpture in particular. Third (a periodizing frame), there is the supposition that the studio falls or that it has fallen, and, along with this, the implication that the studio and the forms of modern art with which it is allied, are in a decisive sense finished, historical.

It is useful to approach these framings from the other side of the line they draw. A consideration of the functioning of the studio in relation to Modernist painting during the late 1940s, 1950s, and 1960s, may require that we extend current lines of thinking of the studio beyond what are by now standard understandings. The work of Mark Rothko, like that of other artists associated with Abstract Expressionism, has been

24

'framed' as emblematic of the limitations of the studio as it functions in Modernist Art. Yet Rothko's work, as I will argue here, also opens up the possibility of an alternative thinking of the studio — one where all such framings manifest their fallibility, where things that fall are not less interesting than things that stand, and where the studio, seen in practical as much as in critical terms, is not yet over but still has the potential to be transformed and transformative.

The Frame, The Studio, and the Studio-Effect

Rothko, to be sure, fits very well into the scenario of the fall of the studio. Take, for example, Slavoj Žižek's account of his work in the book *Looking Awry*. The dark zones (or "black squares") in Rothko's paintings of the 1960s are, Žižek argues, "paranoid constructions," "substitute formations," or "black holes" that attempt to allay the threat of the real by giving it finite shape.[4] The "tragic" trajectory of later Rothko, according to Žižek, lies in the failure of this effort of containment, seen in the way the dark zones in the paintings get

1 John Baldessari, as quoted in Coosje van Bruggen, John Baldessari, New York: Rizzoli, 1990, p. 57.
2 Daniel Buren, 'The Function of the Studio', translated by Thomas Repensek, October, 10 (Fall 1979), pp. 51-67.
3 Robert Smithson, 'A Sedimentation of the Mind: Earth Projects' (1968), The Writings of Robert Smithson, edited by Nancy Holt, New York: New York University Press, 1979, pp. 82-91 (87).
4 Slavoj Žižek, Looking Awry: An Introduction to Jacques Lacan through Popular Culture, London and Cambridge, MA: MIT Press, 1991, p. 19. Žižek uses the "real" here in broadly Lacanian terms to refer to the traumatic kernel, or 'truth', of human subjectivity; the real designates that which ties structures of fantasy or desire and symbolic forms of authority together in a relationship that is never resolved.

25

bigger. (In fact it is by no means evident that they do get bigger.) Žižek summons the image of Rothko's suicide in his studio in 1970 — he was "one day found dead in his New York loft, in a pool of blood" — as only a further, final, confirming instance of the struggle motivating the work.[5] The loft-studio is in effect positioned as yet another modernist black square, yet another attempt to exclude the real that doesn't work.

In her account of the fate of the postwar American studio, Caroline A. Jones suggests that the "closed world" of Rothko's studio is relayed in the "closed world" of his paintings, for example in the way the paintings in the Rothko Chapel in Houston surround viewers on all sides.[6] Rothko's studio, like those of other New York School painters, entails a turning away from the world, just as the paintings coming out of it would remain locked in 'defeatingly' inward forms of signification. A Romantic conception of the studio, valorizing isolation, heroism, and natural as opposed to technological sublimity, is taken to underwrite the paintings. But by the 1960s, according to Jones, the isolated studio of Rothko's generation becomes the "most crucial context" for the inversion of the studio model that takes place in its wake, in the quasi-industrial, post-studio art of Warhol, Smithson, and Frank Stella.[7] Jones aligns the end of the studio "romance" of Abstract Expressionism and the move to post-studio art with the "rupture" marking the death of modernism and the advent of a postmodernism built upon critique — and a new

climate in which "the reality of the world outdoors" breaks into the studio enclosure.[8] Here, in order to challenge these arguments, I would like to draw out the artistic and aesthetic continuities behind what, in this context, appear to be increasingly exhausted divisions between the modern and the postmodern, and similarly between art that requires the apparatus of the studio (or something approaching it) and so-called post-studio art.

Interestingly, whether the real that the studio supposedly excludes is taken in terms of a psychoanalytically-derived truth (Žižek) or whether it is identified with the truth of history, critique, and the 'world outdoors' (Jones), the actual operation of the studio in Rothko's painting — how he uses the studio, how the studio *works* in his painting — receives very little attention in these accounts. Instead, in different ways, the studio models a modern pathology. For writers like Žižek or Jones, it is perhaps nothing other than

5 In fact the small combined kitchen and bathroom adjoining the East 69th Street studio space where Rothko died was not a loft. Rothko at this time had a ground-floor studio. Žižek does not allude directly to the studio in his account of Rothko. Yet, as Buren's essay on the function of the studio demonstrates, in the case of New York painting, the studio-loft is the cliché. And it does seem to be the cliché Žižek is drawing upon in a shorthand interpretation that is far too beholden to a convenient received mythology surrounding Rothko's life and death.
6 See Chapter One ('The Romance of the Studio and the Abstract Expressionist Sublime') in Caroline A. Jones, Machine in the Studio: Constructing the Postwar American Artist, Chicago and London: University of Chicago Press, 1996, pp. 1-59, and in particular pp. 8, 23.
7 Jones, Machine in the Studio, p. 58.
8 Jones, Machine in the Studio, p. 1. It is worth noting that James Breslin (Mark Rothko: A Biography, Chicago: Chicago University Press, 1993) characterizes the role of the studio in Rothko's work in terms that are broadly congruent with those of Žižek and Jones. Breslin, however, differs in paying close attention to the technical and practical considerations that enter into the ways Rothko's various studios work with other aspects of his painting. I am indebted to his accounts of Rothko's studios in this essay.

a pathology *of* the modern. (Or, if their diagnoses fail to persuade, a myth in the eye of the cultural analyst or historian, a back-formation, a symptom of the desire to be postmodern.[9]) Nonetheless, their claims underscore a problem that is inescapable in looking at Rothko's paintings, especially with regard to the role of the studio: that of framing. The more one considers how Rothko's paintings repeatedly figure the frame, or his protectiveness about them and their place (in his phrase, "controlling the situation"), or his secretiveness about his painting procedures, or the fact that he never breaks with painting in the manner of post-studio art, the more Rothko's work seems 'snared' — to use Smithson's word for the effect of the studio — within a fateful inwardness.[10]

Or is it? The striking thing about Abstract Expressionist painting vis-à-vis its precursors was at first seen to be its way of coming *out* into the viewer's space. Both Clement Greenberg and Meyer Schapiro foregrounded the openness of the paintings in their writing.[11] Yet Greenberg's notion of "an almost literal openness" in Rothko's painting, and in Clyfford Still's and Barnett Newman's, later adopted with variations by Donald Judd for its suggestion of a reality not yet arrived at, is less radical than Rothko's own sense of the physical presence of his paintings.[12] The paintings, according to Rothko, are "realistic," not abstract.[13] Their surfaces "rush inward" but also "push outward in all directions."[14] Unlike Ad Reinhardt's paintings, he remarks, "mine are here. Materially."[15]

In a recent interview, the painter Robert Ryman has spoken of Rothko's "realism." Ryman comments:

9 Here I cannot analyze in detail Jones's history of the postwar studio as a cultural signifier or her claims about Rothko in particular. But a couple of points can be made. The first is that Jones's characterization of Rothko as a latter-day Romantic captivated by 'deep dreams of the studio' of a Baudelairean order falls down as soon as one attends to how Rothko's studios function or to what Rothko says about his painting in relation to the studio. For example, a remark made to William Seitz in 1952: "I live on Sixth Avenue, paint on 63rd Street, am affected by the television, etc., etc. (...) My paintings are part of that life" ('Notes from an interview by William Seitz, January 22, 1952', in Mark Rothko, Writings on Art, edited by Miguel López-Remiro, New Haven and London: Yale University Press, 2006, p. 76). Rothko never seems to have been interested in or preoccupied with the studio as such, but only in what certain studios could do.
The second point: it would be possible to trace a critique of the isolationist model of the studio, or of the art it generates, among artists and writers in New York back to well before the 1960s, the period assigned to it by Jones. In his 1936 essay 'The Social Bases of Art' (in Social Realism: Art as a Weapon, edited by David Shapiro, New York: Frederick Ungar Publishing, 1973, pp. 121, 125), Meyer Schapiro includes subject matter in art pertaining to "[the artist's] studio and his intimate objects, his model posing, the fruit and flowers on his table, his window and the view from it" in a negative light, as indicative of a structure which upholds "the passivity of the modern artist with regard to the human world." In 1957, Schapiro ('Recent Abstract Art', in Meyer Schapiro, Modern Art: Nineteenth and Twentieth Centuries: Selected Papers, New York: George Braziller, 1979, p. 217) reverses this attitude. He now comments positively on the move to abstraction in painting and sculpture: "It was not a simple studio experiment (...); it was related to a broader and deeper reaction to basic elements of common experience." In 1967, Barnett Newman (as quoted in Harold Rosenberg, Barnett Newman, New York: Harry N. Abrams, 1978, p. 27) looks back on the outlook of artists in the late 1940s in the following terms: "We felt the moral crisis of a world in shambles, a world devastated by a great depression and a fierce world war, and it was impossible at that time to paint the kind of painting that we were doing - flowers, reclining nudes, and people playing the cello."
10 Mark Rothko, as quoted in Dore Ashton, About Rothko, New York: Oxford University Press, 1983, p. 154.
11 See particularly Greenberg's essay 'After Abstract Expressionism' (1962), in The Collected Essays and Criticism, vol. 4, Modernism with a Vengeance, 1957-1969, edited by John O'Brian, Chicago and London: University of Chicago Press, 1993, pp. 121-134, especially pp. 130-131. In 'Recent Abstract Art' (1957), Schapiro (Modern Art, p. 219) writes: "The art of the last fifteen years tends more often to work with forms which are open, fluid or mobile."
12 Greenberg, 'After Abstract Expressionism', p. 131.
13 Mark Rothko, as quoted in 'Notes from an interview by William Seitz, January 22, 1952', p. 77. This assertion does not stop Rothko from arguing elsewhere against mimetic or representational interpretations of his paintings and declaring himself 'an abstract painter', as he does in his 1958 Pratt Institute talk (also in Rothko, Writings on Art, p. 127). Rothko's sense of what makes his paintings 'realistic' is bound up with his repeatedly avowed materialism.
14 Mark Rothko, speaking to Alfred Jensen in 1953, as transcribed by Jensen, cited in Breslin, Mark Rothko, p. 301.
15 Rothko, as quoted in Ashton, About Rothko, p. 96.

The aesthetic goes outward to the wall. (...) Wherever [a Rothko] is it will have an effect on the things around it, and things around it will affect it (...). That's part of the realism of the painting: it is affected by real light, and the real presence of where it is.[16]

Ryman also says: "The painting looks easy. It looks as if it just happened."[17] Another artist concerned with the physicality of painting and the problems of edges and framing, Stella, has recently described his early *Black Paintings* as "closer to Rothko than just about anything else."[18] Yet in Rothko, this realism or physicality also operates in another way. It is not just a question of materiality or of a literal conception of painting, but also one of a physicality tied to bodily sensation. In the draft of a letter to Clyfford Still, Rothko writes that painting has to have the "concreteness of real flesh and bones, [and] its vulnerability to pleasure and pain."[19] The surface is a limit having the porosity and fragility of skin. In an early manuscript, probably written in the early 1940s, in which he attempts to outline a theory of art, Rothko writes of "sensuality" and, above all, touch, as central to painting because of their common capacity to escape both the objective and the subjective.[20] In a similar vein, Ryman notes a feeling of "nakedness" related to the absence of the frame and the way Rothko paints around the deep edges of the pictures. It is perhaps

this nakedness that Marina Abramović also discerns in Rothko's work. Reflecting on the Pollock and Rothko retrospectives of 1998-99 in the context of her concerns with the predicament of the body — or that of its disappearance — in contemporary life, Abramović distinguishes what she calls the "completeness" of Rothko's painting from Pollock's "nervousness."[21] She and Ryman recall Rothko's emphasis on the role of touch and corporeality in his painting.

These considerations invite us to think of Rothko's painting in terms of an aesthetic of oscillating forces. This aesthetic extends into Rothko's use of the studio — and from it. The lived-in complexions of Rothko's paintings are the result of what happens indoors, away from the light. Nevertheless, Rothko says his colors are not "isolated laboratory tools," but colors that "have seen the light of day."[22] The remark surely echoes the historically-charged appeal of a certain matter-of-factness, a certain pragmatism, that makes itself felt in American art in the 1940s and 1950s. The

16 Robert Ryman, 'Interview with Jeffrey Weiss, May 1997', in Jeffrey Weiss et al., Mark Rothko (exh. cat.), Washington, New Haven and London: Yale University Press, 1998, p. 368.
17 Ryman, 'Interview with Jeffrey Weiss', p. 367.
18 Quoted in Jonathan Jones, 'The Prince of Whales', The Guardian, April 5, 2001. The question remains of how to reconcile the Stella who says this with the Stella who, for Jones and other commentators, exemplifies a postmodernism premised on a consciousness of its break with the modernism of Rothko's generation.
19 Rothko, 'Undated Draft of a Letter to Clyfford Still', in Clifford Ross (ed.), Abstract Expressionism: Creators and Critics, New York: Harry Abrams, 1990, p. 170.
20 See 'Particularization and Generalization', in Mark Rothko, The Artist's Reality: Philosophies of Art, (edited by Christopher Rothko), New Haven and London: Yale University Press, 2004, p. 25.
21 See Janet A. Kaplan, 'Deeper and Deeper: Interview with Marina Abramović', Art Journal, 58, 2 (Summer 1999), p. 16.
22 Mark Rothko, 'Undated Working Notes', in Ross, Abstract Expressionism, p. 173.

radical thing about Rothko's mostly conventional technique is, as the conservator Dana Cranmer has noted, his manipulation of paint components, particularly his thinning of paint.[23] It is a radicality that happens in the preparation, but that unfolds on the surface as a certain blankness. Matter-of-fact though Rothko's way of painting may be said to be — or 'easy', Ryman's word — the effect of his layers of thin paint is a surface that is at once complex and elusive, conveying an enigma of agency, or the character of an event. It looks as if it just happened.

What I would like to call the 'studio-effect' in Rothko depends on two closely related factors: the fluidity of thin paint and a rule of fascination. I shall expand on this term shortly. A lot of Rothko's friends, assistants, and associates remember the long intervals he spent doing nothing — nothing, that is, but looking at the paintings. In a photograph taken in a temporary studio set up in the garage of a rented holiday house in 1964, Rothko looks almost like someone watching a movie. With their scale, elusiveness, and mutability of surface, the paintings are screen-like. Rothko adhered to a pragmatic working method where process was to a degree secondary to the procuring of effects. He used the same analogy to describe his work as Alfred Hitchcock — that of the organ player. (Making movies was pressing chords, "playing the various emotions," Hitchcock said.)[24] The *effects* of the paintings are what Rothko spent a lot of time observing, and adjusting. According to his studio assistants, who did almost

all of the painting of the Houston Chapel paintings, Rothko's work in the studio revolved around processes of trial and error: testing various mixtures of paint, drying times, hanging heights, and so on, and making adjustments. And, again, looking — for hours, days, even weeks. Rothko's tendency to economize and take shortcuts, possibly where his paint-thinning began, is another sign of this pragmatism. The work was in certain ways mechanical. The paintings were serial and straightforwardly painted. Studio devices, also suggestive of the film set, played a key role: rope and pulley systems; moveable walls; floor-lamps on rollers; spotlights turned up to the ceiling in his dark Bowery studio.[25] The studio became a vehicle for producing effects, an instrument. At the same time it functioned as a moment of suspension. There is the caesura of the almost blank, thinly-painted surface, the caesura of a prolonged, fascinated look, the caesura that opens up between this surface and this look. Indeed, these are manifestations of the studio-effect in Rothko.

Rothko kept moving studios. It was not until

23 See Dana Cranmer, 'Painting Materials and Techniques of Mark Rothko: Consequences of an Unorthodox Approach', in Mark Rothko 1903-1970 (exh. cat.), London: Tate Publishing, 1996, pp. 189-197.

24 Rothko (Pratt Institute talk, 1958, in Writings on Art, pp. 126, 128) speaks in comparable terms of painting "the scale of human feeling" and of "measure" as vital ("feelings have different weights") to the "immediate transaction" that is at stake in his painting. For Rothko's analogy between his painting and organ-playing, see Barry Schwabsky, "'The Real Situation': Philip Guston and Mark Rothko at the End of the 1960s', in Schwabsky, The Widening Circle: Consequences of Modernism in Contemporary Art, Cambridge: Cambridge University Press, 1997, p. 11. Alfred Hitchcock's analogy between his filmmaking and organ playing is recalled in Ernest Lehmann's DVD commentary on North by Northwest, Warner Brothers, 2001.

25 For this last point I thank Michael Goldberg (personal communication, February 2007).

1952, when he was 48, that he rented his first studio, a loft on West 53rd Street.[26] He moved to another studio, another loft, on West 61st Street in 1956, set up an additional studio in his Provincetown house in 1958, the same year he moved to a new studio — a former YMCA gym, a half-basketball court — in the Bowery. Rothko moved studio again in 1962, this time to another loft, on First Avenue. In 1965 he made one more move, to a large East 69th Street studio, a former carriage house and riding rink.

This sequence is significant, as much for what is absent from it as for what it reveals. During the late 1940s and early 1950s, Rothko painted in his living room. There was no studio. In this respect, Jones's claim that Romantic constructions of the studio played a central, material, or authenticating role in his work at this crucial time — or that they could guarantee it — when he, in fact, painted at home and did not have a studio, makes little sense.[27] Yet, once it begins, and particularly from the late 1950s onward, the momentum of this itinerary is expansive. The changing architecture of Rothko's studios can be correlated with the scaling-up of his paintings. In the complicated and often volatile two-way traffic between the studios and the real or imagined destination of the paintings, the studio doesn't necessarily come first. Rothko's moves coincide in part with commissions for given locations, tying in, in 1965, with the Chapel commission, in 1962 with his commission to paint for the Holyoke Center at Harvard University, and in 1958 with the commis-

sion for the Four Seasons restaurant in the Seagram Building in New York. For the Chapel project, Rothko had to find a studio that was large enough for the work. A built-to-scale simulation of three of the eight walls of the chapel, still to be built in Houston, came next. The Seagram and Harvard projects involved similar sequences. The studio set-up comes after — is an effect *of* — the determination of the work's projected destination. Conversely, the covered skylight now in the Chapel is, like much else, a ghost of Rothko's 69th Street studio. He liked the latter's central parachute-covered skylight. The studio location, doubling the destination location, becomes more important, not less so, as Rothko's painting becomes more overtly site-oriented. Yet the other side to this is that Rothko withdrew from the Four Seasons commission; that the paintings for Harvard were eventually removed on account of irreversible deterioration and damage and are now rarely displayed; that Rothko did not live to oversee the installation of his paintings in Houston. In none of these cases is it possible to say with assurance that the project was realized, that what the artist planned or imagined or set up in his studios to happen outside them really took place. What remains constant in these itineraries — between studio and 'site' — is

26 Rothko did, however, have a studio at the back of the loft he shared with Edith Sachar, his first wife, in 1942-43.

27 Jones, Machine in the Studio, pp. 58, 371. Jones writes (p. 371): "Securely modernist in the immediate postwar period, the solitary space of the studio was guarantor of the Abstract Expressionist canvas's authenticity, its presence as an individuating object created (authorized) by an isolated, heroic artist-genius."

an orientation toward suspension, an out-of-placeness that attaches itself to the paintings wherever they go. In short, the realism of the caesura itself.

In the late 1950s, at the time of the Seagram project, Rothko speaks, impossibly, of his paintings as being "not paintings," or "not pictures."[28] Painting, it seems, could not simply be *itself.* In Rothko's thinking, the mode of his paintings' address to the viewer, and the spaces of their viewing, are questions that are evidently *part* of his work. They are not only part of it, but in fact pivotal to its direction from the late 1950s onward — effectively in the wake of Abstract Expressionism as a collective phenomenon — and most strikingly in his commissioned series of paintings that begin around this time. Rothko's mobilization and transformation of studio spaces in this period can, in the same way, be understood as a means of approaching these questions. Yet it is also the case that such questions inform the work of other artists of his generation. The studio that comes out of Abstract Expressionism, often a large disused commercial space, not so unlike a Smithson 'site', seems to activate the displacement of the studio, if not its fall. The outward movement of Rothko's studios is not 'inverted' in post-studio art, as Jones claims, but continued.

Between the Studio and the Artwork

Yet to see the studio's undoing as its great feat, or saving grace, would be to miss the point. This would be the trap Smithson falls into in his essay 'A

Sedimentation of the Mind' (1968) — that of see-ing the studio as a "snare" from which there could be "deliverance."[29] Or, to recall the title of a recent book, that of supposing a unilateral movement 'from studio to situation'.[30] Smithson's *Spiral Jetty* (1970) remakes the world as a studio — another 'converted' studio — and thus, once more, offers the studio as world. The *Spiral Jetty* is pictorial in the same way that Rothko's paintings are 'not paintings'. It, too, is a kind of trap. Like Rothko's paintings, it works be-tween forces of location and dislocation. In 1972, in an essay about the Jetty, Smithson writes of a "double path" where site and non-site converge.[31]

It would also be missing the point to reduce Rothko's work, in post- or pseudo-Greenbergian mode, to a near-literality or a transitional prefigura-tion of a post-studio era.[32] The work mobilizes and intensifies a more complex logic: a logic of the simul-taneity of the site and the non-site in the artwork and already in the studio, moving or turning between one and the other. The sense that the site and the non-site

28 Mark Rothko, as quoted in Ashton, About Rothko, pp. 155, 197.
29 Smithson, 'A Sedimentation of the Mind', p. 87.
30 The book is Claire Doherty (ed.), Contemporary Art: From Studio to Situation, London: Black Dog Publishing, 2004.
31 Robert Smithson, 'The Spiral Jetty' (1972), in Holt (ed.), The Writings of Robert Smithson, pp. 109-116 (115). Smithson associates the site with physicality, multiplicity and open limits, and the non-site (in terms that recall his characterization of the studio) with abstraction, unity, and closed limits.
32 One could turn around the argument put by James Meyer (Minimalism: Art and polemics in the Sixties, New Haven and London: Yale University Press, 2001, p. 126) to the effect that Frank Stella's "retreat" from his early stripe paintings "suggested that the divide between the literalist aesthetic of Donald Judd and Fried's optical model was irresolvable, leaving no third way." The point may instead be that in the wake of Rothko and others, a commingling of illusion and literality in art becomes inescapable.

are in the same place, that they coincide, presents itself as a surface that is both a screen and a thing; a color that is locatable yet spatially ambiguous; a pictorialism inflected by the architectural and by the cinematic; a place, a physicality, that is also pictorial. Like Rothko's other series of paintings for rooms, his Chapel paintings oblige the viewer, in his phrase, to "turn in space."[33] The way the paintings face one another across the octagonal space sets up a situation, yet also produces a movement. The displaced situation of the paintings — the sense that they are not absolutely of this place — is re-activated and refracted in this 'turning'. Rothko, who never saw the paintings installed, imagined the very similar facing triptychs on the Chapel's east and west walls 'engulfing' the spectator who cannot possibly see both of them at once and cannot tell them apart.[34]

The near impossibility of photographing this situation is symptomatic. On the Rothko Chapel internet site, a 360-degree navigable Quicktime photo, stitched together from multiple photographs made by a rotating camera in the middle of the Chapel interior, takes precedence over still photographs. The turns that the Chapel sets in motion are, from this point of view, comparable with the double path, sculptural and cinematic, of Smithson's *Spiral Jetty*. Still more resonant is the famous shot in Hitchcock's *Vertigo* (1957) where the camera encircles the long kiss between Kim Novak and James Stewart. Again this is to do with getting caught up in a complex 'turning in

space' — the word "vertigo" is derived from the Latin *vertere*, to turn. Hitchcock said:

> I had the hotel room and all the pieces of the stable made into a circular set, then I had the camera taken right around the whole thing in a 360-degree turn. Then we put that on a screen, and I stood the actors on a small turntable and turned them around. So they went around, and the screen behind them gave the appearance of your going around with them.[35]

A similar play of distance and closeness, location and dislocation, heightened perception and disorientation, sets in motion the logic of fascination that is an integral element of the studio-effect in Rothko's work (as

33 A phrase recalled by the writer and curator Katherine Kuh, as quoted in Jeffrey Weiss, 'Rothko's Unknown Space', in Weiss, Mark Rothko, p. 320.

34 Cited in Sheldon Nodelman, The Rothko Chapel Paintings: Origins, Structure, Meaning, Austin: The Menil Collection/University of Texas, 1997, p. 126. See also Breslin, Mark Rothko, p. 480, p. 655 n. 66. To recall a point made by James Breslin, the lowered outer panels of these triptychs – which I would call lapsed triptychs – are surely in part a result of the pulley system in Rothko's studio, which made it easy to adjust the hanging height of his paintings.

35 Alfred Hitchcock quoted in Donald Spoto, The Art of Alfred Hitchcock: Fifty Years of his Motion Pictures, New York: Hopkinson and Blake, 1976, p. 330. Spoto observes that the camera in this shot in effect kisses or embraces the actors. 32 One could turn around the argument put by James Meyer (Minimalism: Art and Polemics in the Sixties, New Haven and London: Yale University Press, 2001, p. 126) to the effect that Frank Stella's "retreat" from his early stripe paintings "suggested that the divide between the literalist aesthetic of Donald Judd and Fried's optical model was irresolvable, leaving no third way." The point may instead be that in the wake of Rothko and others, a commingling of illusion and literality in art becomes inescapable.

in Hitchcock's). In a related way, one can think here of Rothko's comments on the centrality of touch and his concern with "creating a state of intimacy" and intensity in his paintings.[36] At the heart of the fascination of the picture/screen, for Rothko and for Hitchcock, is its capacity to prolong and transport a kind of touch.

In Rothko's single-panel paintings, on a different scale, blurring and chromatic intensity imply a vertiginous aesthetic — a receptivity not fully in control of itself, not clearly able to distinguish subjective and objective, inside and outside, back and front, down and up. Leo Bersani and Ulysse Dutoit have commented that some of Rothko's paintings appear suspiciously mimetic; they are like pictures of walls with pictures on them.[37] Even if in saying this they come close to the unconvincing style of representational reading that it seems best to avoid when looking at paintings like Rothko's, the observation underscores the deep uncertainty to which the interplay of physicality, artifice, and illusion in Rothko's work can give rise. The paintings mark their situation of suspension and their suspension of situation. One could think here of how the floating — again, suspended — rectangular figures or zones in Rothko's best-known paintings, in his words, typically "do not run to the edge" but "stop before the edge," while the painting in fact continues past the conventional limit, going around the edge to the stretchers' sides.[38]

Rothko had no studio until 1952, but by then the studio, as a figure *in* painting, as a figure *of* paint-

ing, was already a force in his thinking. Rothko remembered spending "hours and hours" in front of Matisse's *Red Studio* (1911) after the Museum of Modern Art bought it in 1949, and spoke of Matisse as crucial to the transformation of his painting at that time.[39] *The Red Studio* surely is what Bersani and Dutoit say Rothko's paintings might be. It is a painting of paintings on a wall, in a room, a studio. Yet in this painting, abstraction infiltrates representation; it is not a case of representation hypothetically dissembling itself in abstraction. Matisse introduces a curvature of space and an ecstatic disorientation into a certain visual order and the pictorial architecture associated with it. Rothko commented: "You become that color, you become totally saturated with it."[40] It is perhaps Matisse who uncannily supplies Rothko's work in the 1950s and 1960s with a provisional point of origin in the studio: in the place where the studio turns into fiction, where it becomes vertiginous, in a sea of red paint.

36 Rothko uses this phrase in his talk at the Pratt Institute in 1958 (Rothko, Writings on Art, p. 128).

37 See 'Rothko: Blocked Vision', in Leo Bersani and Ulysse Dutoit, Arts of Impoverishment: Beckett, Rothko, Resnais, Cambridge, Massachusetts, and London: Harvard University Press, 1993, pp. 93-145. With regard to Rothko's paintings for Houston — and, oddly, forgetting the octagonal shape of the Chapel interior — Bersani and Dutoit write (p. 134): "What is being imitated [in the paintings] is (...) the rectangular shape of the canvas itself, as well as of the room in which the painting is hung."

38 Mark Rothko, as quoted in 'Notes from an interview by William Seitz, January 22, 1952', p. 77.

39 See, for example, Ashton, About Rothko, pp. 112-113.

40 Mark Rothko, as quoted in Breslin, Mark Rothko, p. 283.

Continuous Project Altered Daily

Robert Morris

Kim Paice

When Robert Smithson wrote in 1968 about the "fall of the studio," he singled out the work of Robert Morris for mention.[1] Wistfully he wrote of Morris's "unbounded methods or procedures" and a "world of non-containment," and, pointing to the openness of his friend's work, encouraged fellow producers not to be enslaved by the studio or to an ideal of creativity that was "designed by the vile laws of Culture."[2] Since artists had grown interested in "boring" things, Smithson explained that pavement, holes, trenches, mounds, heaps, paths, ditches, roads, and terraces were considered to have "aesthetic potential." In a push toward the anti-aesthetic, he recognized that a new poetic language was being born of destruction and in that regard, "Instead of using a paintbrush to make his art, Robert Morris would like to use a bulldozer."[3]

However, Morris himself has never written about studio practice as such, let alone ever abandoned it. He has occupied a number of conventional studio spaces, including spaces on Great Jones Street, Grand Street, Mulberry Street, and Greene Street in a loft where he had formerly lived. Yet, Morris has made a number of works that are about displacing or ruining the artist's studio. These works exemplify Morris's self-conscious conflict over how to increase public awareness of the manner in which his works have been conceptualized and yet limit the symbolic presence of language, images, and gestures in them.

44

Neo-Dada

Revisiting and exploiting the historical legacy of Dada allowed Morris to make works in which he plays with the notion of expropriating the studio and folding performance into hybrid objects, a number of which were able to be used, manipulated, or opened and closed. In some of these works, by symbolically transferring the traditionally private property of the artist (the studio) into the public domain, and by putting the studio and art-making on display, Morris emphasized a social quality of this body of work. The artist's apparent interest in blurring lines between genres and places related to his being a sculptor and a dancer who was sharing a studio with other dancers, who themselves had highly inventive practices. He was undoubtedly inspired by and valuable to partners Simone Forti and Yvonne Rainer, with whom he shared a studio on the top floor of a building on Great Jones Street. The studio "was completely open," recalls Rainer, and "Morris made small sculptures in a corner, like the *Box with the Sound of its own Making*. Simone rehearsed us in *See Saw* at one end. I rehearsed my first solo, *Three Satie Spoons*."[4]

Research for this essay included personal interviews and close study of the Robert Morris Archive, The Solomon R. Guggenheim Museum, New York, which houses many unpublished documents, files, correspondence, and part of Morris's library.

1 Robert Smithson, 'A Sedimentation of the Mind: Earth Projects', in Robert Smithson, Robert Smithson: The Collected Writings, edited by Jack Flam, Berkeley: University of California Press, 1996, pp. 100-113.

2 Smithson, 'A Sedimentation of the Mind', p. 102.

3 Indeed, the noise of bulldozer-building demolition later played a prominent part at the end of one section in Morris's "They," which was part of the sound-sculpture installation Voice (1974). Robert Smithson, 'Towards the Development of an Air Terminal Site', in: The Collected Writings, pp. 52-60 (56).

4 Yvonne Rainer, correspondence with the author, 16 October 2007.

Morris's performances have secured a place amongst his most scandalous works, and by 'scandalous' I mean structurally open. As I have explained elsewhere, when one examines Morris's photographs of performing with and in works of the early 1960's, it is apparent that performance is the basis of Morris's Neo-Dada artworks.[5] Revisiting Dada may have brought about a sense of inertia, but at the same time it led the artist to make puns on impotence and self-importance, most obviously in the perplexing *I-Box* (1962). This object photographically pictures the naked artist, standing inside his studio, and in turn, this photograph is nestled within a pink I-shaped cabinet whose door swings open and shut. Through a self-conscious intellectual identification with John Cage, Jasper Johns, and Marcel Duchamp, Morris also made a number of works that involve text- and noise-driven compositions, and that invite viewers to puzzle over the quandary of a score that goes nowhere, or that is folded into the present moment of reading. Most famously, this occurs in Morris's *Box with the Sound of its Own Making* (1961).[6] A tape-recording of the little wooden box's construction, which is contained in the box and played when the work is displayed, brings the space and time of labor into the sphere of the public and viewing. It drags the studio, metaphorically speaking, into the gallery or museum, rather than proclaiming the studio to be obsolete. In letters, Morris solicited Cage's approval for this box, among other works, writing to the composer that he was trying to create conditions for the "death

46

of process (...) a kind of duration of idea *only*."[7] So, too, does Morris's *Card File* (1963) bear Cage's imprimatur. Fittingly, there is no bolt of lightning to be had from the deadpan work. *Card File* consists merely of a wall file that has been mounted on a piece of wood. Alphabetically-arranged index cards in slots, each marked with the date and time of a given event, document the vagaries of making the file and include such headings as "Interruptions" ("7/18/62, 2:45 pm On trip to find file met Ad Reinhardt on corner of 8th Street and Broadway. Talked with him until 5:30 by which time it was too late to continue trip"), "Working Periods" ("17 are counted"), and "Conception" ("7/11/62, 3:15 pm While drinking coffee in the New York Public Library"). With *Card File*, Morris succeeded in reaching from the interiority of the work to the exteriority and temporality of making the work and then, ultimately, into the present tense of viewing and reading the work, all the while telling us unremarkable stories of how the work was made. Anticipating what Lucy R. Lippard and John Chandler would say six years later about art's dematerialization, namely, that the artist's study had begun to replace the traditional artist's studio in conceptual art and process-oriented art, Morris

5 Kimberly Paice, 'Catalogue', in Robert Morris: The Mind/Body Problem (exh. cat.), New York: Solomon R. Guggenheim Museum, 1994.
6 Rule-driven scores were used in Morris's work as late as 1974, with the splicing of texts – 'The Four', 'We', 'They', 'Cold/Oracle', 'He/She', 'Scar/Records', and 'Monologue' – in the sound work Voice (1974). See Kimberly Paice, 'Voice (1974)', in Paice, Robert Morris, pp. 256-261.
7 See Branden W. Joseph's presentation of 'Bob Morris, "Letters to John Cage"', October, 8 (Summer 1997), pp. 70-79 (71, 74). In a letter dated 27 February 1961, Morris refers to Box with the Sound of its Own Making and says that he had previously mentioned the work to Cage.

used the Main Reading Room of the New York Public Library as experimental laboratory and art production site.[8]

Although the resulting alphabetical index that he created "parades its own presumed self-containment" by including its own production history in type and on index cards, *Card File* also transforms "the presumed privacy of thinking into the public medium of speech and the logic of propositions," according to Rosalind E. Krauss.[9] Chance encounters and their disclosure are taken to the point of absurdity, and they expose the everyday as well as the category of publicity, i.e., a desire to exhibit artistic production in order to emphasize the 'workly' quality of the work on display. Merely bumping into Ad Reinhardt is, therefore, woven directly into the artwork's fabric by mention on a card.[10] Both the file and box designate the fluidity with which Morris conceived what is inside and outside of art-making — and the studio. Beyond insisting on the social quality of the work — with seeming unconcern for what or who the public may be, beyond someone of Cage's or Reinhardt's stature — Morris's Neo-Dada works indicated his beliefs that the studio was a place that could be redefined and that art-making could be staged. In these developments, privacy takes a back seat.

Minimal Art

Minimal art led Morris to focus his attention on the meanings of viewing as performance and to reconsider the purposes of both the architectural environ-

ment and the studio. Bounded space and the built environment, neither explicitly studio nor exhibition space, were the physical frame of reference for Morris's minimal props, gray polyhedrons, and metal and fiberglass works. The significance of the artist's own studio as site of making was partly usurped as industrial fabricators, such as Aegis, were making works for Morris, while he himself acted as planner. Just as the theme of de-emphasizing the artist's biography littered his own writings, such fabrication facilitated the notion that the artist's physical input was minimally relevant to outcomes, namely, works that were made.[11] Still, this three-dimensional work spoke intensely to the world of built enclosures, both the studio and the site of exhibition. Thus, although curator Martin Friedman found Morris's work "puritanical" and "atopical" in 1966, he admired the way that "environment is a critical factor (...) because these dense forms forcefully consume space and strongly relate to walls, floors, and ceilings." In his correspondence with Friedman, Morris confirmed, that "physical contact with a surface can both be a use of that surface as well

8 Lucy R. Lippard and John Chandler interrelate the "dematerialization of art" with the new conceptual emphases in American art. More than this, however, I am interested in how they recognize the dual collapse of craft and the private studio. See Lucy R. Lippard and John Chandler, 'The Dematerialization of Art', Art International, 12, 2 (February 1968), pp. 31-36.
9 Rosalind E. Krauss, Robert Morris: The Mind/Body Problem, p. 4.
10 Morris, 'Letters to John Cage' (78). Morris's letter to Cage, dated 12 January 1963, says that Cage had not yet seen the Card File, which was on view at Green Gallery on 57th Street from 15 October to 2 November 1963.
11 Scholars have worked to return biography's relation to the work. See Interview by Pepe Karmel, 'Robert Morris: Formal Disclosures', Art in America, 83, 6 (June 1995), pp. 88-95, 117-19; Anna C. Chave, 'Minimalism and Biography', Art Bulletin, 82, 1 (March 2000), pp. 149-163.

as a way of acknowledging that a limit is there, existing with the work itself."[12]

We sense the ambiguity of acknowledging the physical space but denying its specificity. As James Meyer has more recently explained, the situation in minimal art was a turning point in the thinking of sculpture as installation.[13] The step from minimal bricks, columns, pillars, and portals to architectural and social contexts and real places, including the artist's studio, was a modest conceptual leap, which artists such as Michael Asher have been able to make tremendously interesting and analytically very rich. It was the perception of an asymptotal relation of this art to everyday items and places, presumably *other* than the artist's studio, that put Clement Greenberg in the camp that opposed minimal art: "No matter how simple the object may be, there remain the relations and interrelations of surface, contour, and spatial interval," and, for these reasons, Greenberg continued, "Minimal works are readable as art, as almost anything is today, including a door, a table, or a blank sheet of paper."[14]

"Self-effacing" is how art historian Barbara Rose described minimal art's "mechanical impersonality" in 1965.[15] This sculpture's "frequent kinship with the world of things" (and with Dada) led her to liken this sculpture to basic units of language or information, but not in any way to the artist's hand or the artist's personal spaces. Like Annette Michelson, who insightfully called Morris's minimal work "apodictic," Rose

considered Morris's sculpture to be a series of simple and factual assertions involving exchangeability.[16]

Without literally using the term 'studio,' Morris eventually disparaged "the total separation of means and ends in the production of objects, as well as the

12 Martin Friedman, 'Robert Morris: Polemics and Cubes', Art International, 10, 10 (December 1966), pp. 23-27 (23); Robert Morris, letter to Martin Friedman, 24 August 1966. From here, it seems a short conceptual distance to the rubbings of books and electrical outlets, among other items, that Morris made in his studio on Mulberry Street in 1972. See Kimberly Paice, 'Rubbings (1972)', in Robert Morris: The Mind/Body Problem, pp. 240-243. Likewise, Curator Eugene C. Goossen was struck by the importance of how minimal art both coupled with and decoupled from architecture. It is not difficult to follow his thinking in decisions to include such paintings as Georgia O'Keeffe's Lake George Window (1929) and Ellsworth Kelly's Window: Museum of Modern Art, Paris (1949) alongside minimal sculpture in 'The Art of the Real: USA 1948-1968'. Reviewing that show, Gregory Battcock chastised Goossen for "academicizing" Minimalism and limiting the work's potential to contest real places and institutions (museums and universities). Gregory Battcock, 'The Art of the Real: The Development of a Style: 1948-68', Arts Magazine, 42, 8 (Summer 1968), pp. 44-47.
13 James Meyer, Minimalism: Art and Polemics in the Sixties, New Haven, CT and London: Yale University Press, 2001, p. 166.
14 Clement Greenberg, 'Recentness of Sculpture', in American Sculpture of the Sixties (exh. cat.), Los Angeles: Los Angeles County Museum of Art, 1967, p. 25.
15 Barbara Rose, 'A B C Art', Art in America, 53, 5 (October/November 1965) pp. 57-69; also reprinted in Gregory Battcock (ed.), Minimal Art: A Critical Anthology, New York, NY: E.P. Dutton & Co. Inc., 1968, pp. 274-297 (274).
16 Annette Michelson, 'Robert Morris: An Aesthetics of Transgression', in Robert Morris (exh. cat.), Washington DC: Corcoran Gallery of Art, 1969, p. 13. Rose ties ABC Art to Gertrude Stein's Lectures in America (1935), works of poet-painter Kasimir Malevich and Marcel Duchamp, and Marshall McLuhan's Understanding Media: The Extensions of Man (1964). Poet David Antin emphasizes the techniques of isolation in Morris's work, which, he says, make the context for works seem alien. See 'Art & Information, 1 Grey Paint, Robert Morris', Art News, 65, 2 (April 1966), pp. 23-24, 56-58. By similar reasoning, Hal Foster wrote that minimal works were made, in keeping with the mode of late-capitalist production, to "signify in the same mode as objects in their everydayness, that is, in their latent systematic." Hal Foster, 'The Crux of Minimalism', in Individuals: A Selected History of Contemporary Art (exh. cat.), Los Angeles: Museum of Contemporary Art, 1986, pp. 162-183 (179). See also Jean Baudrillard, For a Critique of the Political Economy of the Sign (trans. Charles Levin), St. Louis: Telos Press, 1981, p. 104. A priori composition and the use of readymade components were implicit in minimal art's design focus, and opened logically for Morris onto the industrial fabrication. This factor left minimal work open to criticisms that were proffered by Marcuseans, such as Ursula Meyer in the 1960s, that this work did not resist rationalism or depart from the logic of commodities. Ursula Meyer, 'De-Objectification of the Object', Arts Magazine, 43, 5 (Summer 1969), pp. 20-22. Historians later tried resurrecting Morris's minimal art and dance via Herbert Marcuse's Freudo-Marxian explanation of desublimated labor.

concern to make manifest idealized mental images," which, he said, "threw doubt on the claim that the Pragmatic attitude informs minimal art of the '60s."[17] It was as if he lamented that the artist's mental images never had a place of their own, and that such a place would have to be the artist's studio.

Performance

We find still more interesting responses to the studio in Morris's performances, therefore this essay culminates with them. In the performance-work *Site* (1964-67) and the performative exhibition *Continuous Project Altered Daily* (1969, hereafter *Continuous Project*), the artist inventively realized the prospect of performing displacements of the studio and studio practices. In contrast to the representational and documentary nature of the Neo-Dada works mentioned previously, these works have the peculiar effect of making a spectacle or, perhaps it would be better to say, a 'show' out of the fall of the studio. Using theatricality in these works, Morris prodded the distinctions between the artist's use of the studio as habitat and as a space that the artist merely inhabits, and that is not the same as the exhibition gallery as a space that s/he appropriates for her or his own use. By positioning viewers to experience these typically distinct operational spaces synchronously, Morris violated the dualistic economy of studio and exhibition space, and basically put on display the exchange value that is produced in the traffic from the studio to the gallery.

The earlier work, *Site*, was a dance that was first performed at Stage 73 for the Surplus Dance Theater in New York in 1964. This work intermingled the visible presence of an abstract architectural environment, one that was implicit in minimal sculpture, with the abstract white planes of paint in Edouard Manet's modern painting *Olympia* (1863). Garbed all in white and yet identified as an artist-worker, Morris was masked by an uncanny cast of his own face that Jasper Johns contributed and that hid Morris's facial expressions. Moving about like an automaton, Morris's dance involved carrying white-painted rectangles of plywood as if he were moving the artist's studio, wall by wall. As accompaniment, Carolee Schneeman posed as a nude and powdered Olympia on a minimal white bed, while a tape recording, made from Morris's studio window, of a painfully noisy jackhammer, played on stage from inside a white cube on the left side of the stage.

By 1969, Morris put forth the notion that even raw materials shall be considered as information to be perceived, much like photographs and other kinds of language, particularly items organized in lists and sets. The mailing for the show *Continuous Project* was, accordingly, merely informational: very reductive,

17 Here Morris refers to a recent essay by Barbara Rose, 'Problems of Criticism VI: The Politics of Art, Part III', Artforum, 7, 9 (May 1969), pp. 46-51. See Morris, 'Notes on Sculpture, Part 4: Beyond Objects', Artforum, 7, 8 (April 1969), pp. 50-54; reprinted in Continuous Project Altered Daily: The Writings of Robert Morris, Cambridge, MA, London, New York: MIT Press in association with the Solomon R. Guggenheim Museum, 1993, pp. 51-70 (67).

black type on a white background, simply stating the artist's name, two sites, the gallery of Leo Castelli on 77th Street and 103 West 108th Street, and a spare list of materials: aluminum, asphalt, clay, copper, felt, glass, lead, nickel, rubber, stainless, thread, and zinc.

The locus of the artist's studio and art-making, Morris wrote a year before, in the watershed essay 'Anti Form', had, historically, been crucial to the dubiousness of naming raw materials and turning them, by whatever process, from 'stuff' into objects to be consumed. Contemporary art, including his own, he insisted, should depend on materiality that would be capable of eliciting new perceptual modes and in turn undermine linguistic and imagistic constraints in art-making.[18] In the culminating fourth installment of the 'Notes on Sculpture' essay series, he further explained that Minimalist objects had "provided the imagistic ground out of which 1960's art was materialized."[19] minimal art had come dangerously close to naming, that is, making "manifest idealized mental images and assert[ed] forms before substances."[20]

To address these factors, denials, and reversals, Morris tried, briefly, to make perception, information processing, and material transformation his priorities and to put aside object production. Construction sites readily appealed to him for their rawness and for their dissimilarity to the totally manufactured urban environment in which the gestalt principle dominated experience.[21] Calling them "small theatrical arenas," Morris said such sites were the opposite of refuges.

Not safe or sheltering places for dwelling, such arenas were "the only places where raw substances and the processes of their transformation are visible, and the only places where random distribution is tolerated."[22] These sites offered the kinds of sensory experiences that he hoped would stimulate the stunted perceptual apparatus of urban dwellers (and viewers), which is constantly numbed by the already-built and overly-gridded environment.

Morris's *Continuous Project* was an action of artistic labor in a thoroughly makeshift studio situation, where the artist's live performative work crisscrossed the storage space of the Castelli Gallery with a jury-rigged construction site. With over a ton of material at his disposal, the toiling artist deprived himself of traditional outcomes, such as objects or structures, e.g., categories or items that are related to systems, and he documented this deliberate deprivation in an idiosyncratic theory of alienation from his work products.

Continuous Project was not traditional fare for a gallery or performance space, even though the

18 Robert Morris, 'Anti Form', Artforum, 6, 8 (April 1968), pp. 33-35; reprinted in Continuous Project Altered Daily: The Writings of Robert Morris, pp. 41-49.
19 Morris, 'Notes on Sculpture, Part 4', p. 64.
20 Morris, 'Notes on Sculpture, Part 4', p. 67.
21 When Morris moved to New York with his dance partner Simone Forti, they were struck by the overly-created qualities of the urban environment. This experience became relevant to Morris's presentation of the artist's studio in Site. Forti wrote: "In the spring of 1959, Bob Morris and I moved to New York. I just couldn't believe that place. What shocked me most was being immersed in an environment that seemed to have been completely designed and created by people (...). I remember how refreshing and consoling it was to know that gravity was still gravity. I tuned into my own weight and bulk as a kind of prayer." Simone Forti, Handbook in Motion, Halifax and New York: Press of the Nova Scotia College of Art and Design with New York University Press, 1974, p. 34.
22 Morris, 'Notes on Sculpture, Part 4', p. 69.

parameters for distinguishing indoor works from out-
door works of art were being eroded at the time. In
fact, Morris was able to incorporate into *Continuous
Project* the soil from a work that he had recently shown
indoors at Dwan Gallery. To document the work pri-
vately, Morris kept notebooks about the ongoing labor
in *Continuous Project*, from 28 February to 22 March
1969, describing processes of mixing water and grease
with clay, stringing up and ripping down cotton and
muslin sheets, piling and shoveling asbestos and dirt,
tearing felt strips, hammering wood, and building
platforms only to make them collapse under the weight
of dirt. These process-documenting notebooks sug-
gest that Yvonne Rainer was responsible for remind-
ing Morris that "play" should be part of the project,
although she does not recall being involved as such.[23]
Morris ruminated in this chronicle that the process
left him cold, frustrated, disgusted, and "bored."[24] He
found it was difficult to resist having preconceptions
of the work that would result each day: "I had no idea
of what I'd do or put in there except I knew I'd work
everyday." He engaged in a nebulous activity that be-
gan with manipulating conventional materials while
trying to find nonsensical or unexpected syntactical
arrangements of these materials. These efforts were
aimed at the formally interesting and the temporally
drawn-out:

I started with a ton of clay. I had some threadwaste from the Thread piece. Barrels, I don't remember what was in them. I started putting plastic down. I had 400 pounds of cup grease. I started building tables, and I brought felt, the clay got hard. I stretched felt over, making layers or things. At the end of each day, I took a photo, which was developed that night. Then the next day, I'd put it up. So you begin to have a record of the past. The last day, I cleaned it up and made a recording, the shoveling, all that stuff. So what was left was the recording of cleaning plus the photographs. That's the nature of the piece, always in process.[25]

Leaving the recorder playing back this sound in the emptied Castelli warehouse at the end of the month when the work was closing, suggests more than cleaning up the space. It solidifies the importance of

23 Morris's unpublished notebooks document that "Yvonne [Rainer], Ted, and Joanne" were involved with making this work and that members of Pulsa stopped by the warehouse one day. Rainer underscores that the work was not collaborative between her and Morris, however, and that her work of the same title, which was performed in her studio, was independent of Morris's project. Yvonne Rainer, correspondence with the author, 27 August 2007.
24 Letting his mind drift, he wrote without obviously bracketing his feelings about upcoming professional engagements and plans for works that he might make, including a film about weightlifting that never materialized.
25 Tape-recorded Interview from 1977 with Thomas Krens, Tape 4.2, in the Robert Morris Archive at the Solomon R. Guggenheim Museum of Art, New York.

Continuous Project within the overall series of studio displacements that are tucked so quietly into his works that they may go quite unnoticed or misunderstood as a thematic body of work. In this gesture of sounding out, we sense Morris's continued desire to proffer information or to use mediums as languages. But why would he still rely on such an appurtenance in this anti-formal work? Indeed, the paradox is that he was still working to create and display exchange value. The revulsion that Morris described in his journal was not towards the physical process of making or manipulating materials, but to the very idea of making something out of materials and his labor. Morris did not reject the notion of exchange value by making this project as a work that was not for sale. He even turned photographs of it into a multiple — an accordion-style paper foldout of stages and details of the project — which was published by Marian Goodman's Multiples, Inc. in 1970. In a sense, this was the opposite approach to meaning that Rainer sought with language in her own work of a similar title, *Continuous Project-Altered Daily* (1969) (*CP-AD*):

By the time I was making CP-AD, talk was related to spontaneous behavior by the dancers and reading by the non-dancers. Earlier talk appeared in the form of recitations while moving. In the early days of CP-AD, I tried to

58

strike a balance between 'behavior' and 'polished' dancing configurations. It wasn't always easy.[26]

Directly inspired by reading Anton Ehrenzweig's writings, Morris had acknowledged *Continuous Project* as the first occasion where he wanted to use the processes in art-making to work through levels and aspects of his own personality. This seemingly new position with regard to the role of the 'self' in art-making related to Morris's preoccupation, around 1967-1971, with materials that resisted formal unification and seemed altogether unlike the built environment.[27] Morris described the importance of visually and mentally scanning over such unfixed materials, as Ehrenzweig discussed, rather than of focusing and fixing on familiar things, proper names, or recognizable forms. Morris hoped to transfer the sensing of indeterminacy to viewers so that they might become more unified in the face of oceanic sensations

26 Yvonne Rainer, correspondence with the author, 16 October 2007. That Rainer's project shared a name with Morris's, she says, related only to the fact that "we were both into indeterminate structures" at that time. Rainer's predilections for play and empathy in her work were not aims that Morris shared. For the role of these terms in Rainer's work, see Carrie Lambert, 'On being Moved: Rainer and the Aesthetics of Empathy', in *Yvonne Rainer: Radical Juxtapositions 1961-2002* (exh. cat.), Philadelphia: Rosenwald-Wolf Gallery, 2002.

27 Morris informed Thomas R. Krens that Continuous Project was directly related to the permuted stadium-shaped Untitled (1967) that is currently in the Panza Collection, which was acquired by the Solomon R. Guggenheim Museum, New York. Tape Recorded Interview from 1977 with Thomas R. Krens, Tape 4.2, in the Robert Morris Archive at the Solomon R. Guggenheim Museum of Art, New York. Morris himself refers to the work as "stadium-shaped." Most untitled works in his oeuvre bear such casual nomenclature of which he is the source, not me. This work bears the number 67.172 in the Robert Morris Archive.

of the overwhelming power of the world around us, as Ehrenzweig suggested could be an outcome of such encounters with the haecceity material world.[28] Still, it was primarily the aim of unifying himself that Morris advanced in his private journal. Publicly, he wrote that he wanted to breach routine orientations, since it is the "concrete physicality of matter," in process-oriented work, that "allows for a change in the entire profile of three-dimensional art: from particular forms, to ways of ordering, to methods of production and, finally, to perceptual relevance."[29]

To develop ways of making art that would secure art's relevance for the people who experience it, Morris relied on the notion that "perception has a history."[30] In taking up this understanding or way of ordering, he hoped to move still further from what he called "studio- and factory-generated commodity art."[31] In 1971 he simultaneously theorized about possible routes out of the potentially toxic cul-de-sac that was created by exchange in process-oriented materiality. In particular, Morris expressed his interest in hand-manipulated material that was left uncommodified, but not raw, and that could be used in environmental-scale work that explores "the more or less 'unmade'," "suppresses visual incident," and locates process in "the one who participates" in this art.[32] So, Morris leaves the 1960's with the studio and self in tow. No longer a place for production, the studio was for him rendered redefinable, stageable, portable, implicitly empty *and* overly full of information about

being rather than about "having done," much like his selected writings, which were named after *Continuous Project Altered Daily*'s indexical traces, recorded sounds, sequestered and supplemental journal, photographable instances of work-in-progress, foldouts of double takes, mess-making and tidying reversals, and scores that go practically nowhere at all.

28 Ehrenzweig's name does not appear in 'Anti Form' but figures in 'Notes on Sculpture, Part 4: Beyond Objects'. Anton Ehrenzweig, The Hidden Order of Art, A Study in the Psychology of Artistic Imagination, Berkeley: University of California Press, 1967. This author's method derived from the school of depth psychology as it was developed in England, and Ehrenzweig acknowledged the crucial influence upon his work of Marion Milner's playful book on how to embrace leisure, An Experiment in Leisure, London: Chatto and Windus, 1937. Milner's book was initially published under the pseudonym 'Joanna Field'. This source does not seem to have translated into Morris's work, which continuously orients itself not around de-translation but around treatises, statements, theories, and authoritative translations of works, however non-referential they may be, into more work.
29 Morris, 'Notes on Sculpture, Part 4', pp. 67-68.
30 Morris, 'Notes on Sculpture, Part 4', p. 61.
31 Robert Morris, 'The Art of Existence: Three Extra-Visual Artists: Works in Process', Artforum, 9, 5 (January 1971), pp. 28-33; reprinted in Continuous Project Altered Daily: The Writings of Robert Morris, pp. 95-117 (95).
32 Morris, 'The Art of Existence', p. 95, 97.

"My Studio is the Place where I am (Working)"

Daniel Buren

Wouter Davidts

The art of yesterday and today is
not only marked by the studio as
an essential, often unique, place of
production, it proceeds from it. All my
work proceeds from its extinction.

Daniel Buren, 1971.[1]

(...) the day when I cannot move or
travel anymore, as I have done over
the past forty years, I will either stop
working or my work will be different.
The only thing that I can imagine
helping to keep it going in its present
form might be my long experience of
moving and looking at different places.
Perhaps with documentation I could
still work, but I would miss those little
details that you can only see when you
are there, when you meet people. My
work would be completely different and
certainly, as far as I [can] tell from my
viewpoint today, would revert to more
traditional aspects. I prefer not to think
about it!

Daniel Buren, 2006.[2]

Daniel Buren

In 1971, French artist Daniel Buren ended the essay 'The Function of the Studio' by stating that his work proceeded from "the extinction" of the studio.[3] At the

This essay is a translated and rewritten version of 'Mijn Studio is waar ik me bevind. Daniel Buren en de afschaffing van de studio', published in De Witte Raaf, 18, 113 (January-February 2005), pp. 14-15. I wish to thank Dirk Pültau for his editorial comments on the original version and Daniel Buren for the kind permission to reprint the photograph of his office in Paris (originally published in Catherine Francblin, Daniel Buren, Paris: Art Press, 1987, p. 61)

1 Daniel Buren, 'The Function of the Studio', translated by Thomas Repensek, in October, 10 (Fall 1979), pp. 51-59. The original French essay 'Fonction de l'Atelier' dates from 1971, but it was first published in English in 1979 in the journal October, in a translation by Thomas Repensek. All further quotations in the essay stem from this translation, unless otherwise indicated. The original French essay was published in Daniel Buren, Les Écrits (1965-1990). Tome I : 1965-1976, edited by Jean-Marc Poinsot, Bordeaux: CAPC Musée d'art contemporain de Bordeaux, 1991, pp. 195-204. The early writings of Daniel Buren were edited and published in 1991 by Jean-Marc Poinsot in three volumes: Les Écrits (1965-1990) Tome I: 1965-1976; Tome II: 1977-1983; Tome III: 1984-1990. Further on in the essay, I shall use the abbreviations LE I, II & III.

2 '"The Function of the Studio" Revisited: Daniel Buren in Conversation', in Jens Hoffmann and Christina Kennedy (eds.), The Studio (exh. cat.), Dublin: Dublin City Gallery The Hugh Lane, 2006, pp. 103-106 (106). This interview appeared alongside a reprint of the aforementioned English translation (see note 1) of 'The Function of the Studio' in the catalogue for the exhibition The Studio in the Hugh Lane Gallery in Dublin, 1 December 2006 - 25 February 2007. This show took Buren's essay, together with the permanent display of the former studio of Francis Bacon at the Dublin museum, as the starting point. Through the work of 18 artists, from Buren and other famous protagonists of the post-studio era such as John Baldessari, Andy Warhol, Martha Rosler, or Martin Kippenberger, the show explored the fate of the studio in the decades after Buren's essay. The exhibition The Studio in Dublin was not the only recent exhibition on the postwar artist's studio that was based upon Buren's seminal essay. Although named after the famous work by Bruce Nauman, Mapping the Studio in the Stedelijk Museum in Amsterdam (12 May-20 August 2006) also took Buren's essay as its point of departure. The Amsterdam show was, unfortunately, not accompanied by a catalogue. For a description of the curatorial project, see: Leontine Coelewij, Mapping the Studio, in Stedelijk Museum Bulletin 02, 2006, pp. 20-25. In the exhibition Ateliers: L'artiste et ses lieux de création dans les collections de la Bibliothèque Kandinsky at the Centre Pompidou in Paris (1 April-28 May 2007), Buren was again the main figure that represented the "post-studio" section in the exhibition and in the catalogue. See: Didier Schulmann (ed.), Ateliers: L'artiste et ses lieux de création dans les collections de la Bibliothèque Kandinsky, Paris: Editions du Centre Pompidou, 2007. In all three exhibitions, large quotations of Buren's essay were printed on the wall. Another reprint of the essay can be found in the book From Studio to Situation, edited by Claire Doherty (London: Black Dog Publishing Limited, 2004, pp. 15-18)

3 In the original French essay Buren, uses the term "abolition," which means to do away with or to abolish. It's remarkable that the English translation opts for the far more extreme and apocalyptic term "extinction," which signifies both destruction and eradication.

time, these apocalyptic words seemed to be the direct outcome of his most recent personal artistic developments. Six years earlier, the artist had exchanged painting for a practice of in situ works, reducing his painterly tools to a single formula: the systematic use of a formal pattern of 8.7-centimeter-wide, or 3.5 inches, vertical stripes, alternating colored stripes with white or transparent ones. Since then, Buren has applied this *outil visuel*, or visual tool, onto the manifold materializations of the art apparatus and its various institutional and architectural frameworks. The striped pattern is not reflexive — since it has been reduced to a zero degree — but operative: it is active somewhere. Through their specific application on a given site or support, the stripes aim to elucidate the material conditions of the work of art and its various modes of production, presentation, and reception. This undertaking, according to Buren, continues to oblige him to work 'on site': "'in situ' means, at least in my understanding of it, that there is a voluntary bond between the site of reception and the 'work' that is produced, presented, and exhibited there."[4] An artwork that is made elsewhere — on a site either preceding or exterior to where it will be on view — can never reveal the influence and impact of the given framework of the exhibition. In order to avoid what Buren calls "les risques du dehors" or the external risks, he invariably merges an artwork's site of presentation with its site of production.[5] This ambition however has had important consequences for the paradigmatic space of the

studio. Since every artwork, Buren realized, is made on site, a separate workspace became an obsolete, useless, even absurd relic. His artistic activities no longer required a studio and thus allowed him to get rid of his former studio, which apparently was just "a cave without heating and lit by a glass roof."[6] Over the last three decades, Buren has merely occupied an office, a place where, according to the artist, only "letters are written."[7] He exchanged the fixed workspace of the studio for a moveable, mobile spatial condition, an artistic situation of work. Ever since then, his studio has coincided with the institutional context in which he operates. Whereas Marcel Broodthaers, in 1968, transformed his studio into a museum by opening the first department of his *Musée d'Art Moderne* (*Département des Aigles / Section XIXème siècle*) at 30 rue de la Pépinière in Brussels — the opening of which Buren actually attended — the former decided to convert the museum into his studio, time and again. At first sight, Buren's moveable studio appears to be as equally

4 (My translation); Daniel Buren, 'Du volume de la couleur' (1985), in LE III, pp. 97-102 (100): "'In situ' veut dire enfin dans mon esprit qu'il y a un lien volontairement accepté entre le lieu d'accueil et le 'travail' qui s'y fait, s'y présente, s'y expose'."
5 (My translation); Daniel Buren, 'Sauve qui peut, Atelier! Entretien avec Catherine Lawless' (1989), in LE III, pp. 407-418 (412).
6 (My translation); Buren, 'Sauve qui peut, Atelier!', p. 409 : "(...) une cave non chauffée éclairée par une verrière (...)."
7 Daniel Buren, 'Das Atelier im Kopf: Ein Interview mit Daniel Buren von Isabelle Graw', Texte Zur Kunst, 13, 49 (2003), pp. 58-65 (63). In a recent email correspondence with the author (19 January, 2009), Daniel Buren explicitly stressed the fact that the office never "replaced" the studio in "his willful abolition of the studio as a unique and personal site for the production of an artwork," since this would seem to falsely imply a conceptualist reorientation of the artist's practice in which "the works were merely ideas that one could write down and then send via the mail to museums and galleries to have them executed." (my translation)

empty and fictitious as Broodthaers mobile museum. In merging the studio with the museum or vice versa, both artists focus on the separate roles and sites they have occupied respectively within the institutionalized art world since the 19th century. Both the studio and the museum are pivotal elements in the commercial art circuit. Together with Broodthaers and contemporaries such as Dan Graham, Hans Haacke, or Michael Asher, Buren is now widely considered to be one of the protagonists of institutional critique, that branch of postwar art that aimed to reveal the cultural, sociopolitical, and economical mechanisms of the art system. While, over time, many have interpreted Buren's virulent critiques as opposing the system, the artist claims to have always maintained a more ambiguous position. In many interviews, Buren has stressed that his anti-romantic and anti-idealist stance has never involved a resolute repudiation of the art apparatus, but rather that it entails both a critical and yet pragmatic identification with it. He departs from the inevitability and inescapability of the institutional regime, but refuses to take it for granted. His relentless investigation of "all the frames, envelopes, and limits (...) which enclose and constitute the work of art" is never meant, so the artist stresses, to leave them behind, let alone to eliminate them. Those who read his critical assertions as a plea "to burn or to close down" the art institutions, Buren commented in an interview with Jérôme Sans in the late 1990s, simply "took their desires for reality."[8]

The studio, however, presents an exception. It is the only site in the institutional nexus that Buren claims to have overcome, even to have extinguished.[9] That this assertion is made at the end of an essay that is now widely considered to be the manifesto for *in situ* practice in general, and for post-studio practice in particular, might at first not look surprising, yet it is all the more significant. Upon closer inspection, there lies an intriguing discrepancy at the heart of Buren's influential but nevertheless arguable position within the global development of site-specific practice. Buren has often noted that he launched the term *in situ*, and that only later did it became *en vogue*.[10] His mobile practice has indeed served as a pioneering model for those artists that incessantly fly around the world to intervene in different places,

8 (My translation); Daniel Buren and Jérôme Sans, Au sujet de, Paris: Flammarion, 1999, pp. 125; See also 'In Conversation: Daniel Buren & Olafur Eliasson', in Artforum, 43, 9 (May 2005), pp. 208-214 (212); Buren, 'Das Atelier im Kopf', p. 63.
9 The essay Reboundings (Brussels: Daled & Gevaert, 1977) is another rare occasion on which Buren succumbs to what Hal Foster (The Return of the Real: The Avant-Garde at the End of the Century, Cambridge, MA.: MIT Press, 1996, p. 25) has termed "apocalyptic impulses." Here the artist ends in equally dramatic terms when he states that it is no longer a matter of "challenging the artistic system" but that his work "aims at nothing less than abolishing the code that has until now made art what is, in its production and in its institutions." But contrary to the essay 'Function of the Studio,' he does not name one institution in particular.
10 For a detailed definition by Buren of 'his' term "travail in situ," see: Daniel Buren, 'Du volume de la couleur', p. 100. Buren uses the expression "in situ" for the first time (in a public document) on the occasion of the censoring of his work Peinture-Sculpture during the Sixth Guggenheim International in 1971. In 1974 the artist uses it again in an interview with Liza Bear (Kunst bleibt Politik, in Avalanche, [December 1974], p. 18), when referring to the installation in the Guggenheim: "The only thing I wanted to say with that piece could only be said by the piece itself in situ. By removing it from the view, it meant that everyone was discussing it in a vacuum." For a more detailed account of Buren's use of the term "in situ,": Jean-Marc Poinsot, Quand l'oeuvre a lieu: L'art exposé et ses récits autorisés, Genève/Villeurbanne: Mamco/Institut d'art Contemporain & Art édition, 1999, p. 86 (note 21); p. 93 (note 8).

institutions, and cities, according to their own artistic idiom or formal yet conceptual strategy — a process that has only been sped up by the global increase of art biennials, public art commissions, and city exhibitions.[11] The broad artistic assimilation and general institutional recuperation of the term over the last two decades, Buren likes to note, have hollowed it out to such an extent that even he himself finds it difficult to use.[12] But contrary to his assessment, this attrition can not merely be accredited to later generations of site-specific practice. A close reading of 'The Function of the Studio' reveals that Buren's own radical stance towards the studio contains a critical crux, that is, it manifests both the frailest point of *in situ* practice as well as the germs of the later abrasion into mere idiosyncratic interventionism.

First Frame

'The Function of the Studio' starts with a systematic analysis and harsh evaluation of the role and significance of the place and space of the studio, akin to Buren's analysis of the critical limits (1970) and the traditional places of the art apparatus: the museum (1970), the exhibition (1973), and the gallery (1977).[13] The studio, according to Buren, is the exclusive site for the production of placeless art: "The studio is (...) a boutique where we find ready-to-wear art." Whereas since the 19th century the museum, both as institution and building, functions as the primary space for the *public presentation* of art, the studio functions

as its unique space of *private production*. This turns the studio into "the first frame, the first limit, upon which all subsequent frames/limits will depend." It's the non-exchangeable place of origin for a work of art. It constitutes the private and fixed environment that houses, protects, and isolates a work of art from the outer world. Since an artwork is allowed to be on its own in the studio, it belongs there: "it is in the studio and only in the studio that it is closest to its own reality." But unfortunately, Buren continues, this is "a reality from which it will continue to distance itself." To exist and hence to lead a public life of its own, every artwork needs to be exhibited *somewhere*. This "unspeakable compromise of the portable artwork" entails a departure that is nothing but fatal, even catastrophic: "The work thus falls victim to a deadly paradox from which it cannot escape, since its purpose implies a progressive removal from its own reality, from its origin." Every artwork is doomed to

11 I refer here to the recent historicizing and critical analysis of site-specific practice in such familiar sources as: Douglas Crimp, 'Redefining Site Specificity', in On the Museum's Ruins, Cambridge, MA.: MIT Press, 1993, pp. 150-186; Hal Foster, 'The Artist as Ethnographer', in The Return of the Real, pp. 171-203; James Meyer, 'Nomads: Figures of Travel in Contemporary Art', in Alex Coles (ed.), Site-specificity: The Ethnographic Turn, London: Black Dog Publishing Limited, 2000, pp. 10-29, later republished as 'The Functional Site; or, 'The Transformation of Site Specificity', in Erika Suderburg (ed.) Space, Site, Intervention: Situating Installation Art, Minneapolis: University of Minnesota Press, 2000, pp. 23-27; Nick Kaye (ed.), Site Specific Art. Performance, Place, and Documentation, New York: Routledge, 2000; Johanne Lamoureux, L'art insituable: De l'in situ et autres sites, Montréal: LIEUdit Collection, 2001; Miwon Kwon, One Place After Another: Site-Specific Art and Locational Identity, Cambridge, MA.: MIT Press, 2002.
12 Buren and Sans, Au sujet de, p. 101.
13 The essays 'Fonction du Musée' (1970), 'Limites Critiques' (1970), 'Fonction de l'Atelier' (1971), 'Fonction de l'Exposition' (1973), and 'Qu'attendez-vous' (1977) are published in the collected writings, respectively in LE I pp. 169-174; LE I pp. 175-190; LE I pp. 195-204; LE I pp. 329-334; LE II pp. 11-14.

reside in a place where it doesn't belong and destined to be manipulated by people it does not belong to. Yet strangely enough, Buren experiences this inescapable fate of the artwork as a dreadful tragedy. And what's more, he blames this misfortune on the studio. But why the studio? This we only learn after he has elaborated the different options in dealing with the discrepancy between the places of production and consumption. He meticulously evaluates each and every one of them, only to discard them as (self-)deceptive. Only then do we discover the true foundation of Buren's "distrust of the studio and its simultaneously idealizing and ossifying function": a "personal" experience as a young artist.

In the mid-1970s, the seventeen-year-old Daniel Buren committed himself to the study of painting in the French regions of Provence and Côte d'Azur, from Paul Cézanne to Pablo Picasso. He was very much interested in the impact of the geographical location and of the specific context on the work. Buren visited numerous studios, of both young and old, celebrated and obscure painters. Regardless of the diversity, quality, and richness of the paintings, and of the reputation of the visited artists, Buren was primarily struck by the "truth" of the work: "This 'reality/truth' existed not only in terms of the artist and his work space but also in relation to the environment, the landscape." With "disappointment", however, he observed that this genuineness vanished in "the gap between the studio and the gallery."[14] When leaving the studio, the artworks

fell short of an "energy essential to its existence": they suffered from an irretrievable "loss of the object." Torn from their context, their "environment," the artworks were deprived of their meaning and life. Buren thus discovered an intimate bond between the truth of an artwork, its maker and its place of origin: "What I later came to realize was that it was the reality of the work, its 'truth', its relationship to its creator and its place of creation, that was irretrievably lost in this transfer." Apparently, what bothers Buren the most is that, when artworks move to the museum, they are severed from all the other works, objects, and traces that mark and populate the working space and which are a part of the production process. Buren is thus not so much preoccupied by the production process itself, but first and foremost by the environment of the workplace. He does not want to renounce the genuine presence of an artwork amidst its production context — which, according to the artist, is "extinguished by the museum's desire to 'install'." In fact further on it becomes apparent that he even wants to regain a certain authentic presentness, that is, when he discusses another, yet *historical* influence for his suspicion: the studio of Constantin Brancusi.

In the eyes of Buren, Brancusi is "the only artist" that exhibited "real intelligence in his dealings with the museum system and its consequences, and

14 In the original French text, Buren uses the beautiful expression "cimaises parisiennes," which regrettably is translated to merely "gallery" in English. As such, the implied curatorial manipulation of the Parisian picture rails is reduced to merely a spatial container.

who, moreover, sought to oppose it by not permitting his works to be fixed or even arranged according to the whim of some departmental curator." In his will, Brancusi donated the entire contents of his studio, including the works, sketches, tools, books, and records to the French State, but with the stipulation that it be preserved altogether.[15] Thus not only did Brancusi prevent the future dispersal of his works and the subsequent speculation on them, he guaranteed first and foremost that every visitor would enjoy a viewpoint similar to his own during the production process: "He is the only artist who, in order to preserve the relationship between the work and its place of production, dared to present his work in the very place where it first saw light, thereby short-circuiting the museum's desire to classify, to embellish, and to select. The work is seen, for better or worse, as it was conceived." But was Brancusi's move as audacious as Buren presents it? The desire to preserve the works' production context in its entirety is essentially the product of the fear — Brancusi's, and in this case also Buren's — that the viewer will encounter the work *differently* than the artist envisioned. Buren is not so much concerned about the viewer's conditions of perception; he first and foremost wants to safeguard "the same perspective as [the artist] himself at the moment of creation." His attack on the studio is driven by his inability to accept that every artwork is unrooted by definition as soon as it is exhibited. Although he centers his critique on the museum and its manipula-

tive manners — what Buren labels the catastrophic fate of Brancusi's work "in the hands of the public" — his real target is the exhibition.[16] The Latin verb *exponere*, which lies at the origin of the term exposition, not only means to present or to exhibit, but also to expose, to put outside.[17] While every exhibition grants an artwork a public place within the world, it at once deprives it of every later relation with that world too. Since Brancusi's decision to donate the studio and its contents to the French State inevitably meant that it would become 'public,' the predestined alienation also applied to his workplace and every possible object it contained. While Buren claims that Brancusi managed to maintain "the everyday character" of his workplace in opposition to the concealing operations of the museum, the everyday nature and environment of the studio (represented by the bench, chisels,

15 Buren offers a rather distorted version of the actual donation process and will of Brancusi. Whereas he states that Brancusi "dispos[ed] a large part of his work with the stipulation that it be preserved in the studio where it was produced," the actual will of Brancusi reads a bit differently. Brancusi had his will drawn up one year before he died, when he aleady knew that his studio ran the risk of being demolished. The will, dictated by the artist on 12 April 1956, merely stipulated that his studio and its contents were to be conserved as a whole after his death, but it envisioned immediately a place for it within the walls of a museum of modern art and thus its inevitable institutional 'reconstitution': "Je lègue à l'État Français pour le Musée national d'art moderne absolument tout ce que contiendront au jour de mon décès mes ateliers situés à Paris, impasse Ronsin, numéro 11, n'exceptant que l'argent comptant, les titres ou valeurs qui pourraient s'y trouver et qui reviendront à mes légataires universels. Ce legs est fait à charge par l'État français de reconstituer, de préférence dans les locaux du Musée national d'art moderne, un atelier contenant mes œuvres, ébauches, établis, outils, meubles." (as cited in Marielle Tabart [ed.], L'atelier Brancusi, Paris: Éditions du Centre Georges Pompidou, 1997, p. 14)
16 Buren, 'Das Atelier im Kopf', p. 60.
17 Daniel Payot, 'Événement, parodie, présence: Le musée et l'exposition', in Jean-Louis Déotte and Pierre-Damien Huyghe (eds.), Le jeu de l'exposition, Paris/Montréal: L'Harmattan, 1998, pp. 65-85; Jean-Louis Déotte, Le musée, l'origine de l'esthétique, Paris: L'Harmattan, 1993, p. 54.

hammers, and record player among other things) was at any rate doomed to ossify into a curious but anecdotal décor as soon as it was exposed to the public, after the artist's death.[18] Regardless of its later subsequent reconstructions, the "conceptual totality designated by the artist" was destined to become a mere solemn reminder of a work process long past.[19]

The Fall of the Studio

Buren experienced the fall of the studio differently than his contemporary Robert Smithson, who also exchanged painting for a more hybrid practice and is considered to be another protagonist of the post-studio era. In the section 'The Dislocation of Craft — and Fall of the Studio' of his 1968 text 'A Sedimentation of the Mind: Earth Projects', Smithson discards the studio as a dated straitjacket of craftsmanship and creativity: "Deliverance from the confines of the studio frees the artist to a degree from the snares of craft and the bondage of creativity."[20] In order "to use the actual land as medium," he takes refuge in new and different techniques, abandoning the studio as the unique and artisanal space of production.[21] Smithson utilized diverse strategies and spread his artistic production across various sites and producers that could no longer be identified with a central, authoritarian source. He worked in both the museum and the desert, used a bulldozer, a typewriter, and still and motion picture cameras, ultimately

76

producing sculptures, photographs, texts, and films. With his *Site/Non-Site* works, in particular, Smithson radicalized and instrumentalized the suspension of destination that lies at the heart of the modern condition of publicness, and that is — albeit only partially — mediated by the private space of the studio.[22] He never felt the urge to eliminate the studio, but merely regarded it as one of the many possible places in the maze-like process of an artwork's production of meaning. Smithson felt no grief about the inevitable loss of the object that occurs in the travel between a work's site of production and its site of presentation, but

18 While the English translation of 1979 uses "the banality of the work," I prefer to stay closer to the original French text, which uses the expression "ce côté quotidien," which could be more appropriately translated as "the everyday nature."

19 Daniel Buren and Jens Hoffmann, 'Exhibiting the Studio', in Jens Hoffmann and Christina Kennedy (eds.), The Studio (exh. cat.), Dublin: Dublin City Gallery The Hugh Lane, 2006, pp. 105-106. In the original French essay of 1971, Buren remarks, in a footnote, that "[h]ad Brancusi's belongings remained in the studio in the Impasse Ronsin, or even in the artist's house (even if removed to another location), Brancusi's argument would only have been strengthened." In 1971 he referred to the first reconstruction of the studio in 1962 at the Musée National d'Art Moderne, then located in the Palais de Tokyo. At the time of the publication of the English translation of the text in 1977, the studio had already undergone a second reconstruction in 1977 on the north side of the piazza in front of the newly-built Centre Pompidou. In the 1979 text, Buren extends the footnote by stating that this second reconstruction "renders the above observation obsolete." Since 1997, a third reconstruction can be visited on the same north side of the piazza, designed by Renzo Piano. For a detailed history of the moving and reconstruction of the studio, see: Tabart (ed.), L'atelier Brancusi.

20 Robert Smithson, 'A Sedimentation of the Mind: Earth Projects' (1968), in Robert Smithson: The Collected Writings, Berkeley: University of California Press, 1996, pp. 100-113 (107).

21 Robert Smithson, 'Towards the Development of an Air Terminal Site' (1967), in The Collected Writings pp. 52-60 (56).

22 For a historical account of the 'mediating intervention' of the modern artist's studio, see: Frank Reijnders, 'De tussenkomst van het atelier', in De Witte Raaf, 15, 94 (November-December 2002), pp. 17-20. See also Oskar Bätschmann, The Artist in the Modern World: A Conflict Between Market and Self-Expression, Köln: DuMont Buchverlag, 1997, pp. 93-108. For a broader historical context of the genesis of the artist's studio, see: Michael Wayne Cole and Mary Pardo (eds.), Inventions of the Studio: Renaissance to Romanticism, Chapel Hill: University of North Carolina Press, 2005.

instead, as he explained in a discussion with Michael Heizer and Dennis Oppenheim in 1970, exploited it most lucidly: "The closer you think you're getting to it, and the more you circumscribe it, the more it evaporates. It becomes like a mirage and it just disappears. The site is a place where a piece should be but isn't. The piece that should be there is now somewhere else, usually in a room. Actually, everything that's of any importance takes place outside the room."[23] Neither the object of the *Non-Site* nor the actual *Site* appear as complete: place, object, and experience refuse to concur in the spatio-temporal framework of the exhibition. The only thing one is confronted with is "a very ponderous, weighty absence."[24] Both work and site are, as Smithson remarked in the essay 'Incidents of Mirror-Travel in the Yucatan' on the *Mirror Displacements* series of 1969, forever displaced: "Yucatan is elsewhere."[25]

Buren, on the other hand, seeks a solution for the loss: he eliminates the studio and replaces it with a site-specific practice. He neither accepts nor exploits the loss that takes place within every exhibition, but tries to overcome, even repair it. Although Buren overturns Brancusi's approach by dissolving the studio into the specificity of a site, his strategy is marked by a similar distrust towards the alienating character of the enterprise of exhibition. Buren's attack on the studio is driven by his desire to avoid the artwork leading a life that differs from the one he has envisioned for it himself. He wishes to

short-circuit a process that cannot be cut short. The fact that an artwork leads an altogether different life cannot be circumvented by turning the exhibition space, for a longer or shorter period, into a studio. As soon as the work is accomplished, it is turned over to the space and event of the exhibition, and to the inevitable condition of publicness that the latter embodies. It remains surprising that precisely this condition of publicness, which Buren has repeatedly analyzed in meticulous detail, nevertheless seems to contain an unbearable aspect to him.

Buren's solution, however, does not solve much. He simply replaces the truthful bond between work and studio by another truth: that of the persona of the artist working *in situ*. He substitutes for the modern cult of the monastic artist, the postmodern adoration of the nomadic and networking interventionist. The delivered authenticity resides in the promise that the work comes to life and is produced *by him* and *on site*. Although Buren, in accordance with his minimalist contemporaries, acknowledges the influence, impact, and significance of an artwork's context, the resulting artwork nevertheless remains the result of an authorial and individualized intervention.

23 Robert Smithson, 'Discussions with Heizer, Oppenheim, Smithson/Liza Bear and Willoughby Sharp' (1970), in The Collected Writings, pp. 242-252 (250).
24 Robert Smithson, 'Robert Smithson. June 20, 1969/Patsy Norvell', in Alexander Alberro and Patsy Norvell (eds.), Recording Conceptual Art: Early Interviews with Barry, Huebler, Kaltenbach, LeWitt, Morris, Oppenheim, Siegelaub, Smithson, and Weiner by Patricia Norvell, Berkeley: University of California Press, 2001, pp. 124-134 (127).
25 Robert Smithson, 'Incidents of Mirror-Travel in the Yucatan' (1969), in The Collected Writings, pp. 119-133 (133).

Buren may have physically left his studio, yet in his head he never truly vacated its space. The studio still represents the private process of creation and the highly individual production of meaning that he never ceased to cherish. In this respect, the studio may be regarded as one of the most essential and yet most frail aspects of Buren's practice: his true point of departure yet ever-denied point of reference. Why else does the artist need to insist on the literal claim that his practice has prevented him from occupying an actual workplace? He almost always confesses, in the same instant, that his studio is far from inexistent, empty or fictitious, but 'inherent': he embodies and inhabits it in person. Wherever he goes, he told Phyllis Rosenzweig in 1988, his studio 'comes down': "My studio is, in fact, where I find myself."[26] In an interview with Isabelle Graw, Buren even boasted that his relentless and frenetic activity — epitomized by the fact that he often has "merely twenty-four hours or one week" in between two exhibitions — has led to a complete identification between the studio, the world, and himself: "My studio has multiplied itself in the world, so it feels as if I'm in my studio every day to produce things."[27] This both bodily and spatial (im)personification of the studio lies at the basis of the recurrent criticism that his work is merely a repetitive and idiosyncratic intervention. Every works starts with *his* artistic presence, with his personal intervention. Time and again the stripes tell us: Buren was here.

Daniel Buren

26 (My translation); Daniel Buren, 'Entretien avec Phyllis Rosenzweig' (1988), in LE III, pp. 357-359 (358) : "Mon atelier, en fait, est le lieu où je me trouve." In the catalogue of the exhibition The Studio in Dublin (p. 35), this statement is rather peculiarly translated to "My studio is, in fact, the place where I am working."

27 (My translation); Buren, 'Das Atelier im Kopf', p. 63: "Mein Atelier hat sich in die Welt hinein multipliziert, und es fühlt sich so an, als sei ich jeden Tag in meinem Atelier, um Dinge zu produzieren."

81

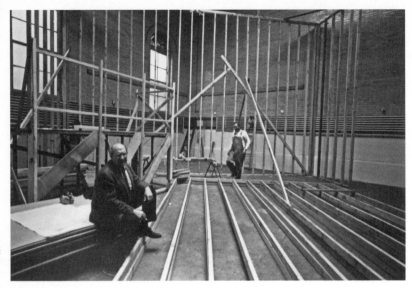

1 Mark Rothko

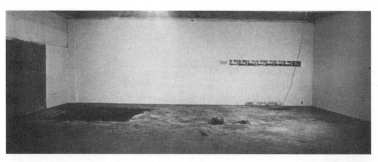

2 Robert Morris

1 Hans Namuth, Untitled (alterations to Rothko's East 69th Street studio,
 New York, December 1964), 1964.
 Photograph Hans Namuth
 Courtesy Center for Creative Photography, The University of Arizona
 © Hans Namuth Estate
2 Robert Morris, Continuous Project Altered Daily, Castelli Warehouse,
 January 1969. Intermediate and last stages.
 Reproduced from Robert Morris (exh. cat.), edited by Michael Compton
 and David Sylvester, London: Tate Gallery, 1971
 © Robert Morris

3 Daniel Buren

4 Bruce Nauman

3 **Daniel Buren,** Photo-souvenir: Le bureau de Daniel Buren, **Paris, 1987.**
Photograph Daniel Buren
© **Daniel Buren**
4 **Bruce Nauman,** Bound to Fail, **1967. (Color photograph, part of the portfolio**
"Eleven Color Photographs", 1966-67/1970, edition of 8)
Various collections
Reproduced from Please Pay Attention Please: Bruce Nauman's Words,
edited by Janet Kraynak, Cambridge, Mass.: The MIT Press, 2005
© **Bruce Nauman 1967 c/o Pictoright Amsterdam 2009**

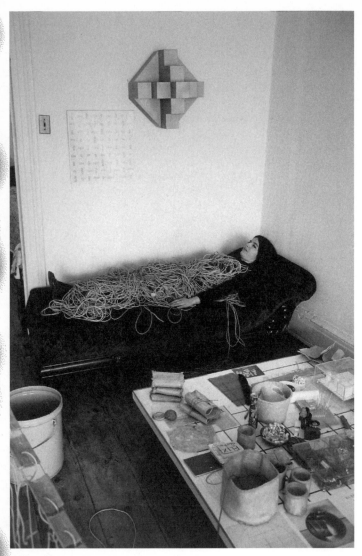

5 Eva Hesse

6 Martin Kippenberger

7 Olafur Eliasson

8 Jan De Cock

Seeing through the Studio
Bruce Nauman

MaryJo Marks

Recounting time spent in his first studio, after graduating from art school in 1966, Bruce Nauman said:

> If you see yourself as an artist and you function in a studio and you're not a painter (...) you do all kinds of things – you sit in a chair or pace around. And the question goes back to what is art? And art is what an artist does, just sitting around the studio.[1]

Some forty years earlier, Siegfried Kracauer had published a short essay on the subject of boredom.[2] Instead of examining, as one might expect, the tedium of modern industrial labor and the repetitive, oversimplified tasks that constitute unskilled work, his topic was modern leisure. Kracauer considered its diversions, however spectacular, just as dull. Moreover, he concluded, contemporary popular culture —designed as escape from the drudgery of work— distracted from life. The critic doesn't complain that the modern subject is bored; rather, that no one is bored enough. He advocates a kind of "extraordinary, radical boredom."[3] Neither concerted productivity nor focused play, it entails the fruitfulness of just sitting around, making or doing apparently nothing:

> But what if one refuses to allow oneself to be chased away? Then

boredom becomes the only proper
occupation, since it provides a kind
of guarantee that one is, so to speak,
still in control of one's own existence.
If one were never bored, one would
presumably not really be present at all
and would thus be merely one more
object of boredom. One would light
up the rooftops [like a neon sign] or
spool by as a filmstrip.[4]

The remedy? Stay home, Kracauer instructed, draw
the curtains and recline on the couch so that:

one flirts with ideas that even become
quite respectable in the process, and
one considers various projects that,
for no reason, pretend to be serious.
Eventually one becomes content to
do nothing more than be with oneself,
without knowing what one actually
should be doing (...). Frivolous, one
harbors only an inner restlessness
without a goal (...). If, however, one

1 Bruce Nauman as quoted in Coosje van Bruggen, Bruce Nauman, New
 York: Rizzoli Publications Inc, 1988, p. 14.
2 Sigfried Kracauer, 'Boredom' (1924), in The Mass Ornament: Weimar Essays,
 Cambridge, MA: Harvard University Press, 1995, pp. 331-336.
3 Kracauer, 'Boredom', p. 331.
4 Kracauer, 'Boredom', p. 334.

has the patience, the sort specific
to legitimate boredom, then one
experiences a kind of bliss.[5]

Sounding like the rarefied, detached condition of
the flâneur, this state specifically resembles the luxury
of aesthetic disinterest and artistic autonomy, of not
"knowing what one should actually be doing" in more
utilitarian terms.[6] But the aesthete's state, ennui, dif-
fers from the tedium that permeates unskilled work
or daily life. As Patricia Spacks notes, "Ennui implies
a judgment of the universe; boredom, a response to
the immediate. Ennui belongs to those with a sense
of sublime potential, those who feel themselves supe-
rior to their environment [and are] unable to separate
the pose from the reality of boredom."[7] Kracauer's es-
say locates the latter in "the vulgar boredom of dai-
ly drudgery." For Maurice Blanchot, this "boredom
is the Everyday become manifest."[8] Bruce Nauman,
it seems, conflated the two: everyday boredom and
Kracauer's "extraordinary, radical boredom" were
coupled as a recurring trope within his aesthetic prac-
tice. Yet while sharing some traits, Nauman's drifting
around the studio differed from Kracauer's state of
listlessness in the parlor.

For one thing, the artist implied that even while
merely sitting or pacing he was, nonetheless, work-
ing; and doing so in a place, the studio, designated
for work. Moreover, he was hardly idle, generating a
vast number of artworks in the span of a few short

years. But his studio was productive of certain psychic states, as well. If some artists were analogizing their studios to other cultural models — Andy Warhol's 'factory', for instance, or Claes Oldenburg's 'store', both suggesting commerce and producing tangible goods — Nauman's studio became a laboratory for behavioral experiments as much as aesthetic ones. His 1970 artist's manifesto stated, "Lack of information input (sensory deprivation) = breakdown of responsive systems"; under the subtitle "Withdrawal as an Art Form" he extolled the "Examination of physical and psychological response to simple or even oversimplified situations."[9]

Nauman was self-reflexively examining the condition of an artist intentionally deprived, among other things, of past models for artistic practice. His empty studio, conducive to this, might be likened to a B.F. Skinner box.[10] But the form of strategic deprivation that engaged Nauman had a specific name:

5 Kracauer, 'Boredom', p. 334.
6 For aesthetic disinterest as "purposiveness without purpose" see Immanuel Kant, Critique of Judgment (trans. J.H. Bernard), New York: MacMillan Press, 1951.
7 Patricia Spacks, Boredom: The Literary History of a State of Mind, Chicago: University of Chicago Press, 1995, p. 13.
8 Maurice Blanchot, 'Everyday Speech' (1959), Yale French Studies, 73 (1987), pp. 12-20 (12).
9 Bruce Nauman, 'Notes and Projects', Artforum, 9, 4 (December 1970), pp. 44-45 (45).
10 The behavioral scientist B.F. Skinner's famous wooden box was designed to test the responses of mice, rats, and pigeons to deprivation and rewards in a highly controlled environment. Nauman's 1988 Learned Helplessness in Rats (a plastic maze with a video of rats circulating its corridors) made the lab-rat analogy explicit.
 While the phrase "learned helplessness" might imply a critique of the passive viewer, when applied to the artist it suggests deskilling: that one learn to be helpless in former areas of competence by unlearning skills previously acquired and venerated.

deskilling.[11] It signaled the deliberate loss of conventions, materials, or routines that had formerly determined, on the most basic level, what an artist does and practices doing in the studio. And this approach favored photographic means that have been historically aligned with deskilling. Nauman used these (film and video, still photography and holography) to record everyday acts or objects found in the mostly barren studio, employing photo-based mediums in the most mundane and literal fashion, as is often deskilling's wont. Obviously he didn't intend for the work to be judged boring, seeking strategies to offset what he recognized as its potential tedium. "Many things you could do [like this] would be really boring, so it depends a lot on what you choose, how you set up the problem in the first place. Somehow you have to program it to be interesting."[12] Speaking tongue in cheek, he considered showing his films on network television by noting, "I would like to have an hour or half an hour to present some boring material."[13]

We can imagine a typical model of artistic fumbling or frustration followed by breakthrough periods of inordinate creativity; or picture the alleviation of boredom as an incentive to work. But for Nauman, like Kracauer, killing time was embraced and engineered as revelatory in itself. Nor did he run from the specter of failure. Like boredom, it crops up repeatedly in the early work. Sometimes boredom or failure structured a work's production. The nature and duration of Nauman's movies, for example, were often determined

by his psychic or physical fatigue when performing reductive, repetitive tasks. But these states were equally evident on the spectator's side. The 1970's corridor pieces replicated the empty studio as deprivation box. These barren, Sheetrock tunnels induced viewers to monitor (as his manifesto advocated) their "response to simple or even oversimplified situations" conditioned by "withdrawal as an art form."[14] The films and videos of extremely simple exercises — in which both the acts depicted and the movies themselves endlessly repeat — created similar effects.

How did the audience respond? As one critic noted, Nauman's works "elicit in the spectator a simultaneous feeling of tedium and engrossment."[15] Another said that, in his observation, the typical viewer's reaction was to "glaze over (…) and flee."[16] As for the work's critical reception in the mainstream press, boredom was often mixed with bewilderment or rage. Some felt,

11 The term first appears in 1981 with Ian Burn's essay, 'The Sixties: Crisis and Aftermath (The Memoirs of an Ex-Conceptual Artist)', Art & Text, 1 (Fall 1989), pp. 49-65. It has come to signal the antiquation of unique artisanship and manual expertise in craft, replaced, for instance, by mechanical mass production, serial forms, or conceptual schemes.

12 Willoughby Sharp, 'Interview with Bruce Nauman', Avalanche, 2 (Winter 1971), pp. 22-31 (27).

13 Sharp, 'Interview with Bruce Nauman', p. 30.

14 Nauman's work sought a participatory role for the audience, but strictly circumscribed their actions. For a different reading of this dynamic see Janet Kraynak, 'Dependent Participation: Bruce Nauman's Environments', Grey Room, 10 (Winter 2003), pp. 22-45. She cites qualities -other than boredom that might repel the viewer, describing the audience's experience as an "alienating encounter. The viewer is assaulted... frightened ...and cornered." While Kraynak also points out the prison-like effect of some Nauman pieces, one should note that incarceration is always, and primarily, characterized as boredom.

15 Jane Livingston, 'Bruce Nauman', in Livingston and Marcia Tucker, Bruce Nauman: Works from 1965 to 1972 (exh. cat.), Los Angeles: Los Angeles County Museum of Art, 1972, p. 21.

16 Peter Schjeldahl, 'The Trouble with Nauman', Art in America, 82, 4 (April 1994), p. 85.

apparently, that their time had been wasted. As one might expect, Hilton Kramer's review of Nauman's 1973 Whitney Museum retrospective was scathing.

> Mr. Nauman's exhibition is no easier to describe than it is to experience, for there is pathetically little here that meets the eye -a few sculptures of no sculptural interest, a few photographs of no photographic interest, a few video screens offering images that somehow manage to be both boring and repugnant.[17]

He is bored and repulsed, in particular, by Nauman's refusal to engage established conventions specific to a given media. Describing the same show, Robert Hughes called it "simpleminded," nominating it "the most vapid show" of the year. "It could hardly have happened to a thinner talent (...). It makes the most tedious of Warhol's movies seem like the chase scene in *Bullitt*. Every so often, Nauman inflects the monotony a little."[18] These are easy fish to fry, but the rhetoric ("boring," "pathetically little," "thin," "simple minded," "vapid," "tedious," "monotony") is worth noting, all of it affiliated with boredom.

We could say that the philistines didn't count, and they certainly didn't in the long run, Nauman becoming arguably the most lauded, influential, and

successful artist of his generation. Ten years earlier, though, Leo Steinberg argued that they did. For any viewer's "discomfort or the bewilderment or the anger or the boredom," as he put it, was a way to track and analyze certain paradigm shifts in modern art.[19] To "evaluate [art] in the absence of available standards," he asserted, entailed a profound kind of deprivation, the "sacrifice" and "discarding" of known values for artists and viewers alike.[20] Steinberg described a public, genuinely troubled by those shifts that seem to change the worth of art.

And this should give what I call "The Plight of the Public," a certain dignity. There is a sense of loss, of sudden exile, of something willfully denied – sometimes a feeling that one's accumulated culture or experience is hopelessly devalued (...). This sense of loss or bewilderment is too often described simply as a failure of aesthetic appreciation or an inability to perceive the positive values in a novel experience (...) there is no dignity or

17 Hilton Kramer, 'In the Footsteps of Duchamp', The New York Times, March, 30, 1973, p. 28.
18 Robert Hughes, 'Vapid Wanderkind', Time Magazine, April 16, 1973.
19 Leo Steinberg, 'Contemporary Art and the Plight of its Public' (1962), in Other Criteria, London: Oxford University Press, 1972, pp. 3-16 (5).
20 Steinberg, 'Contemporary Art and the Plight of its Public', p. 15.

positive content in resistance to the new. But suppose you describe this resistance as a difficulty in keeping up with another man's sacrifices?[21]

The critic found that audiences' "habitual assumptions" and previous experience made them feel "*entitled* to some pleasurable reward (...) but there is a curious lack of reward. There is something withheld."[22] Withdrawing the conventional attributes of a given medium, or art in general, Nauman withheld its anticipated pleasures, interest, and stimuli. In other words, the discomfort and boredom were generated in part by deskilling.

Nauman's reply to such indifferent or negative appraisals was blunt. The haranguing print *Pay Attention Motherfuckers* (1973) or the beseeching collage of the same year, *Please, Pay Attention Please*, suggested that engagement — although of an unorthodox kind — was, indeed, required. Boredom is the inadvertent failure to sustain attention, one's own or another's. In these works, the onus to stay absorbed rests with the viewer (although a photograph of Nauman's studio in 1993 shows a drawing above his desk which bleats *Make Me Think*, implying that the two earlier works might be self-admonishing, as well). None of these graphic works provides much by way of purely visual interest. The print, however, was written in reverse script, thus obstructing other expectations. It muddled the words' legibility and the viewer's skill

in deciphering them; the pace of reading, retarded, was sluggish at best. But the words' import, to "pay attention," and the work's perceptual complexity, point to a heightened degree of focus or conceptual dexterity, producing a dialectics of tedium and engrossment, indifference and engagement, failure and success. Nauman wanted our attention, the work soliciting and rewarding it; but in a different manner, again attributable to deskilling.[23] Real boredom or failure is unintended (at least consciously), but deskilling is a deliberate failing, the refusal to meet known criteria for aesthetic interest. All of which returns us to Nauman's first professional studio, a former San Francisco storefront, and its modes of deprivation.

He told us what he was doing in his studio, and it wasn't much: the most banal of daily routines that usually serve as diversion — sitting and drinking coffee, pacing or meandering — until an idea strikes or an event transpires. Tedious in themselves, they are activities generally located before, after, or in between more substantive ones. But these everyday events were precisely the ones that Nauman chose to document in his photo-based work.

21 Steinberg, 'Contemporary Art and the Plight of its Public', p. 7.
22 Steinberg, 'Contemporary Art and the Plight of its Public', p. 7.
23 "It always seemed to me that [artists] were court jesters. They were responsible for providing something of interest for everyone else... I always thought that was wrong and that everyone ought to be putting in a little more effort" instead of being passively entertained. Nauman in Kristine McKenna, 'Bruce Nauman: Dan Weinberg Gallery', Los Angeles Times, January 27, 1991, p. 4.

The earliest performance things that were filmed were things like you sit in the studio and what do you do? Well, it turned out that I was pacing around a lot, so that was an activity that I did so I filmed that, just the pacing.[24]

When I had a studio, I was working very little [and] I didn't know what to do with all that time. (...) There was nothing in the studio because I didn't have much money for materials. So I was forced to examine myself and what I was doing there. I was drinking a lot of coffee, that's what I was doing.[25]

The conjunction of empty time (so much that he "didn't know what to do" with it all, turning surplus into deficit) and empty space ("nothing in my studio") was the precondition for Nauman's prolific creativity during this period. Again, his earliest artistic endeavors are characterized by withdrawal, abstaining from the obvious activities or material resources that a conventional studio practice would provide. This might imply that Nauman's art of the mid-1960's was created ex nihilo, culled from thin air with the kind of quasi-magical virtuosity parodied in some of his works, such as *Art Make-Up* (1967-68). It consisted of four films in which Nauman applied makeup to his face and body.

The title, however, alluded to making up art, and one's artistic identity, wholesale. Yet the genesis of Nauman's art, like the objects or actions it deployed, had a specific origin and milieu. Instead of the studio, it was the Everyday, which has its own spatial and temporal parameters.[26] Obliterating the ordinariness of daily life, the studio is supposedly a special place in which extraordinary things occur on a regular basis; Nauman's work routine suggested otherwise.

Content to hole up alone in the empty studio he would walk around and record that, as in the film *Walking in an Exaggerated Manner Around the Parameter of a Square* (1967-68); or he would find himself in domestic mishaps, depicted in the color photograph *Spilling Coffee Because the Cup was too Hot* (1966-67). Two early photo-montages, *Flour Arrangements* (1966), a pun on flower arranging, and *Composite Photo of Two Messes on the Studio Floor* (1967) recorded another, albeit organized, mess. The artist swept flour strewn across the floor and photographed the resulting piles, his only activity in the studio over an entire month. In the 1968 films *Bouncing Two Balls between the Floor and Ceiling* and *Bouncing in the Corner*, Nauman mapped the studio's spatial parameters or the trajectory of his bodily movements in relation to them. The

24 Lorraine Sciarra, 'Bruce Nauman' (1972), in Bruce Nauman, Please Pay Attention Please: Bruce Nauman's Words, **edited by Janet Kraynak,** Cambridge, MA.: The MIT Press, 2005, pp. 155-172 (166).
25 Willoughby Sharp, 'Nauman Interview', Arts Magazine 44 (March 1970), pp. 22-27 (24).
26 Theorizing the Everyday has its particular historical coordinates as well. Beginning in the 1950s, writers such as Blanchot, Roland Barthes, and Henri Lefebvre took up the topic as an object for analysis.

artist was equally attuned to temporal conditions in his studio, whether in acts he performed there (bouncing, sitting, pacing) or in the conditions of photographic mediums used to record them. He experimented with slow-motion and high-speed film, performed actions for the camera in slow motion, or cinematically recorded himself in static, immobile states (such as *Wall-Floor Positions* (1968), an exercise that again took its cues from the material coordinates of the studio). Conversely, the still photographs sometimes captured a sequence of events over time, through pasted montage or, as in *Failing to Levitate in the Studio* (1966), double-exposure. Most often, though, he synchronized real and cinematic time with a stationary film or video camera, eschewing jump cuts or other editing devices. Nauman also attended to the temporal nature of certain psychic states. These included boredom's duration, experienced as unremitting, regardless of how long it lasts; and Everyday time, an uneventful flow of routine events perceived, Blanchot said, as "stationary movement."[27] As Nauman put it, "My idea was that the films should have no beginning or end; one should be able to come in at any time and nothing would change."[28] Tracing the studio's physical and temporal determinates, he was actually reconfiguring its discursive boundaries, the yardsticks measuring aesthetic values and artistic identity.

Nauman's San Francisco studio, formerly a local bodega, included a large plate-glass window that still displayed a neon beer advertisement. Next to this

the artist installed two of his own works. One was a neon spiral that read *The True Artist Helps the World by Revealing Mystic Truths* (1967); the other, from 1966, a clear Mylar sheet with the words *The True Artist is an Amazing Luminous Fountain* inscribed around its border. Like the beer sign hung adjacent to them, they functioned as a form of commercial advertisement — announcing in hyperbolic terms the goods and activities procurable from a 'true' artist's studio. This, in effect, turned the studio back into a store.[29] The option of installing them on a window, the glass support integral to the work, was explicitly prescribed by the titles. The Mylar's title contained the phrase *Window or Wall Shade*, while the neon was subtitled *Window or Wall Sign*.

One could simply read the words on the surface, the opaque neon tubes or letters on Mylar partially obstructing the view to the scene beyond. But opting for the window installation (instead of the potential wall presentation) also allowed one to look through the spaces between the letters and through the glass support surrounding them. The works' double-sided nature, due to the window's transparency, was redoubled in the translucent elements — the neon's cast light and the Mylar's clear plastic. Furthermore, both

27 Blanchot, 'Everyday Speech', p. 15.
28 Sharp, 'Interview with Bruce Nauman', p 28.
29 Benjamin Buchloh (Formalism and Historicity: Authoritarianism and Regression, Paris: Territoirs, 1982, p. 39) has described Nauman's use of light in his corridors as retaining its everyday affiliations: "Nauman has reversed the formalist aestheticism of [Dan] Flavin's fluorescent lights. By reinstalling them simply and functionally in his corridors, he allows the immediate and authentic experience of the elements of the work."

works could be viewed, like a photographic negative, from either side. Depending on the spectator's position, one looked out onto the public, social terrain of the street or into the studio's privileged, sequestered domain. But unlike the beer sign, the script was reversed when seen from the street. Like the artist's reversed prints and drawings, the 'correct' orientation was not necessarily the one Nauman favored.

Hung on the window, the neon and Mylar pieces encompassed a swath of actual space in real time. Minimalist sculpture of this era was similarly marked by the phenomenological activation of real time and space, a quality that prompted Michael Fried to criticize it in 1967 for being overly "literal."[30] While Nauman's work trafficked with this kind of literalness, it mobilized other aspects of the literal as well. Incarnating certain metaphors in material form, it literalized them. The window exhibition format, for instance, made physically manifest the notion of truth-as-transparency, duplicating the texts' musings on truth and revelation. Illumination, another metaphor for truth, was materially present in the neon's light, echoing the Mylar's verbal imagery of a "true" artist as "luminous." Moreover, the neon's hue and the Mylar's colored sheet — both pink — conjured up the aphorism of "seeing the world through rose-colored glasses." This, too, materially embodied an idea implicit in the texts. The conceit that artists actually "help the world" suggests the utopian beliefs that color and filter aesthetic discourse or judgment, just as the pink

108

light and plastic sheet color and filter the works' visual reception. Yet these works were not entirely ironic, for the view from Nauman's studio, a perspective at once physical and ideological, was double-sided.

The statements seem intended figuratively, not literally. Nauman, however, claimed that their declaration of traditional aesthetic sentiments was a "test" to see if he could take the content at face value. It was "a totally silly idea," he stated, "and yet, on the other hand, I believed it. It's true and it's not true at the same time."[31] Nauman was acknowledging some investment in the text's preposterously utopian claims while at the same time his art, he said, contained "nothing mystical, nothing confusing, nothing hidden."[32] Moreover, he asserted, the Mylar and neon pieces barely registered or qualified as art. "I had an idea that I could make art that would kind of disappear — an art that was supposed to not quite look like art. In that case, you wouldn't really notice it until you paid attention. When you read it, you would have to think about it," to decide, that is, if you believed in the statements and if the works met any criteria for art.[33] The view onto the street included its random pedestrians, virtually Nauman's only audience at the time, or so he claimed. They must have been baffled if, indeed, they noticed the display at all. Categorical confusion

30 Michael Fried, 'Art and Objecthood', in Gregory Battcock (ed.), Minimalism: A Critical Anthology, New York: E.P. Dutton, 1968, pp. 116-147.
31 Bruce Nauman, as quoted in Brenda Richardson, Bruce Nauman: Neons, Baltimore: The Baltimore Museum of Art, 1983, p. 20.
32 Bruce Nauman, as quoted in Livingston, 'Bruce Nauman', p. 24.
33 Bruce Nauman, as quoted in Richardson, Bruce Nauman: Neons, p. 20.

renders the works' status as art, like the window itself, almost invisible; or, like the reversed script, initially indecipherable.

The exchange between opacity and transparency, surface and depth, recalls other photographic paradigms and metaphors. The photograph's physical surface, for example, typically evaporates into the scene's depicted depth, transforming the print's opacity into a transparent window. In other ways, as Roland Barthes argued, photography pivots on its denotative and connotative axis. Barthes privileges denotation, the photograph's documentary literalness (and oft-presumed superficiality) over its connotation's imputed profundity or symbolic depth.[34] Language, likewise, traffics between transparent, denotative speech and its more opaque connotations or rhetoric. Nauman often wed language to photography in order to foreground their literal and figurative exchanges. The 1966 photograph *Failing to Levitate in the Studio* begins as a test of the artist's physical endurance and, if one believed in levitation, psychic prowess. We see his body hung in midair, head and feet resting on folding chairs, and falling to the ground — the result of both gravity and photographic double exposure (another kind of transparency). It's an exercise in bodily and mental failure, a recurring motif in Nauman's films and videos. But the image carries a broader sense of inadequacy, of systemic failure and diminished aura. The title becomes an allegory for the artist's inability to retain an "elevated" state in

the studio or, in other words, to be productive, amazing, and luminous there.

If failure was symptomatic of Nauman's daily studio activities, his early photographs are rife with it. Grouped as a portfolio in 1970 (all taken in 1966 or 1967), these included the picture of spilled coffee previously cited. The series also contained his first acknowledged photograph, an image of five mechanical drill bits bored into a piece of wood and punningly titled *Drill Team*. A play on words, the image presaged the rote bodily 'drills' Nauman would record in his cinematic works. Like *Drill Team*, the movies invoke the repetitive drill of the military exercise and its affinity with the monitored, repeated lab experiment. The other pictures similarly transpose a colloquial phrase from verbal to visual registers; the titles' figurative language is literalized, made manifest in concrete form. But first the process is enacted on a linguistic level. The colloquialisms, intended as metaphor, are interpreted literally. In punning relationships between image and text, Nauman's set of photographs oscillate between these poles. Another picture, *Self-Portrait as a Fountain*, visually incarnated the phrase from the Mylar sheet. A jab at figurative and heroic public sculpture, it showed Nauman spouting water from his mouth like some backyard putto. We might surmise that what he 'spouts' are

34 See Roland Barthes, Camera Lucida (trans. Richard Howard), New York: Hill and Wang, 1981; See also his essays, 'The Photographic Message' and 'Rhetoric of the Image' in Image-Music-Text (trans. Stephen Heath), New York: The Noonday Press, 1977.

the mystical revelations, incantations, and astounding artistic feats that make the 'true' artist a fount of wisdom or creativity. In fact, he is spitting, a base and vulgar gesture. Like the artist's failure to levitate in the studio, this action deflates the metaphysical rhetoric and its delusions of grandeur.

Other images in the portfolio invoke failure directly. Vision falters in *Finger Trick with Mirror* where two hands, doubled in the mirror's reflection, are mistaken for four. A photograph of Nauman preparing a sandwich cut in the shape of the letters "w-o-r-d-s", *Eating My Words* suggests the embarrassment accompanying failure, especially the hubris of overreaching. In *Feet of Clay*, depicting Nauman's feet encased in mud, the artist's movement is impeded. So, too, in *Bound to Fail*, which pictures him with both hands tied behind his back, its title's pun declaring failure inevitable. Achieving something with 'one hand tied behind your back' is the conventional adage for extraordinary facility or skill; not the case, however, with one foot. Regarding his sculpture *Device to Stand In (Brass Floorpiece with Foot Slot)* (1965-66), the catalogue raisonné notes, "Nauman likened this piece to choreography for a dance in which the viewer is invited to participate within very narrow boundaries (so narrow, in fact, that he compared it to dancing with one foot nailed to the floor)."[35] In *Bound to Fail*, it is the artist's body, not the spectator's, which is immobilized. More specifically, he inhibits his manual dexterity, a hallmark for traditional artistic practice. Handi-

craft's loss, of course, is deskilling's calling card; and photography's, too. *Untitled* (1971), Nauman's last still photograph to date, shows the artist's hands and feet resting upon a sheet of drawing paper, each digit interlaced with a pen or pencil. This image implies that either appendage can draw with equal dexterity. The artist's indifference to their usual hierarchy, however, elevates one at the other's expense. The comparison devalues manual skill, the same effect that the work's own medium — photography — has on drawing, the task pictured within the image.

First installed at DIA New York in 2001, *Mapping the Studio I (Fat Chance John Cage)* presented a panoramic view of Nauman's current studio in Galisteo, New Mexico. Consisting of seven videos projected onto four surrounding walls, it documents what transpired there during 42 nights when no one was present.[36] Instead of looking through the window into Nauman's studio, we are transported inside it, the whole space materializing around us. (When later exhibited at DIA Beacon, the images were projected onto semi-transparent scrims, making the room visible, like Nauman's San Francisco studio, from inside or out). All the strategies of the early cinematic work are present: an exploration of ordinary activities in an empty studio; the stationary camera without an operator; the excruciatingly long take, real and filmic

35 Joan Simon (ed.), Bruce Nauman, Minneapolis: Walker Art Center, 1993, p. 200.
36 Paired down to a mere 42 hours, the viewer can now linger - as Kracauer encouraged - in languor.

time synchronized; the quality of still photography's temporal stasis within a cinematic medium; and the attenuated economy, banality, and monotony of the seemingly uneventful. The piece epitomizes Maurice Blanchot's definition of daily life: "Nothing happens, this is the everyday."[37] Like his similar description of the Everyday as "stationary movement," we witness one hour bleeding anemically into the next. Arguably offering little of remote interest, *In the Studio* is nonetheless riveting. Full of activity, its nocturnal ramblings are background and quotidian: the air conditioner hums on and off; the random insect or mouse scurries through; a dog barks; a screen door slams. It recalls the dynamics of Nauman's earlier studio, framed again in terms of boredom and failure:

I had no support for my art then (...). That left me alone in the studio; this in turn raised the fundamental question of what an artist does when left alone in the studio. My conclusion was that I was an artist and I was in the studio, then whatever I was doing in the studio must be art. And what I was in fact doing was drinking coffee and pacing the floor. (...) At this point, art became more of an activity and less of a product. (...) What you are to do with the everyday is an art problem.[38]

114

Here the work's status as art doesn't require — unlike, say, the ready-made — external affirmation; it doesn't depend on the institutional context of gallery or museum ('support' not forthcoming at the time anyway). Nauman simply declared his activities art, putting the artwork as a tangible entity, and its legitimizing frame, under erasure.

On the other hand, the definition relies on an older cultural model and thus a degree of public consensus — that art-making takes place in the studio. But Nauman unravels even this convention by hewing to it in a literal manner, the way "working to rule" undermines industry's rules and its industriousness by attending to them exactly, explicitly, minimally. Art is whatever an artist does in the studio. Period. Even, Nauman's caveat, when he is "just sitting around the studio." Mutually dependent, the art and the studio exist by virtue of the artist's mere presence, a minimal guarantor of their identity as they are of his. In *Mapping the Studio*, though, the artist has essentially evacuated the premises. Aesthetic value now accrues to anything that happens in the studio and passes before the camera's lens, in his absence. The artist's activity is replaced by the recording equipment, left to its own devices; and by the audience, left to fend for themselves, for the work places us (illusionistically, physically, psychically) in the studio where Nauman ought

37 Blanchot, 'Everyday Speech', p. 15.
38 Ian Wallace and Russell Keizere, 'Bruce Nauman Interviewed', Vanguard 8 (February, 1978), pp. 15-18 (18).

to be and leaves him, essentially, out of the picture. This is where deskilling's pact with photography — both reducing the signs of artistic presence, agency, or authorial intervention — leave him, as well.

Nauman kept the studio as a site for production. But he abandoned many artistic skills formerly acquired and subsequently lost through deliberate attrition.[39] Responding in kind to those who found his work lacking in interest (such as Kramer's remark about the artist's "photographs of no photographic interest"), Nauman deemed their criteria of no interest to him:

> Certainly there are artists who function entirely within the discipline. I would find those people uninteresting. Not that they're not talented or skilled or all those things, but it's not of interest to me. In that sense there's a great deal of confusion, because it doesn't require being able to draw or being able to paint well or know colors; it doesn't require any of those specific things that are in the discipline to be interesting. On the other hand, if you don't have any skill at all you can't communicate either, so it's an interesting edge between – that edge is interesting for those reasons.[40]

The new toolbox that Nauman proposed was compelling, but in unprecedented ways. It meant overturning the old one (like some long-forgotten cabinet or desk drawer, a catchall) and dumping the contents on the studio floor. Nauman inspected the array of devices and doctrines and even the container, the studio itself. He sorted and threw out unnecessary or broken parts, worn-out aesthetic materials, forms or strategies. Salvaging what he could, he swept up the former studio's mess in order to start fresh. While hardly rendering the studio a tabula rasa or his practice a blank slate, it was empty enough. And he washed the windows to let in the light of the Everyday. It was illuminating — perhaps, sometimes, even amazing or luminous — in its own, ordinary fashion.

39 He had, after all, studied painting in art school but claimed that shortly thereafter "I had no idea of how to go about making a painting anymore." Nauman in Sharp, 'Nauman Interview', p. 25.
40 Michele de Angelus, 'Interview with Bruce Nauman' (1980), in Bruce Nauman, Please Pay Attention Please: Bruce Nauman's Words, pp. 197-296 (286).

Portraits of the Artist with Work

Eva Hesse

Kirsten Swenson

In the winter of 1968, Eva Hesse posed in her studio for the fashion photographer Hermann Landshoff. The resulting photographs — tableaux vivants in which the artist herself animated her sculptural materials — seem to capture a performative relationship to her art. Yet Hesse never did perform with her work in any public sense and, with one exception, these images were kept private in her lifetime. They were first published six years after the artist's death in Lucy Lippard's 1976 monograph, then in Bill Barrette's 1989 catalogue raisonné, and subsequently in every major study of her work. Although Landshoff's photographs of Hesse performing privately in her studio play a crucial role in mediating the artist's posthumous reception, they have gone largely unanalyzed.[1]

When Hesse's work was installed for exhibitions in the 1960's, her forms elicited associations such as "devitalized" (Robert Smithson), "flaccid" (Lucy Lippard), or "remote, and lifeless" (Mel Bochner) — descriptors that delineate a prior or possible vitality hinted at but never affirmed by the work itself.[2] The Landshoff photographs provide a lens through which Hesse's forms are of, or about, the lived body, the female body in particular; a potentially political association in the 1960's that was an animating principle of Hesse's work, intimated but never openly revealed in its display. This tension animated her work's critical reception as well — most notably Lippard's writings where we read that "specific organic associations are kept at a subliminal level."[3] In this essay, I will seek to restore

120

access to the historical circumstances of these photographs of Hesse in her studio, understanding the scope and significance of her performative poses in relation to the phenomenological premises and tacit gender politics of minimalism, as well as the function of her studio as a space for negotiating the diverse 'post-studio' strategies of minimalism, conceptualism, and performance that prevailed in the New York art world of the 1960s.

Hesse's datebook indicates that Landshoff visited her studio on several occasions in late 1968 and January 1969.[4] Hesse knew him through his sister, Ruth Vollmer, an artist whose pairing of organic and mathematically-derived forms was of interest to Hesse and, though a generation older, one of Hesse's closest friends in the late 1960's. Landshoff had arrived in New York in 1941. He was, like Hesse who arrived in 1936, a German Jewish émigré who had fled the Nazi regime. A commercially successful photographer working regularly for magazines geared toward young women, including *Mademoiselle* and *Junior Bazaar*, Landshoff's trademark style

1 Anna C. Chave discusses the Landshoff photographs in terms of "the ritual of the pose" in her essay 'Striking Poses: The Absurdist Theatrics of Eva Hesse', in Geraldine A. Johnson (ed.), Sculpture and Photography: Envisioning the Third Dimension, Cambridge: Cambridge University Press, 1998, pp. 166-180. The photographs elicit a Kleinian analysis of the phallus from Mignon Nixon in 'Posing the Phallus', October, 92 (Spring 2000), pp. 98-127.
2 Robert Smithson, 'Quasi-Infinities and the Waning of Space', Arts Magazine, 41, 1 (November 1966), pp. 28-31 (31); Lucy Lippard, 'Eccentric Abstraction' (exhibition brochure), New York: Fischbach Gallery, 1966, n.p.; Mel Bochner, 'Eccentric Abstraction', Arts Magazine, 41, 1 (November 1966), p. 58.
3 Lippard, 'Eccentric Abstraction', n.p.
4 Eva Hesse Papers, Allen Memorial Museum, Oberlin College.

involved on-site shoots of models in spontaneous poses. He was considered a pioneer of the new naturalism that marked postwar fashion photography. In the 1940's, Landshoff had photographed members of the Jewish intelligentsia, including Albert Einstein, as well as Peggy Guggenheim, Max Ernst, and their circle of surrealist expatriates, and fellow photographers, including Ansel Adams, Weegee (a.k.a. Arthur Fellig), Margaret Bourke-White, Richard Avedon, and Edward Steichen.[5] Although he was never ultimately considered a 'fine art' photographer, Landshoff's aspirations might be gleaned from the subjects to which he was attracted, as well as from his two coffee-table books — highly formalist and surrealist-inflected photographs of shells and dolls.

Landshoff's résumé and the prescheduled photo shoots suggest that his visits to Hesse's studio involved a certain formality, but beyond the appointments in Hesse's datebooks, nothing is known about the actual circumstances. Did Landshoff initiate the shoots? Hesse? Vollmer? Nonetheless, both Hesse and Landshoff would have possessed historical awareness of the importance of self-fashioned images of the artist in the studio, an almost exclusively male trope through the early 1960's.[6] In 1967, the Museum of Modern Art, New York (MoMA) had hosted an influential retrospective of Jackson Pollock in which his drip paintings were hung in proximity to Hans Namuth's photographs of the artist at work in his studio — a display that prompted the critic Barbara

Rose to propose that "the distributional, anti-formal, process, or body art that succeeded Minimalism in 1967 were inspired by the larger-than-life blow-ups of Namuth's Pollock photographs."[7] But unlike Pollock, absorbed in the solitary act of painting, Hesse is not at work in the Landshoff photographs. Her studio emerges not so much as a place for work, but as a place for displaying, staging, and acting, while also functioning as a compendium of external sources.

In perhaps the most reproduced photograph of the series, Hesse lies stiffly but smiling in the background on her chaise longue, covered in a tangle of rope. A table, fashioned by Hesse's friend Sol LeWitt from one of his trademark gridded structures and with a Lucite model of his room-scale *Serial Project #1* (1966) on top, comprises the foreground of the photograph. This studio table was the subject of one of Landshoff's photographs taken on the same day — without Hesse in the background but with an identical arrangement and deliberate composition. As art historian Anne M. Wagner has shown in detail, it includes "a copy of the periodic table — an elemental listing of the starting place of form. This is no

5 The Hermann Landshoff Archives are located at the Fashion Institute of Technology, New York City. It was Landshoff's practice to destroy his proofs and negatives, keeping only prints of shots deemed successful. Approximately ten extant images are located both in his archive and that of Eva Hesse.

6 Caroline A. Jones (Machine in the Studio: Constructing the Postwar American Artist, Chicago: University of Chicago Press, 1996, p. 40) chronicles the "topos of the male artist in his studio" that prevailed through the early 1960s as "a gendered construct excluding women."

7 Barbara Rose, 'Namuth's Photographs and the Pollock Myth', in Barbara Rose (ed.), Pollock Painting, New York: Agrinde Publications, 1980, n.p.

impersonal inclusion; it is a handwritten object, signed and dedicated from Carl Andre to Eva Hesse." Additionally, Wagner identifies reviews of Hesse's work by John Perreault and Hilton Kramer, and exhibition invitations for Ruth Vollmer and for Hesse's first solo show.[8] Combined with the Lucite model of a LeWitt serial piece, test pieces and sundry grommets, knick-knacks, and mementos, the studio table is something of a collage of the artist's friends, influences, and interests, while indexing the currents of her art's reception. This studio is anything but cloistered; it is a crossroads of diverse practices and sources as much as it is a private space of production.

Under the date January 16, 1969, the following appears in Hesse's appointment book:

2:00 Landshoff
+ still life of table
total failure
I was here waiting[9]

Cryptic as it is — did Landshoff show up at all on January 16? did Hesse consider the table still life "a total failure"? — the entry suggests in any case that it was a preplanned affair. Indeed, the fact that the studio table acts as a subject itself, like a still life rife with metonymic objects, suggests the specificity and intricacy of the dialogue Hesse was composing in her studio.

The background of the photograph is equally dense with significant items. A wall piece by Robert

Smithson projects rigidly over Hesse reclining on her chaise longue. While the modular forms and duality of this early three-dimensional wall-relief (probably 1965) were a departure point for the sculptural work Hesse began in 1966, it had become a conservative relic by 1969, in relation to Smithson's nonsites and emergent post-studio practices. To the left of the Smithson wall piece is a word collage by Andre with strings of prepositions like "out onto about over" written at perpendicular angles within the format of a grid. These banally-stated positions were prompts — words as signs extracted from grammatical context, part of Andre's conceptual practice and related to the decontextualized, pedestrian movements that characterized the choreography of Yvonne Rainer, with whom he collaborated in the 1960's. The photograph shows Hesse herself layered under a sprawling tangle of rope (that would later become a sculpture, her untitled 'rope piece' of 1970), while she is quite literally bracketed by the work of others, carefully positioned among a field of referents. She is located, the photograph seems to say, somewhere in relation to Andre, Rainer, Smithson, LeWitt, Vollmer, and others.

Conventional readings of Hesse's work suggest that her ideas originated from working closely with materials, and that her vaguely associative bodily forms express the properties of latex, cheesecloth,

8 Anne M. Wagner, Three Artists (Three Women): Modernism and the Art of Hesse, Krasner, and O'Keeffe, **Berkeley: University of California Press, 1996, pp. 194-195.**
9 Eva Hesse Papers, Allen Memorial Museum, Oberlin College.

fiberglass, and papier mâché.[10] While surely accurate, this narrative draws on an anachronistic construct of the artist in her studio, acting as a solitary producer who was disengaged from the political implications of performativity and the critique of art and institutions that was implicit in the multimedia and conceptual practices of her peers. Landshoff's photographs of Hesse in her studio posing with her work however suggest a kind of private experimentation with new, performative correspondences between the art object and the body that were being actively explored by Rainer and the Judson Dance Theater Group, as well as Bruce Nauman, and to a lesser extent, Richard Serra.[11] Rainer's influence in particular comes across in a second photograph, for which Hesse transformed herself into a kind of living sculpture by suspending herself on a chair while her hands are tethered inside a cuff-like tube of latex-coated cheesecloth. The suspended pedestrian motion seems rooted in the simple correspondences between "dance activity" and "minimalist tendencies" that were proposed by Rainer in her analysis of her arrangement *Trio A*: "simplicity [in objects, substitute] singular action, event, or tone [in dance]; human scale [in objects, substitute] human scale [in dance]" and so on.[12] As an avid attendee of Judson Theatre performances (and friend of Rainer), Hesse was keenly aware of Rainer's delineations of abstract, non-allusive relationships between three-dimensional objects and the human body.

The Landshoff photographs, both as histori-

cally conscious depictions of the artist in her studio and representations of an array of objects and referents, reveal the extent to which Hesse incorporated diverse extra-studio practices into the conceptual bedrock of her art. They indicate Hesse's awareness of the contemporary status of the studio as a place that was being turned inside out by artists such as Nauman, and rendered obsolete by others such as LeWitt. Dominant 'post-studio' practices of the 1960's, whether factory fabrication (LeWitt and Bochner), installation- or performance-based engagement with institutional spaces, or conceptualism (Rainer, Serra, Nauman, Robert Morris), were predicated on a tacit (or explicit) critique of the hermetic space of the studio. Well aware of this marginalization of the studio by her colleagues and friends, Hesse notably maintained a more conventional studio-based practice. As Mel Bochner recounted, unlike himself and LeWitt,

10 See a.o. Elisabeth Sussman (ed.), Eva Hesse, New Haven: Yale University Press, 2002.
11 In an interview in early 1970 (Interview with Cindy Nemser, Eva Hesse Archives), Hesse expressed her interest in making films, a "new vehicle of content" that might offer a "closer connection with the absurdity of life"- the elusive theme in which she often sought recourse when discussing her art. And film was "in vogue now. Everybody's doing it," Hesse commented, continuing to predict that her own film would be "very abstract," though "I am sure in the first one I would use people." As an artist whose sculptural forms emphasized a tactile investment in materials and process, Hesse's unrealized interest in film – she died prematurely of brain cancer several months after the interview – suggests the extent to which assumptions about medium specificity had been exceeded at that moment as well as the expanded terms in which she had begun to consider artmaking. In this regard, it is possible to see her interest in posing for Landshoff, and the nature of the poses that she chose, as an exploratory step toward time-based media and performative enactments already employed by Bruce Nauman, Richard Serra, and other contemporaries.
12 Yvonne Rainer, 'A Quasi Survey of Some "Minimalist" Tendencies in the Quantitatively Minimal Dance Activity Midst the Plethora, or An Analysis of Trio A', in Gregory Battcock (ed.), Minimal Art: A Critical Anthology, New York: Dutton, 1968, pp. 263-273 (263).

127

"Hesse always kept a very physical, hands-on relationship to her work. Her work became a model of how to escape the severe solipsism of the art of that period — a way out of the mental blockhouse."[13] She maintained keen awareness of these conceptual and performative modes of artistic activity, choosing to engage them indirectly rather than enter forthrightly into such contemporary discourses and practices. The privacy of the studio allowed the artist to maintain a studied distance from the public and the explicit forms that the latter took in the work of her colleagues. Opening up her studio to the lens of a professional photographer, Hesse notably chose to pose *with* her art — not absorbed in the process of making it and seemingly unaware of the photographer's presence (Pollock), or standing next to it with a faraway gaze (Rothko), but *in* it, quite literally *wearing* it, impishly animating her art — and materials that would become art — for the camera.

Still, I would argue, Hesse paradoxically reintroduced and adapted 'post-studio' strategies to the studio and the production of material forms as well. By 1970, the latter could no longer be properly designated as objects or sculpture. Her work became increasingly mutable, engaged with the space it occupied and the contingencies of its installation. For example, the untitled 'rope piece' of 1970 that Hesse was photographed arranging in her studio by Harry Groskinsky for *Life Magazine*, changes with every installation, reflecting the judgment of its installers and the coordinates of the site of display. By 1970, she had

rejected the concept of unitary, portable objects, and her studio became, increasingly, a staging ground for installations that would become animate and complete only after they left the space.

Landshoff's visits to Hesse's studio late in 1968 and in January 1969, occurred at a pivotal moment in her career, marked by two major exhibitions of her work — her first solo show at the Fischbach Gallery in November 1968, followed by her inclusion in Robert Morris's exhibition of 'anti-form' art, entitled *9 in a Warehouse*, at the uptown venue of the Leo Castelli Gallery in December of that year. Both exhibitions garnered prominent reviews and resulted in a new recognition for Hesse within the New York art world. But the critical attention Hesse received in response to these shows was mixed, and there was some consensus that her work was less vital than that of other artists in the Warehouse show. Philip Leider, editor of *Artforum*, wrote in *The New York Times* that "Eva Hesse, a genuinely engaging artist, should have shown stronger work."[14] Others were more pointed. Max Kozloff juxtaposed Hesse's "picturesque versions of minimal sculpture" with Serra's "violent" and "authentic" latex scatter piece and lead splash piece.[15] Reviewers of her solo exhibition commented on her work's

13 Mel Bochner, as quoted in Barry Rosenberg and Marc Strauss (eds.), In the Lineage of Eva Hesse (exh. cat.), Ridgefield, CT: Aldrich Museum of Contemporary Art, 1994.
14 Philip Leider, 'The Properties of Materials: In the Shadow of Robert Morris', The New York Times (December 22, 1968).
15 Max Kozloff, '9 in a Warehouse', Artforum, 7, 6 (February, 1969), pp. 38-42 (40-41).

witty and surreal demeanor — one reviewer found "the sense of humor which informed most of these works a touch bizarre," while another called them "wry, limp 'toys'," noting that "there is a bland quiet pleasure to these loony pieces."[16] John Perreault issued a powerful and unusual piece of art criticism in response to Hesse's first solo show, which was cut out and given pride of place on her studio table. I quote it here at length:

> The kind of queasy uneasiness [the works] evoke makes one want to stroke them gently (...). Having one of these pieces would be like having a very, very neurotic pet (...). Whether Miss Hesse intends it or not, her sculpture (or her anti-sculpture) causes very complicated emotions in the viewer. She forces upon us a stringent consciousness or self-consciousness of our bad habits of identification and psychological projection. The rapid-fire flip-flop from perception of her anti-form forms to perception of our perception and perception of our emotional reaction to these forms and textures is an experience that involves a marriage of attraction and repulsion, passivity and aggression.[17]

To a certain extent, I want to situate Hesse's poses with her objects in the wake of responses by Perreault and others who drew out the playfulness, anthropomorphism, and emotional effect of her work, and also to see the poses as a rejoinder to powerful critics such as Leider and Kozloff who found her current work staid in comparison to the immediacy of installations by Serra in the Warehouse show. In Landshoff's portraits, Hesse seems determined to stage a response to the formalism, detached conceptualism or 'solipsism' of Bochner and LeWitt, but also to assert a newly radicalized performativity that keyed her practice to new strategies and media. The positive reviews of her first solo exhibition, especially by Perreault, whom Hesse admired and whose intense emotional response likely pleased her, may have encouraged her to push her work in the direction of an increasingly animated, anti-formal sensibility.

The fact that only one of the Landshoff photographs was published in Hesse's lifetime suggests that the artist had not resolved what role these images would play in glossing and marketing her art. The only context for which Hesse provided one of the Landshoff photographs — albeit a restrained example — was the 1969 catalogue for *Art in Process IV*, an exhibition at Finch College Museum of Contemporary Art. The photograph shows Hesse staring intently at the

16 Emily Wasserman, Artforum, 7, 5 (January, 1969), p. 60; Martin Last, ArtNews, 67, 7 (November, 1968), p. 14.
17 John Perreault, 'The Materiality of Matter', The Village Voice (November 28, 1968), p. 19.

viewer, holding a sheet of clear plastic between herself and the camera, a plastic drop cloth that she used in making her important installation *Contingent* (1969), merging her own image with the process of making the piece. The *Art in Process* format purported to lay bare the machinations of the creative process, to demystify the production of an artwork by revealing the private activities that unfold in the sequestered space of the studio. However, precisely through laying bare these origins, the *Art in Process* concept realized discursively complex, multi-media works of art, in which meaning was dispersed among textual, photographic, and graphic outlets (film and audio were included in some cases) through which the artist might guide the reception and critical interpretation of her work.[18]

The Landshoff photograph was just one of several documents Hesse offered to fulfill the exhibition's mandate of presenting artwork that would normally stand on its own among "developmental, related or inspirational material, showing the artist's personal approach to his work."[19] In the catalogue she also included a meandering, deeply personal artist's statement. In April, 1969, Hesse was diagnosed with a brain tumor and underwent a series of operations. She had begun work on *Contingent* in late 1968, producing a test piece, and continued to develop the installation until she fell ill in 1969. She was at work on *Contingent* when Landshoff visited her studio, hence the drop cloth and her inclusion of this photograph in the catalogue that accompanied *Contingent*'s debut at

Finch College. The artist's statement weaves together commentary on her illness and discussion of the process of making *Contingent* with studio assistants, and current events. It reads in part:

> Began work somewhere in November –
> December, 1968.
> Worked.
> Collapsed April 6, 1969. I have been
> very ill.
> Statement.
> Resuming work on piece,
> have one complete from back then.
> Statement, October 15, 1969, out of
> hospital,
> short stay this time,
> third time.
> Same day, students and Douglas Johns
> began work.
> MORATORIUM DAY
> Piece is in many parts.
> Each in itself is a complete statement,
> together am not certain how it will be[20]

18 Other artists in Art in Process IV included Robert Morris, Bruce Nauman, Robert Ryman, and Mel Bochner.
19 Elayne Varian (ed.), Art in Process IV (exh. cat.), New York: Finch College Museum, 1969, n.p.
20 Varian (ed.), Art in Process IV, n.p.

This explication of process in the form of a personal narrative accompanying the work itself seems to engage a particular post-studio moment: the studio doors are flung open to reveal an artist coping with severe illness, contemplating uncertainties about the outcome of her work, and impinged upon by the social tumult of the Vietnam War. This was no longer the same studio that Landshoff had photographed. The studio had become a workshop: assistants were present, Hesse was (temporarily) convalescent, and to make work at all it was necessary to enlist the help of others.

When handled and posed with, Hesse's objects seemed all the more absurd: crude, graphic depictions of cocks and balls, for instance, that are assigned a particular valence by virtue of the fact that the one handling and posing is a woman and the artist. For some of the photographs, Hesse returned to sculptures produced the previous year, employing them as props. The 1967 wall piece *Not Yet* is tethered to the wall of the studio in one photograph, and Hesse, seated on the floor, ensconces her head among its mesh sacs stuffed with plastic drop cloths and lead weights. Hands placed on the testicular or ovular forms, Hesse presses two units to her face. In the privacy of her studio, the erotic, even perverse implications of her forms become theatrically explicit: the sacs of *Not Yet* invite a kind of mock sexual indulgence while, in another photograph, the attached sleeves of an untitled cheesecloth and latex piece are worn as a straitjacket.

By desublimating that which Lippard prudently

suggested be "kept at a subliminal level," Landshoff's private studio photographs of Hesse point to the persistent question, or perhaps problem, of the body in the context of minimalism and post-minimalism. Hesse's art is a reminder of the performative implications of minimalism, especially the shift of focus from artwork to the body — the artist's body and that of the viewer — implied by the prevailing interest in phenomenology and embodied perceptual engagement with objects that informed the practice and critical reception of minimalism in the 1960s. In her artist's statement for *Contingent*, Hesse goes on to narrate a strategy of elusiveness, suggesting that the installation emerged out of experimentation guided by a belief in formal contradiction, e.g., "tight and formal but very ethereal. sensitive. fragile."[21] This embrace of contradiction, the logic of opposites, describes how Hesse situated herself in relation to minimalism, engaging principles of seriality and predetermined geometric regularity, but countering reliance on systems with handcrafted forms and intimations of the body. Hesse's poses for Landshoff exaggerate this latent signification of her work by appending materials and organic forms with specifically female modes of comportment.

The Landshoff photographs mark a shift toward Hesse's self-consciously performative engagement with her art. As a point of comparison, the publicity photograph used by the Fischbach Gallery for Hesse's first

21 Varian (ed.), Art in Process IV, n.p.

solo show in the fall of 1968 suggests a retrograde and passive image of femininity: the artist kneels demurely behind her sculpture *Accession III*, with hands clasped and gaze averted.[22] The Landshoff photographs, by contrast, capture a playful abandon in which the (female) body of the artist is deployed to animate her work. Hesse's poses for Landshoff are imbricated with the imageries of fashion magazines, reminiscent of Cecil Beaton's theatrical portraits of vamping celebrities like Audrey Hepburn or Twiggy, from the pages of *Vogue*. Her poses in the privacy of her studio embrace culturally feminine modalities of seduction and sensuality, demonstrating correspond-ences between her artwork and the scale and shape of her body, and realizing the tactile appeal of her art. Leaning on the back of a chair, extending her legs and smiling broadly at the camera, Hesse's arms and hands are sheathed in an elongated sleeve. This wearable art — several crudely joined segments of latex-coated canvas — is presented as both an encumbering, entrapping straitjacket and an absurd muff-like accessory, in sharp contrast to the devitalized, lifeless presence that the same piece might suggest when hanging limply on a wall.

It is practically impossible to imagine other artists in Hesse's milieu posing in this vamping fashion; the conceptual minimalism practiced by LeWitt, for instance, with its emphasis on technologized forms signaling the possibility of mass production and the hands-off dictum "the idea is the machine that makes the art," disables the possibility of a libidinal encoun-

ter with the artist in his studio.[23] Hesse's poses address a fundamental contradiction within this conceptual-minimal ethos: the radical bodily contingency of the viewing subject inherent in Minimalist sculpture. Hesse's radically performative interpretation of her works fulfills the possibilities implied by this radical bodily contingency and activates the phenomenological implications of their forms in terms of embodied, specifically female poses. The imagined sensual encounter, through touching, holding, wearing, covering and being covered, the suggested but forbidden promise of her objects, was realized by Hesse in front of the camera in the privacy of her studio. Subjected to culturally feminine behaviors of play and seduction, her works function as surrogate fashion objects (sleeves, shawl, headdress) to be worn by the female body.

While Maurice Merleau-Ponty's widely-read tracts on phenomenology did not postulate embodiment as gendered, later feminist interlocutors have logically asserted the primacy of gender in extending his claims that the social field always already informs embodiment — that the body and perception are experienced through culture in an inextricable intertwining of the social and the biological.[24] Though this formulation would become refined in later feminist

22 The Fischbach Papers are in the Archives of American Art, Washington, DC.
23 Sol LeWitt, 'Paragraphs on Conceptual Art' (1967), in Alexander Alberro and Blake Stimson (eds.), Conceptual Art: A Critical Anthology, Cambridge, MA./London: MIT Press, 1999, pp. 12-16 (12).
24 For an example of this feminist revisionism of Merleau-Ponty's thought, see Iris Marion Young's famous essay 'Throwing Like a Girl', in On Female Body Experience: "Throwing Like a Girl" and Other Essays, Oxford: Oxford University Press, 2005.

philosophy, for Hesse, it was already accessible through the work of Simone de Beauvoir, whose *The Second Sex* she had read with great interest in the mid-1960's.[25] In the Landshoff photographs, Hesse paired Beauvoir's philosophical notion that one is not born a woman but *learns* to be a woman, that gender is constructed through culture, with minimalism's insistence on embodied encounter. Meanwhile, viewers, such as Perreault, who encountered her work in conventional installations, still experienced it as "lifeless" or evoking a "queasy uneasiness."[26] Against the walls of a white cube, the desire to touch or to pet, or to project too much, is tempted but denied. In this context, Hesse's work's relationship to the body remained conjectural: it was there but not present, suggested but unproven, impossible to pin down.

That we know Hesse's work and were given access to her studio through Landshoff's photographs only retrospectively speaks to the conditions of minimalism and post-minimalism, especially to the elusiveness that, in her lifetime, allowed the work to be interpreted as both feminist and formalist in its signification. But Hesse's grip on the imagination of generations of artists and critics since 1970 has been strengthened by images of the artist incorporating performance and her body in tableaux with her abstraction. Critic Barbara Rose made the claim that, when Harold Rosenberg wrote his famous essay 'The American Action Painters', he wasn't talking about Abstract Expressionist paintings on a gallery wall.

Rather, she said, "Rosenberg was describing Namuth's photographs of Pollock."[27] In a similar way, the Landshoff photographs have shaped Hesse's posthumous reception thanks to Lippard's decision to pair these images with Hesse's work in her 1976 monograph and their subsequent appearance in every major publication on the artist. They made the relationship of Hesse's work to her body, or simply 'the body,' concrete. Since then, her sculptures have been read as "part-objects" and "dismembered, squashed, and discarded genitalia."[28] And the sanctum of the studio was permanently ruptured.

25 Simone de Beauvoir, The Second Sex, New York: Vintage, 1989.
26 Perreault, 'The Materiality of Matter', p. 19.
27 Rose, 'Namuth's Photographs and the Pollock Myth', n.p.
28 See Mignon Nixon, 'Posing the Phallus', October, 92 (Spring, 2000), pp. 98-127; and Anna Chave, 'A Girl Being a Sculpture' in Eva Hesse: A Retrospective (exh. cat.), New Haven: Yale University Press, 1992, pp. 99-117 (101).

Creation, Recreation, Procreation

Matthew Barney, Martin Kippenberger, Jason Rhoades, and Paul McCarthy

Julia Gelshorn

Atelier as Fitness Studio

The studio is nearly empty, except for a trampoline in the center of the room. An artist, armed with a pencil, takes a run-up and repeatedly jumps on the trampoline. With each jump he makes a single mark on the ceiling. Over the course of time, the lasting lines on the ceiling produce a face. The actions are part of Matthew Barney's performance *Drawing Restraint 6* (1989), the sixth episode in a series that the artist began in 1987, when he was still a student at Yale University, and which he resumed between 2004 and 2005 with parts 9 through 12.[1]

Drawing Restraint 6 clearly exemplifies the series' concept: in various studio experiments, the process of drawing is being hindered by diverse obstacles.[2] For each performance, Barney equipped his studio with different tools from athletic training, like ramps, ropes, rings, weights, and a trampoline. While the artist performs risky stunts in order to generate drawings on the ceiling and walls of the studio, he is restrained. The series is not performed for an audience; the artist is only in the company of the person documenting the performance in photographs and video.

In *Drawing Restraint 1* (1987), Barney performs the drawing act between two mild inclines at either end of the studio and different wall hooks. An elastic line from the floor is strapped to his thighs. As his body moves up the inclines, resistance increases.

142

The drawings generated at the top of the slope and along the walls show androgynous figures engaging in sport, which could accordingly be read as representations of Barney's drawing act itself. Remarkably, the quick and sketchy lines do not reveal the strenuous process of their creation. In *Drawing Restraint 2* (1988), the action is further complicated: the studio becomes populated by even more challenging ramps and larger and heavier tools that hinder the drawing process. At a certain point, Barney even wears hockey skates that increase the instability and require additional physical strength.

The *Drawing Restraint* series converts the artist's workplace into a fitness studio where the artistic labor is being disciplined in a similar way to biking and running on the appropriate equipment for training. And akin to the fitness studio, the increasing degree of difficulty of the exercises emphasizes the artist's supreme effort. Barney, who originally started a career as an American football player, turns the sport-

1 Hans Ulrich Obrist (ed.), Matthew Barney: Drawing Restraint (exh. cat.), Cologne/Tokyo: Verlag der Buchhandlung Walther König/Uplink, 2005. See also Nancy Spector, 'Only the Perverse Fantasy Can Still Save Us', in Nancy Spector (ed.), Matthew Barney: The Cremaster Cycle (exh. cat.), Ostfildern-Ruit: Hatje Cantz, 2002, pp. 3-91 (4-5, 22-23); Keith Seward, 'Matthew Barney and Beyond', Parkett, 45, 1995, pp. 58-60; Mirjam Schaub, 'Visuell Hochprozentiges: Übertragung aus dem Geist der Gegenübertragung. Matthew Barneys Cremaster Cycle', in Mirjam Schaub and Nicola Suthor (eds.), Ansteckung: Zur Körperlichkeit eines ästhetischen Prinzips, Munich: Wilhelm Fink Verlag, 2005, pp. 211-228 (217). Matthew Barney repeated the performance of Drawing Restraint 6 in 2004 to document it in video and photographs.
2 Spector, 'Only the Perverse Fantasy Can Still Save Us', pp. 4-5; 'Conversation by Hans Ulrich Obrist and Matthew Barney', in Obrist (ed.), Matthew Barney, pp. 87-91.

ing maxim 'to give one's all' into a mantra for artistic creativity.

In *Drawing Restraint 7-12* (1993-2005), as well as in Barney's later *Cremaster* films (1995-1997), this model shifts from physical experiments into larger mythological-allegorical narratives of resistance as a psychological condition or conflict. The authentic feat of strength of the early studio experiments is replaced by iconography and allegory. The entirely new aesthetic vocabulary of the *Cremaster Cycle* that this shift introduces, is announced in *Drawing Restraint 7* (1993): two satyrs wrestle on the back seat of a limousine while trying to inscribe a mark with their horns in the condensation that has gathered on the car's sun roof. The artist no longer performs the act of drawing himself but turns up in the guise of a third satyr who engages in a series of emblematic actions.[3] The seventh episode initiates a phantasmagorical cosmology in which creation, desire, and fertility enter a symbolical relation.

The scientific diagrams of muscles and hypertrophy that illustrate the catalogue of the *Drawing Restraint* series may be read as explicit storyboards to parts 1 through 6.[4] The term hypertrophy refers to the way in which body muscles depend on resistance to grow through physical work or sport. This condition is taken up by Barney as an analogy for the creative process. Accordingly, in *Drawing Restraint 2*, the word "fortitude" appears on a blackboard, acting as a physical index of the artist's pseudo-biological model

144

of creation. While the development of muscles through hypertrophy requires resistance, Barney indicates, artistic creativity must also be released and channeled by obstacles and self-control.[5]

For Barney, the process of creation is a three-phase cycle entitled *The Path*. It starts with *situation* where subject matter is driven by undifferentiated sexual energy, which generates form. The second phase, *condition*, becomes a visualization of a disciplinary funnel (as for example through restraints) that converts raw and useless energy into something useful and more complex. Finally, in the *production* phase, a form begins to emerge.[6] Whereas this analogy between sexual and biological differentiation and the path of virtue can be found in almost all of Barney's works, and is often linked to a digestive process as well, *Drawing Restraint* is the only series that visualizes *The Path* as an obstacle course in the studio. The form that emerges in *Drawing Restraint* is therefore the artist himself: while the photographs show how the artist builds his own body

3 Cristina Bechtler (ed.), Matthew Barney: Drawing Restraint 7, Ostfildern-Ruit: Cantz Verlag, 1995. See also Katharina Vossenkuhl, 'Matthew Barney', in Rainald Schumacher and Matthias Winzen (eds.), Die Wohltat der Kunst: Post/Feministische Positionen der neunziger Jahre aus der Sammlung Goetz (exh. cat.), Cologne: Verlag der Buchhandlung Walther König, 2002, pp. 39-43. See also Spector, 'Only the Perverse Fantasy Can Still Save Us', pp. 22-23.
4 In the catalogue of the Drawing Restraint series, the conversation of the artist with Obrist is illustrated by diagrams showing muscle tissue and its proliferation, reproduced from William McArdle, Frank I. Katch, and L. Victor, Exercise Physiology: Energy, Nutrition, and Human Performance, 3rd Edition, Media, PA: Lea & Febiger, 1991, pp. 349, 351, and 479. See also Obrist (ed.), Matthew Barney, p. 87. See also Spector, 'Only the Perverse Fantasy Can Still Save Us', p. 4.
5 See Barney's remarks in Obrist (ed.), Matthew Barney, pp. 87-91.
6 Matthew Barney, Diagram of THE PATH, Notes on Athleticism, 1990, Ink on Paper, in Obrist (ed.), Matthew Barney, p. 89. See also Barney's explanations, p. 88; and Spector, 'Only the Perverse Fantasy Can Still Save Us', pp. 5-6.

145

through crazy strongman acts, the resulting drawings may be read as self-portraits. Apart from the explicit self-portrait on the ceiling of the studio in *Drawing Restraint 6*, the formless graphic marks of the other performances can be understood as authentic traces and tracks of the artist's body as well. And finally, the drawing of the so-called 'field emblem', an ellipsis bisected horizontally by a single bar, which signifies the orifice and its closure, functions like a corporate logo, ensuring a certain brand identity for the artist's work.[7]

Nevertheless, the drawings should be considered as performance relics rather than as independent works, since the actual product of the performances is the symbolization of the creative act itself. In the suggestion that sport is a form of artistic work, Barney exchanges artistic expression for the feat of strength per se.[8] By presenting fortitude and bravery as cardinal virtues, and restraint as a form of ultimate self-control, the artist alludes to the modern concept of intellectual and spiritual virtue or *virtus*, but then as a matter of physical fitness.

Although initially Barney's workouts in the studio might come across as mere ironic and excessive exaggerations of famous performances of the late 1960s and 1970s, such as Bruce Nauman's or Vito Acconci's gymnastic exercises in the studio, the deliberate display of masculine creative power and sexual potency compels an intricate understanding and updating of the process of artistic creativity and self-fashioning in the seminal space of the studio.[9] After its mechaniza-

146

tion, industrialization, and the declaration of its fall, the studio is restaged as a mythical site. The *Drawing Restraints* series explicitly joins the avant-garde's efforts and strategies to reject the traditional practical skills and virtuosity inherent in academic art, first described by the Australian Ian Burn under the heading of "deskilling."[10] But Barney promotes the concept of deskilling as an end in itself. The physical restraints only serve to promote the creative act as the symbolic outcome of artistic force and productivity (which explains why the completed work is replaced by mere documentation). Creation is equalled by recreation in the field of sports and measured according to the principles of the highly competitive society of capitalism.

The Artist as Superhero

Martin Kippenberger's installation *Spiderman Studio* (1996) is a small wooden box, inhabited by a kneeling figure fashioned out of iron wire, symbolizing the

7 Spector, 'Only the Perverse Fantasy Can Still Save Us', p. 7.
8 Franceso Bonami, 'Matthew Barney: The Artist as a Young Athlete', Flash Art, 25, 162, (January/February 1992), pp. 100-103; Spector, 'Only the Perverse Fantasy Can Still Save Us', pp. 4-18. For Barney's exhibition of the athletic body as a sculptural site, see Christopher Bedford, 'Matthew Barney: San Francisco', The Burlington Magazine, 168, 1244, (November 2006), pp. 797-799 (797).
9 For a discussion of body art and masculinity, see Amelia Jones, 'Dis/Playing the Phallus: Male Artists Perform their Masculinities', Art History, 17, 4, 1994, pp. 546-584; Amelia Jones, Body Art: Performing the Subject, Minneapolis, MN and London: University of Minnesota Press, 1998, pp. 53-150.
10 Ian Burn, 'The Sixties: Crisis and Aftermath (Or the Memoire of an Ex-Conceptual Artist)', Art & Text, 1, (Fall 1981), pp. 49-65. The notion of deskilling was later expounded upon by Rosalind Krauss; see: Rosalind Krauss, 'Der Tod der Fachkenntnisse und Kunstfertigkeiten', Texte zur Kunst, 20, 1995, pp. 60-67.

artist in the guise of Spiderman. The little edifice recalls the romantic garret of the poor poet and refers to the supposedly low social standard and isolation of artists. Yet, Kippenberger does not represent himself as a genius expelled from society, but as a superhero who is ready to save the world. Armed with brushes, the artist is neither producing nor in action; he is on call. It is not suprising that Kippenberger takes Spiderman as a role model for the artist in his studio. Spiderman's alter ego, Peter Parker, is an inconspicuous little boy with thick spectacles a nerd who got his supernatural strength from a bite of a contaminated spider. Kippenberger clearly refers to the classical myths of the artistic genius, which define the artist as an outsider with a higher mission, but whose talent sadly remains unrecognized.[11] However, in using the character of Spiderman, Kippenberger reveals that genius is merely the disguise of an ordinary person. The hypermasculinity of superheroes like Spiderman or Superman is nothing but the other side of the protagonist's everyday normality.[12] The studio, for Kippenberger, is a place of masking and disguising — where the metamorphosis from ordinary person into superhero happens literally.[13]

Spiderman Studio was first exhibited at the Galerie Soardi in Nice in 1996, a building that famously served as a studio site for Henri Matisse in the early 1930s.[14] In his usual manner of appropriating and combining fragments from different historical contexts, Kippenberger used a photograph of Matisse

at work on the large mural *La Danse* (1931-33) for the exhibition poster. Matisse's dancing figures dissolve with motion studies of the jumping, flying, and fighting Spiderman who now performs the round dance conducted by Matisse. The exhibition was entitled *Martin Kippenberger. L'Atelier Matisse sous-loué à Spiderman*, indicating that it is Spiderman who is competing with the master. In order to fight physically and morally against the mythic Matisse, Kippenberger takes up the guise of the superhero, who acts as the temporary tenant of the legendary place.

The paintings on the walls, a crossing of Color Field painting and conceptual art indicate, however, that the supposedly supernatural powers of the artist have a more prozaic origin. "[U]nder pot/unter Haschisch," "under speed/ unter Speed," "under sleeping pills"/ unter Schlaftabletten, "under red wine/ unter Rotwein" or "under coffein/ unter Koffein"

11 For classical myths of the unrecognized genius, see Ernst Kris und Otto Kurz, Legend, Myth, and Magic in the Image of the Artist: A Historical Experiment, New Haven and London: Yale University Press, 1979; Rudolf Wittkower and Margot Wittkower, Born under Saturn: The Character and Conduct of Artists: A Documented History from Antiquity to the French Revolution, New York and London: W.W. Norton & Company, 1969.

12 Änne Söll and Friedrich Weltzien, 'Spider-Mans Heldenmaske. Kampf um Männlichkeit im Superhelden-Genre', in Claudia Benthien and Inge Stephan (eds.), Männlichkeit als Maskerade: Kulturelle Inszenierungen vom Mittelalter bis zur Gegenwart, Cologne, Weimar, and Vienna: Böhlau, 2003, pp. 296-315.

13 At the same time, this refers to traditional artistic self-representations in the studio, which Beatrice von Bismarck also understands metaphorically as a kind of masking since they represent an inner world through an outer frame. Beatrice von Bismarck, 'Künstlerräume und Künstlerbilder: Zur Intimität des ausgestellten Ateliers', in Sabine Schulze (ed.), Innenleben. Die Kunst des Interieurs: Vermeer bis Kabakov (exh. cat.), Ostfildern-Ruit: Hatje, 1998, pp. 312-321 (314).

14 See Manfred Hermes, 'Spiderman-Atelier, 1996/Spiderman Studio, 1996', in Eva Meyer-Hermann and Susanne Neuburger (eds.), Nach Kippenberger/ After Kippenberger (exh. cat.), Vienna: Schlebrügge.Editor, 2003, pp. 208-211.

are some of the texts that appear, partly in mirror writing. These are the stimulants that release the artist's creative energy. While Kippenberger not only alludes to the lore of drug consumption by artists, he also reflects upon his own regular use, combining sardonic demythologizing with merciless self-exposure.[15] "Every artist is a man," Kippenberger once ironically replied to Joseph Beuys's well-known mantra that "Every man is an artist."[16] Repeatedly reversing the common association of the artist with superpowers, Kippenberger exposed his own normality and imperfections and proffered an ambivalent counter-position to the heroic gestures of the modern artist.[17]

Creativity as Male Potency

The trashy installations of Jason Rhoades, almost all of which confront autobiographical experiences with models of artistic work on the trail between the studio and the art market, offer a similar ruthlessness towards classical myths of artistic creativity. In the influential study *Machine in the Studio: Constructing the Postwar American Artist*, Caroline A. Jones asked whether in Rhoades's installations, the studio had returned in an ironic form.[18] She referred to Rhoades's *My Brother Brancusi* (1995), which was designed for the Whitney Museum of American Art's Biennial and was based on a similarly absurd combination of disparate historical and artistic referents to Kippenberger's *Spiderman*.[19] Rhoades was fascinated by the quality of

Constantin Brancusi's Parisian studio as a spatial art-work and pasted photographs of it on the walls of the installation, all the while suggesting a relation with his brother's housing in a renovated garage. Besides the wide array of objects, materials, and machines, an apparatus incessantly produced donuts, which, being stacked on top of each other on a vertical rod, made a silly allusion to Brancusi's *Endless Column* (1918). One could argue that in Rhoades's work, the studio returns in a satirical fashion rather than an ironic one. Moreover, the satire not only applies to the person-al, centered studios of early postwar art, but equally so to Andy Warhol's mechanized, Frank Stella's ex-ecutive, and Robert Smithson's decentered model of

15 Markus Hermes mentions that Kippenberger was fascinated by the fact that spiders spin their webs differently under the influence of drugs; see Hermes, 'Spiderman-Atelier, 1996/Spiderman Studio, 1996', p. 208. See also Roberto Ohrt, 'Introduction', in Angelika Taschen and Burkhard Riemschneider (eds.), Kippenberger, Cologne: Taschen, 2003, pp. 18-28, (25-26); Isabelle Graw, 'Der Komplex Kippenberger', Texte zur Kunst, 7, 26, 1997, pp. 45-73 (67-68).

16 For Kippenberger's statement, see Susanne Kippenberger, 'Wer war eigentlich mein Bruder?', in Adriani Götz (ed.), Martin Kippenberger: Das 2. Sein (exh. cat.), Cologne: DuMont, 2003, pp. 122-148, (136); Julia Gelshorn, 'Inhalt auf Reisen. Zur Lesbarkeit bildlicher Referenzen bei Rosemarie Trockel und Martin Kippenberger', in Silke Horstkotte und Karin Leonhard (eds.), Lesen ist wie Sehen: Intermediale Zitate in Bild und Text, Cologne, Weimar, and Vienna: Böhlau, 2006, pp. 133-153 (133).
For Beuys, see Clara Bodenmann-Ritter, Joseph Beuys: Jeder Mensch ein Künstler: Gespräche auf der Documenta 5, 1972, Frankfurt am Main/Berlin: Ullstein, 1975.

17 For a discussion of Kippenberger's complex and ambivalent self-exposure, see Diedrich Diederichsen: 'Das Prinzip der Verstrickung: Kippenberger und seine Rezeptionen', Texte zur Kunst, 7, 26, 1997, pp. 75-83; Diedrich Diederichsen, 'Der Selbstdarsteller. Martin Kippenberger zwischen 1977 und 1983/Selbstdarsteller. Martin Kippenberger between 1977 and 1983', in Nach Kippenberger/After Kippenberger, pp. 42-61.

18 Caroline A. Jones, Machine in the Studio: Constructing the Postwar American Artist, Chicago and London: The University of Chicago Press, 1996, p. 467 (note 78).

19 Eva Meyer-Hermann and Sandra Hoffmann (eds.), Jason Rhoades: Volume: A Rhoades Referenz (exh. cat.), Cologne: Oktagon, 1998, pp. 107-111; illustrations, pp. 102-103.

the studio, which Jones treats to detailed discussion. Rhoades's studio is a garage where the artist acts as a handyman who makes mad machines.

Earlier installations such as *Jason the Mason* (1991) and *Jason and Jason Entrepreneurship* (1992) already made fun of existing role models of the artist. *Jason the Mason* refers to a little pig in Richard Scarry's children's book *What Do People Do All Day?*[20] Dressed like the little pig, in bib and braces, and handling a drill or, in some instances, a bricklayer's trowel, Rhoades's performative installation makes a travesty of what today's artists usually 'do all day'. Operating in the old model of the workshop, the artist does rather physical and clearly masculine work, culminating in the building of a Venus figure from bricks, which he then sexually assaults with a drill. In *Jason and Jason Entrepreneurship*, the artist converts artisanal skills into services for hire, such as the rather female-connoted ceramics craft. Rhoades 'repairs' existing Victorian porcelain figur-ines with genitals from chewing gum. This service, however, is but one of many that the artist offers under the slogan, "An honest and hard working man."[21] As an artist, Rhoades is a worker, craftsman, manager, and employer all at once. While he appropriates the classical role models of creation he also incorporates those models that Jones has described as "post-studio" and "post-modern," and which Rosalind Krauss has defined under the radical post-war concept of "deskilling."[22]

Creation Myth (1998) is another colossal installa-

tion, consisting of a chaotic accumulation of material, machines, furniture, and thousands of objects from every day life. The manifold objects constitute different parts, which are to be read as limbs or functions of the human body and thus metaphorize the creative process. A table sculpture builds the centre of the brain (with zones entitled "remembrance," "rebellion", or "the unconscious"). It is linked to a red worm that represents the bowels with a stomach. A little volcano made from cardboard is the anus that symbolically excretes huge brown cigars of packaging. Cameras, projectors, machines, and light constructions symbolize processes such as perceiving, naming, and copying reality. In *Creation Myth*, creativity is portrayed as different ways of absorbing, filing, and processing information, paralleling bodily processes of absorption and digestion.[23] In some parts of the installation, the studio appears linked to the model of the alchemical laboratory, and also etymologically linked to the French word *astelier*, originally meaning a 'pile of wood shavings', and therefore apt for describing the

20 Richard Scarry, What Do People Do All Day?, New York: Random House, 1968.
21 See the illustration in Meyer-Hermann and Hoffmann (eds.), Jason Rhoades, Volume: A Rhoades Referenz, p. 69.
22 Jones, Machine in the Studio, pp. 268-343; Krauss 'Der Tod der Fachkenntnisse und Kunstfertigkeiten', pp. 65-66.
23 Talking about his installation Perfect World, Rhoades has used the term "eco-system" to describe the throwing away and use of things: "In this perfect-world idea, everything would have a use, everything you use, everything, your shit, your e-mail. (...) It's the idea of a perpetual motion machine as a work of art," as quoted in Eva Meyer-Hermann, 'A Place Where Nobody Could Step Over My Extension Cords. Or: The Next Level. At the End of the Rainbow. Perfect World (Interview mit Jason Rhoades)', in Felix Zdenek (ed.), Jason Rhoades. Perfect World (exh. cat.), Cologne: Oktagon, 1999, pp. 10-57 (39).

carpenter's workroom.[24] For Rhoades, the wood shavings represents 'information' that has to be chopped up and made 'digestible'. Accordingly, pictures, mainly pornography from the internet, entering the brain, have to be digested. They are either shredded or pasted onto trunks and hacked to pieces with an ax or a saw. Whereas Eva Meyer-Hermann describes these pictures as undisguised depictions of the procreative act, the use of pornography in *Creation Myth*, not unlike the drug consumption in Kippenberger's *Spiderman Studio*, can be read as stimulants for the artist's creation.[25] Being pasted onto the trunks, the 'hot' pictures wait to be burned to produce creative energy. Creation is here overtly paralleled to sexual procreation, while the male creator is mockingly shown as the representative of God's higher will.[26] On the one hand, this bold and simple spectacle of masculinity may be read as a subversion of masculinity that exaggerates and subverts its characteristics through excess, but on the other hand, it also remains a straight manifestation of machismo and the rituals of creativity.[27] What Caroline A. Jones has called the "ironic return" of the studio proves to be an ambivalent update and extension of the myth of the studio as a male-coded site.[28]

The Mental Space of the Studio

Paul McCarthy, a former mentor of Rhoades, goes even further in questioning the artist's masculinity in the studio. McCarthy does not shrink from

making a laughing stock of the heroic figure of the artist, the creative act and the artist's body. In the video *Painter* (1995), an artist stumbles around in a studio with adjoining corridor and bedroom while trying to paint large-format canvases with enormous brushes and tubes of paint. Adorned with a bulbous nose, a curly blond wig, and flap-like ears, the painter wears nothing but a short smock and socks. Acting like a clown, he repeatedly murmurs, snores, or sings things like "I'm a fucking painter" or the singsong "de Kooning, de Kooning." Every cliché of heroic creation in the studio, particularly the myth of Abstract Expressionism, contrasts with infantile, foolish, and sometimes repulsive actions. "You may understand my actions as vented culture, vented fear," the painter murmurs. In the film *Painter*, actually, it's not only culture that is vented, undermined, and 'squeezed out' but first and foremost the myth of male

24 Duden - Das Herkunftswörterbuch, **3rd edition, Mannheim: Dudenverlag, 2001. See also Eva Mongi-Vollmer,** Das Atelier des Malers: Die Diskurse eines Raumes in der zweiten Hälfte des 19. Jahrhunderts, **Berlin: Lukas Verlag, 2004, p. 30. For the development of the original signification** of the french word atelier, see Philippe Hamon, 'Le topos de l'atelier', in René Démoris (ed.), L'artiste en représentation: Conference papers, Paris III-Boulogne, Centre de Recherches Littérature et Arts visuels, Université de la Sorbonne Nouvelle, 1991, **Paris: Éd. Desjonquères, 1993, pp. 125-144 (125).**
25 **Meyer-Hermann and Hoffmann (eds.),** Jason Rhoades, pp. 127-128
26 **See the little sketch by Jason Rhoades illustrating the lemma "Creation Myth" in Meyer-Hermann and Hoffmann (eds.),** Jason Rhoades, p. 47. For the old topos of the male artist as lover and god, see Lynda Nead, 'Seductive Canvases: Visual Mythologies of the Artist and Artistic Creativity', Oxford Art Journal, **18, 2, 1995, pp. 59-69 and her reference to Balzac's novel** Le Chef-d'oeuvre inconnu **from 1831, in which the great artist likens his relationship to his work (woman) to being 'father, lover, god'.**
27 **See Michael Cohen, 'Jason Rhoades. Mean Metal Machine',** Flash Art, **32, 207, (Summer 1999), pp. 110-113 (112-113).**
28 **Caroline A. Jones also notes that despite the enormous changes in the production of artworks during the 1960s, the trope of the sacred studio did not disappear; Caroline A. Jones,** Machine in the Studio, **1996, p. 2.**

creation in the studio itself. At a certain moment, the protagonist chops off one of his artificial rubber fingers with hysterical laughter. He symbolically castrates himself, exposing his heroic hand as a false prop, a feature that isn't an inherent part of the artist's identity. Castration is definitely at stake here, since throughout the video, countless allusions are made to the fixation with male genitalia and to the analogy between paint brush, hand, and penis.[29] Artistic production, McCarthy seems to suggest, is nothing more than the sublimation of a truly infantile and compulsive existence.

While the studio serves as an isolated room where the artist can let loose his desires without inhibition, it also functions as an architectural "body trap" or psychological straightjacket.[30] Anthony Vidler has described McCarthy's interaction with the architecture of his installation boxes as an "opening up of the closed body to reveal the organs and fleshly desires locked within."[31] Accordingly, the studio in *Painter* not only represents the architectural and mythical frame for the creation of the artist, but can also be read as the artist's mental state of mind turned inside out.[32] What remains of this hysterical violation of the romantic *atelier d'artiste*, is the vulnerable embodiment of a desublimated producer. Yet, as various authors have pointed out, McCarthy's art is no longer concerned with breaking taboos and affronting bourgeois morality. Instead, he turns the seriousness of Viennese Actionism into sick humor and exposes

"that which patriarchal culture represses in order to reverse the sublimatory effects of civilization."[33]

A similar effect is produced by Jason Rhoades's installations and performances even when he cultivates the pretentious gesture. The artistic processes that he uncovers are not only the subject of his works, but also their engine and driving force. So, the structure of his archival practice sometimes threatens to become a trivial metaphor for 'creative chaos'. Concurrently, the dichotomy of the heroic creator and the female object, the never-ending self-reference, and the artist's phallocentrism are negotiated, exposed, and exaggerated, but never discarded. Rhoades's megalomaniacal installations paradoxically continue the heroic masculinity that artists such as Piero Manzoni and Yves Klein had already demonstrated in their body-oriented art by

29 By 1974, in his performance Penis Brush Painting, Windshield, McCarthy was using his penis as a paintbrush and in the period since then male genitalia have been a central motif in his work, alluding as much to the castration complex as to the metaphorical significance of the phallus as a symbol of male authority; see Amelia Jones, 'Paul McCarthy's Inside Out Body and the Desublimation of Masculinity', in Lisa Phillips and Dan Cameron (eds.), Paul McCarthy (exh. cat.), Ostfildern-Ruit: Hatje Cantz, 2000, pp. 125-133 (128-131).

30 Amelia Jones in her analysis of McCarthy's work Inside Out Olive Oil refers to the term "body trap," which McCarthy himself has used in the performance text of his piece Saloon, 1996; Amelia Jones, 'Paul McCarthy's Inside Out Body and the Desublimation of Masculinity', p. 126; for the text of McCarthy's performance, see Ralph Rugoff, Kristine Stiles, and Giacinto Di Pietrantonio, Paul McCarthy, London: Phaidon, 1996, p. 142.

31 Anthony Vidler, 'Panoptic Drives/Mental Spaces: Notes on Paul McCarthy's 'Dimensions of the Mind'', in Phillips and Cameron (eds.), Paul McCarthy, pp. 213-217 (215).

32 In addition, the frame of the Hollywood production studio in which the video was shot must always be considered as a context of McCarthy's work. See, for example, Roberto Ohrt, 'A Zombie from the Alphabet', in Eva Meyer-Hermann (ed.), Paul McCarthy. Brain Box Dream Box (exh. cat.), Düsseldorf: Richter Verlag, 2004, pp. 138-155 (141-142).

33 Amelia Jones, 'Paul McCarthy's Inside Out Body and the Desublimation of Masculinity', p. 127. See also Jennie Klein, 'Paul McCarthy: Rites of Masculinity', in PAJ: A Journal of Performance and Art, 23, 2 (May 2001), pp. 10-17 (15-16).

exaggerating modernist tropes of artistic subjectivity. McCarthy's work, in contrast, seems to continue that focus in body art from the late 1960s and 1970s that led artists like Acconi, Peter Weibel or Chris Burden to perform rather compromising and subversive actions.[34] Unlike Rhoades, McCarthy avoids subject-object dichotomies and works as much with heroic as with effeminate models of the male artist.[35] For this reason, Amelia Jones, with reference to other works by McCarthy, reads his questioning of masculinity as a further development of feminist critique. She even states that McCarthy's work enacts the theoretical insights concerning masculine subjectivity that have been examined by theoreticians such as Judith Butler.[36] In this way, the studio no longer serves, for McCarthy, as a frame to ensure the coherent identity of the male genius. It is, on the contrary, disclosed as a false attribute of an unfixed and unstable identity.

And yet, at the same time, McCarthy is not fully insulated either from participating in a rather spectacular form of self-reference through his studio. His work *The Box* (1995), which contains his entire studio, complete with every table, pen, and floppy disk glued down and turned through 90 degrees, combines the illusionism of the everyday appearance of his workspace with a distorted view of the artist's creative center.[37] His studio being turned on its side forces the viewer to bear an impossible spatial condition and seems to represent, as Vidler put it, "a complex inner world turned upside down."[38] But unlike the psycho-

logical "body trap" of *Painter*, McCarthy's own studio in *The Box* still seems to ensure the façade that his oedipal alter ego in the *Painter* video is not able to establish. McCarthy's documentation of his own studio thus abstains from the radical desublimation of a seemingly obsolete myth. The relationship of *The Box*, in particular, to McCarthy's project *Brain Box*, an imaginary architecture or mental edifice, in which the studio architecture explicitly becomes a frame for the artist's ideas, memories, and the documentation of his work, shows that here, the site of the studio is linked back to the traditional representative and symbolic function of the artist's *atelier*.[39]

34 See Jones, 'Dis/playing the phallus: male artists perform their masculinities'; and Jones, Body Art. Performing the Subject, pp. 103-150.

35 Amelia Jones, 'Paul McCarthy, männliche Body Art und die geschändeten Grenzen der Männlichkeit', in Mechthild Fend and Marianne Koos (eds.), Männlichkeit im Blick: Visuelle Inszenierungen in der Kunst seit der Frühen Neuzeit, Cologne, Weimar, and Vienna: Böhlau, 2004, pp. 247-265 (250).

36 Amelia Jones, 'Paul McCarthy's Inside Out Body and the Desublimation of Masculinity', p. 126.

37 As Tom Holert has put it, McCarthy seems to have reached a point in his career where his mix of referentiality, regressiveness, and transgressiveness can hardly be varied any further. Accordingly, in his recent work, the scandalous and the visceral have, it seems, been crossed with the normality of the "spectacle"; Tom Holert, 'Schooled for Scandal', Artforum, 39, 3 (November 2000), pp. 134-141 (140). On McCarthy's original studios, see John C. Welchman, 'Haus, Hinterhof, Atelier, Kulisse: Paul McCarthys Arbeitsräume', Texte zur Kunst, 13, 49 (March 2003), pp. 105-111. See also Paul McCarthy: Brain Box Dream Box, p. 130.

38 Vidler, 'Panoptic Drives/Mental Spaces' p. 215.

39 On the representational and symbolical function of the studio, see André Chastel, 'Le Secret de l'atelier', in Quarante-huit/Quatorze: Conférences du Musée d'Orsay, 1, 1989, pp. 4-14; Mary Bergstein, "The Artist in His Studio': Photography, Art, and the Masculine Mystique', Oxford Art Journal, 18, 2, 1995, pp. 45-58; Philippe Junod, 'L'atelier comme autopotrait', in Pascal Griener and Peter J. Schneemann (eds.), Images de l'artiste - Künstlerbilder, Conference papers: Comité International de l'Histoire de l'Art (CIHA), Université de Lausanne, 1994, Bern: Peter Lang, 1998, pp. 83-97; Bismarck, 'Künstlerräume und Künstlerbilder: Zur Intimität des ausgestellten Ateliers'; Mongi-Vollmer, Das Atelier des Malers; Marc Gotlieb, 'Creation & Death in the Romantic Studio', in Michael Cole and Mary Pardo (eds.), Inventions of the Studio: Renaissance to Romanticism, Chapel Hill and London: The University of North Carolina Press, 2005, pp. 147-183.

As has been shown, the feminist and post-feminist critique and deconstruction of the studio as seminal site of the 'masculine mystique,' seems to be only the starting point not only for artists like McCarthy and Rhoades, but also for Barney, Kippenberger, and other contemporary artists that have updated the studio as a frame for the ritual display and formation of the artist's identity. Their performances, videos, and installations deliberately intertwine the artist's masculinity and the studio, albeit in a double sense.[40] Even while the classical studio of the artist is turned into either a fitness studio, a garage, a place for private perversity, or a psychological straitjacket, none of the works abstains from ambivalently celebrating creativity. Whether it be through the uncanny and deliberately juvenile humor of Kippenberger, Rhoades, and McCarthy, or the pathetic celebration of Barney, creation is made equated with male power and potency and with a state of being 'high' — be it achieved through sports and hypertrophy, or through drugs and pornography. Neither the mythic status of the studio nor its role as a coded framework is discarded. On the contrary, the attempts to undermine, subvert or renounce the myth, tend only to reveal that the annihilation of the studio is itself a counter-myth.

Matthew Barney, Martin Kippenberger, Jason Rhoades, and Paul McCarthy

40 Bergstein, "The Artist in His Studio': Photography, Art, and the Masculine Mystique', p. 45. For a feminist analysis of male work in the studio, see also Carol Duncan, 'Virility and Domination in Early Twentieth Century Vanguard Painting', in Norma Broude and Mary D. Garrard (eds.), Feminism and Art History: Questioning the Litany, New York: Harper & Row, 1982, pp. 293-313; Lisa Tickner, 'Men's Work: Masculinity and Modernism', in Norman Bryson, Michael Ann Holly, and Keith Moxey (eds.), Visual Culture: Images and Interpretations, Hanover and London: Wesleyan University Press, 1994, pp. 42-82; Nead, 'Seductive Canvases: Visual Mythologies of the Artist and Artistic Creativity'.

Narcissistic Studio
Olafur Eliasson

Philip Ursprung

Thanks to its sluggish economy and the cheap rents for large studios and old apartments, Berlin has become one of the most attractive cities for cultural production since the mid-1990's. While art dealers prefer the prosperity of New York and London, and collectors enjoy the luxury of Miami, the art studios are located in Berlin. Olafur Eliasson, born in 1967 and raised in Denmark, is just one of the many artists, architects, designers, filmmakers, students, and art historians who were and still are attracted by the openness and lively atmosphere of the reunited city. After living in Cologne, the former center of the West German art world, for two years, and after graduating from the Royal Danish Academy of Fine Arts in 1995, Eliasson decided to locate his studio in Berlin. Due to his growing success and ever larger projects and commissions — most notably during the preparation of *The Weather Project* at Tate Modern in 2003 — the artist radically changed the structure of his studio. Firstly, he decided no longer to rely on contractors to produce his art but to use his own team. Consequently, he moved to a larger space in 2002, in which he has been employing between fifteen to fifty collaborators.[1] In August 2008, he moved yet again to an even larger space, an old brewery building in the very heart of the Berlin Prenzlauer Berg. Eliasson himself commutes between Berlin and Copenhagen, where he lives with his family. Near his home he has a small, private workspace — a kind of *studiolo* — where he can be completely by himself and devote time to "drawing

and reading," supported by one or two assistants.[2]

In terms of structure and atmosphere, Eliasson's studio resembles a medium-sized architect's office. People, mostly in their twenties and thirties, are conversing in German, English, Danish, or Spanish about the latest computer software, recently published books, and current exhibitions. Eliasson does not act as his collaborators' superior, but rather as a kind of 'client' who approaches them with ideas for projects and asks how they might be realized — be it a museum in Iceland, a wall relief for a Tadao Ando building, or the façade for the Hirshhorn Museum and Sculpture Garden in Washington DC.[3] But Eliasson's collaborators, as the artist himself reports, have more freedom to carry out their own investigations and experiments than they would have, by contrast, in an architect's studio. They pursue their interests, seemingly unfettered by external pressures. In fact, the main purpose of Eliasson's

This essay benefited from visits to Olafur Eliasson's Werkstatt & Büro in Berlin in January, August, and October 2006, and to his private studio in Copenhagen in October 2006 and January 2007. I am grateful to Olafur Eliasson, Anna Engberg-Pedersen, Caroline Eggel, Einar Thorstein, and Sebastian Behmann, members of Eliasson's studio, for their discussions and information. Additionally I want to thank Michael Diers and Monika Wagner for inviting me to their conference on the studio in Hamburg in 2006, where I presented a provisional version of this essay.

1 Olafur Eliasson, 'The vessel interview, part II: NetJets flight from Dubrovnik to Berlin, 2007', in Olafur Eliasson Hans Ulrich Obrist, The Conversation Series, 13, Cologne: Verlag Buchlandlung Walther König, 2008, pp. 143-178 (172): "A couple of years ago it really expanded and I went from fifteen people to twenty-five, thirty-five, forty-five. At some point, I even had fifty, but now we're back down to around thirty-five people."

2 Olafur Eliasson, 'A post-medium artist, Copenhagen, December 23, 2005', in The Conversation Series, pp. 79-90 (79). The studiolo was initially incorporated in Eliasson's private home in Copenhagen. In 2008, he moved it to a space in the neighborhood.

3 Sebastian Behmann, head of the architecture team at Studio Eliasson, in conversation with the author, January 2006.

studio seems to be the production of questions and the exploration of new issues or, in other words, to do research that may or may not serve as a basis for artworks. One collaborator, an artist, has researched the color white and accumulating knowledge about every shade of white materials and pigments available on the market. Another, an architect, has designed plans for various models of a camera obscura, which may at some point be used for a project. Another artist has developed a *harmonographe*, a device that transposes sound waves into so-called *harmonogrammes* in a process that may eventually be used to generate shapes for an architectural design. Eliasson himself has no private office. He moves around, discusses projects, signs letters, meets visitors, selects photographs, and makes decisions. He is something of a hybrid of *peintre érudit*, German engineer, and American businessman, someone in between Ernst Haeckel, Buckminster Fuller, and a young Bill Gates.

In recent years, Eliasson has developed a spatially and managerially flexible structure that allows him to control virtually the entire production process of his art, that is, from the first experiments and conceptual sketches to the building of models, the testing of structures, and, ultimately, the fabrication (which may be done in house or be outsourced). His team consists of architects, electricians, carpenters, craftsmen, designers, and artists, some of whom are employed on a full-time basis while others are paid by the hour.[4] Eliasson's studio, however, is not limited to

making physical objects. "Knowledge production," as Caroline A. Jones has stated, is equally at stake.[5] Among his closest collaborators are several art historians who assist him in the crucial domain of critical discourse, i.e., the editing of interviews and statements, the invention of titles, or the organization of seminars. This apparatus enables Eliasson to either grow or shrink his studio according to the demand, with an often breathtaking output. While the artist manages to produce and install several exhibitions in international museums and galleries, for which he delivers an astonishing number of installations and photographs, he also works on an ongoing project for BMW's *Art Car*, develops several architectural projects and commissions, and publishes numerous artists' books, catalogues, and interviews.[6]

Research

Over the last decade, the art world has successfully adapted itself to the logic of globalization by concen-

4 Eliasson, "The vessel interview', p. 72: "I have two electricians, two blacksmiths, a carpenter, and a furniture builder, as well as geometricians and artists. I also have two people who are educated in stage design and theater. Then, of course, I have a group of architects, but even within that group there are large differences: some of them are from the world of graphic design, some do very sophisticated 3D-drawings, and some are more hands-on. I have an electrical engineer, and I have a light planner. Occasionally, I have one or two model-makers, just as architectural offices do. Finally, the office itself is divided into rather diverse areas. I have a publication department and an archive with two or three art historians. And then there's the bookkeeper and a project manager."

5 Caroline A. Jones, 'The Server/User Mode', in Artforum , 4, 2 (October 2007), pp. 316-324.

6 The Art Car has been on view at the San Francisco Museum of Modern Art in 2007 and at the Pinakothek der Moderne in Munich, under the title Your Mobile Expectations. See Olafur Eliasson, Your Mobile Expectations: BMW H₂R project, Baden: Lars Müller Publishers, 2008.

trating cultural capital, maintaining high price levels for contemporary art, directing a stable portfolio of living and departed star artists, tapping into the enthusiasm for social networks, and negating boundaries between industrialized nations to facilitate commercial pursuits.[7] Within this development, the artist's studio continues to serve as a major point of reference, since it allows us to understand how work is organized and represented today. On the one hand, the traditional studio embodies pre-globalization from the standpoint of production's coherence. In a world dominated by bureaucratic structures and information technology, it still emerges as a singular place in which creativity can be localized and where ideas and products remain in the hands of one person. On the other hand, the studios of successful artists may serve as both predictive and attractive models for the worlds of industry and research. Caroline A. Jones has argued that "cultural agents' dispersed informational activities in the 1970s and '80s preceded and informed the design of industrial practices were not widely implemented until the '90s."[8] Eliasson's studio, Jones argues, fits within this tradition, operating as a "harbinger of larger shifts, in which the dispersal of contemporary knowledge production offers considerable freedom to form local subjects and volitional collectives."[9] The studios of successful artists appeal to investors and managers because — at least, in the current context of soaring prices of contemporary works — they promise high profits with little capital

investment, simple infrastructure, and no marketing costs. For academics who suffer from the segmentation of knowledge production and economic pressure within the university context, the interdisciplinary and pragmatic organization of the studio holds promise as well. Where else can ideas be realized so freely? Where else is research so pleasing?

Although Eliasson criticizes the effects of globalization and speaks of the relative autonomy of art and the art world, it is obvious that his career, like those of most internationally-acclaimed artists, depends on the globalized economy, large audiences, and a prospering art market. But to what extent does the flexible structure of his studio and its procedures deliver the basis of both his critical and commercial success in today's art world? The artist repeats over and again, almost obsessively, that his studio is *not* mainly about products, but about the process of research. However, what leaves the studio to be exhibited, sold, or read, is mainly physical objects. Although Eliasson puts much effort into discourse and conducting surveys — for example, he produced a catalogue filled with data and debates to go with his exhibition *The Weather Project* — public reception focused solely on the iconic installation in the Turbine Hall. This raises the question of how Eliasson's

7 See Ai Weiwei, Amy Cappellazzo, Thomas Crow, Donna DeSalvo, Isabelle Graw, Dakis Joannou, Robert Pincus-Witten, and James Meyer, 'Art and Its Market: A Roundtable Discussion', Artforum, 46, 8 (April 2008), pp.293-303.
8 Jones, 'The Server/User Mode', p. 317.
9 Jones, 'The Server/User Mode', p. 324.

works relate to his studio. Did the two million visitors who enjoyed *The Weather Project* actually experience the impact and effects of his studio? Did anyone looking at the ancient ice blocks, which were taken from a glacier and conserved by a cooling system, in the exhibition *Your Waste of Time*, in 2006, think about a team of researchers working in the background?[10] Not really. Eliasson's art relies on the beauty of tangible objects, on the effects of opticality, and the unexpected perception of colors, space, and time. The specific look or style of Eliasson's art combines smart engineering with bricolage, and it relies on the way natural phenomena, such as geological formations, are framed and made available in exhibition spaces. The way things are fabricated always remains visible and the technologies are usually simple. Yet every work that is displayed in an exhibition, every installation, every series of photographs, is a finished product that is fully distinct from the place it was made. There is no such thing as a *non finito*, a fragment, or a work in progress. Even the constantly evolving *Model Room*, which has appeared in various exhibitions since 2003, and which recalls a studio situation, is not a real studio and does not explicitly refer to the studio in Berlin. In this respect, I do not subscribe to Caroline A. Jones's claim that the "various exhibitions, installations, and publications are mere slices" of the studio.[11] Rather, I would argue, the studio is staged and transferred to the exhibition space as if it were a 'natural' phenomenon in its own right, a complex and spectacular

happening to be explored and experienced — not unlike the vast landscapes of *Island* that Eliasson probes and depicts himself.

But why, then, is the discourse on the studio so crucial for Eliasson? It is important to note that it has only very recently been added to the discourses of "research" and "experiment" that have formed the interpretative horizon of Eliasson's work since the beginning of his career in the mid-1990's. Word of the "quantum leap" in the size of his studio spread soon after 2002.[12] Snapshots of the studio started to appear in catalogues, such as *Chaque matin je me sens différent, chaque soir je me sens le même* of the Musée d'Art moderne de la Ville de Paris of 2002. But it was only in 2006, after an extensive interview in the *The New Yorker*, that the issue of the studio had become central in Eliasson's self-representation.[13] In November 2007, he published the first volume of *Take your Time (TYT)*, a journal without texts, made entirely of black and white impressions from the studio, and free to download from the artist's website. Its aim was to "organize the current research at Studio Olafur Eliasson in Berlin and present it to a broader audience in a magazine format. As an ongoing project, *TYT* focuses on the development and exchange of ideas in and

10 The show Your Waste of Time took place at Eliasson's gallery
 Neugerriemschneider in Berlin in 2006.
11 Jones, 'The Server/User Mode', p. 323.
12 Eliasson, 'A post-medium artist', p. 60.
13 Cynthia Zarin, 'Seeing Things: The Art of Olafur Eliasson', The New
 Yorker, 13 (November 2006), pp. 76-83.

outside the Studio."[14] And in spring 2008, the monograph *Olafur Eliasson: An Encyclopedia*, published by the Taschen Verlag, brought the studio's centrality in his practice to the attention of a global audience.

His "increasingly adamant insistence on the studio," Jones has rightfully indicated, "is one clue that his physical work needs to be seen in the context of research and other relations."[15] His growing success in the art world and his work's omnipresence in exhibitions, publications, and debates have produced an intriguing contradiction. Diametrically opposed to the image of Eliasson as a quasi-romantic artist, with deep roots in the Scandinavian welfare state and the ideology of community and participation, stands the image of Eliasson as the smart research manager and artistic entrepreneur embedded in the networks of globalized economy, who is eager to expand his influence. The studio, I would argue, is the vital tool with which Eliasson successfully balances those divergent images and succeeds in pleasing almost everyone. The politically-engaged art critic looking for political relevance readily reiterates Eliasson's statements about collaboration, disinterested research, and the critique of cultural institutions. The pragmatic curator, eager to mediate between the expectations of the public, scholars, and museum trustees, welcomes the way he investigates the nature of the institution. The car manufacturer, who profits from deregulation and who actively drives forward the process of globalization, finds inspiration in Eliasson's knowledge

management and networking skills; and, in the case of his *New York City Waterfalls* (2008), the representatives of city marketing and tourism are equally appealed to by the latter. The studio has taken over a central role in his statements, I would argue, precisely because it enables the exhibitions and installations to be *more* than mere objects. It diversifies the image of artistic authorship and thus enlarges the discursive surface of the production, so to speak. By terming his studio *Olafur Eliasson Werkstatt & Büro (Olafur Eliasson Workshop & Office)*, Eliasson identifies the studio as a place where things are made as well as administered. He at once demystifies and re-mystifies the studio as site of artistic production, and manages to appeal to both the romantic idea of the workplace and the administrative notion of the office. The very act of naming the studio resembles both the 'discovery' of a new terrain and the gesture of creating a brand.[16] Jones calls it a "dynamic aggregate of flows and productions (informational, material, economic) (...) a four-dimensional object in space-time."[17] For Eliasson, it is a microcosm, a "small city," and a "model for community."[18]

14 Announcement cards accompanying the bound volume TYT [Take Your Time], Vol. 1, Small spatial experiments, November 2007.
15 Jones, 'The Server/User Mode', p. 317.
16 Although the name Eliasson Werkstatt & Büro appeared on the website from 2006 to 2008, it is not systematically used, and Eliasson was unsure whether to retain it. (Olafur Eliasson, in conversation with the author, Berlin, August 2006). Since summer 2008, it has been replaced by the name Studio Olafur Eliasson. Furthermore, since 2007, some publications have been published by Studio Olafur Eliasson.
17 Jones, 'The Server/User Mode', p. 323.
18 Olafur Eliasson, in conversation with the author, Berlin, August 2006.

The intense promotion of the studio furthermore allows Eliasson to control the reception of his work strategically. For the viewer, the knowledge that the studio is running allows him to insert isolated works of art into a coherent narrative, which reinscribes their intrinsic value in a way that is comparable to the way in which the authority of the artistic personae functions. The studio, in some ways, replaces what was considered 'artistic genius' between the 16th and 19th centuries, or what in late modernism was called a 'star'. It stands for the legitimizing authenticity and the guarantee that the works of art made by an artist, or his assistants, will maintain their symbolic and economic value because they emerge from an inexhaustible source of creativity. And this effort is successful. Once we have seen images of the studio, read or heard about it, it becomes difficult not to perceive the artist's installations as extensions of, or stand-ins for, that site, regardless of whether we have ever had access to the actual studio. In this respect, Eliasson's studio is as split as his own artistic persona. Parallel to the studio as the real site of his art's production, we are confronted with the symbolical studio as its brand. The two are not institutionally distinct, however.[19] Both the real and the symbolic studio mirror each other. One could even consider Eliasson's studio a 'narcissistic' studio. Like the mythical figure of Narcissus, it is fascinated by its own mirror image, and desperately fixates on it, while hoping to unite with it. Comparable to the narrative of Narcissus, this narcissistic studio entangles us, as ob-

servers, as well. Like the nymph Echo, who was attracted by Narcissus, we too are absorbed by the narcissistic studio — and end up speechless or merely echoing what we hear. We find our own image, our own expectations and interests, reflected in the multiple facets of the studio. Who could resist a mirror image of eternal creativity? This narcissistic studio is self-sufficient, self-sustaining. It can absorb and neutralize virtually everything — including critique.

I experienced this quality myself during several visits to both the studio in Berlin and the Copenhagen *studiolo* in 2006 and 2007. In addition to the collectors, journalists, and curators who are usually invited to frequent studios, Eliasson deliberately opens it to scholars and researchers, people who are in a position to control and direct the production of discourse.[20] Unexpectedly, the collaborators that I interviewed started asking me questions as well. They involved me in their investigations. My role soon changed from that of an observer to one who was observed. I began to experience the studio as an engine that Eliasson and his team invited me to tinker with.

19 I am thinking here, for example, of the Office for Metropolitan Architecture (OMA) of Rem Koolhaas and its 'thinktank', AMO, which was founded in 1995. Another example is Benetton's Fabricca, founded in 1994; a private academy and communications research center set up as a school for creative individuals under twenty-five, from all over the world, adjacent to the headquarters of the globalized textile corporation in Treviso, Italy.

20 Many influential cultural critics are loosely connected to Eliasson's studio. The list includes Paul Virilio, Bruno Latour, Peter Sloterdijk, Beatriz Colomina, Jonathan Crary, Mieke Bal, Hans Ulrich Obrist, Peter Weibel, and Rem Koolhaas. This network is part of a larger network that links the studio to architects and planners, and to exhibition spaces involving curators, collaborators, and critics who are invited to join the experimental process and meetings in the studio, and who are kept informed abut the activities of Eliasson and his studio.

I felt the urge to adjust it, to draw a screw here and polish a valve there, so to speak. Was I using it? Or was it manipulating me? Would it eventually absorb my autonomy as an art historian? I became aware of the fact that the whole of the studio was not passively waiting to be investigated by me, but was actively testing how it could make use of me. A few months after my first visit, Eliasson asked me to participate in a new book about his studio.[21] I became part of the enterprise. In fact, the whole studio emerged as a machine that the collaborators keep running — and which keeps them running. *What* this machine produces seems less important than *how* it functions. This is also what Caroline A. Jones asks in her essay on Eliasson: "Just *what* is being researched and produced?"[22] Her answer is "knowledge." But neither she nor I nor any other observer can pinpoint the precise *kind of knowledge* that is produced. Even more astonishing is the fact that no one is bothered that the content of the purported research is virtually ignored. What, then, is the research that is carried out by and in Eliasson's studio, if not pseudo-research? And what are we to name his interest and experiments in science, if not pseudo-science? Is the studio nothing but a giant trompe l'oeil? Or are we seduced by the knowledge that, in a context where most people have replaced *research* by hasty *search* — merely accumulating bits of information — someone is still conducting research with neither economic pressure nor specific aims? Are we attracted to the studio precisely because it is an engine without a plan?

176

Beyond the Factory

Eliasson's studio obviously owes a lot to what is broadly considered to be one of the most effective models during the era prior to globalization: Andy Warhol's Factory, originally located in an industrial loft in New York.[23] Warhol managed his studio in a professional way, and he gathered around him filmmakers, critics, collectors, assistants such as Gerald Malanga, actors such as Edie Sedgwick, musicians such as The Velvet Underground, and curators such as Henry Geldzahler, all of whom experimented with new media, talked, gave interviews, and threw parties. Warhol's Factory was a production space, a stage, a dance floor, a film studio, a concert hall, a gallery, and a living space all at once. It staged artistic process as a collective endeavor, partly joyful, partly stressful, based on the presence of famous artists — with a main star in Warhol, and several famed collaborators and friends — but which was impossible without the division of labor. The 'organic' work rhythm of the solitary modern artist was replaced by a 'mechanical' pace of artistic collaboration that often took place around the clock. In 'the city that never sleeps', there was a factory that never stood still. Life and art symbolically merged; living and working, day and night were intertwined. The interior of the

21 Philip Ursprung, Studio Olafur Eliasson: An Encyclopedia, **Cologne: Taschen, 2008.**
22 Jones, 'The Server/User Mode', p. 318.
23 For the relationship between industry and artists' studios, see Sharon Zukin, Loft Living: Culture and Capital in Urban Change, **Baltimore: Johns Hopkins University Press, 1982.**

Factory was silver-coated, and the windows were covered. The space was hermetically sealed from the outside, serving as a stage for Warhol's narcissism. It mirrored Warhol, the star, but not itself. In Eliasson's studio, on the contrary, one finds neither sofa nor sleeping bag. Life and work do not blend as such, nor do the time for art and the time for work collapse one on top of the other. Of course, Eliasson's collaborators do have spare time for discussion, to sit at tables in the kitchen, and to reflect on their ideas. But the creative work of the group is never totally unstructured. The phases where nothing is produced are formalized. Simply put, instead of parties there are seminars. Instead of failure there is an archive. And instead of ennui there is the studio journal *Take Your Time*.

Warhol's Factory has commonly been seen as the ultimate product of the corporate culture of the early 1960's and its large-scale bureaucratic structures and environments.[24] The production that it staged, however, was closer to 19th-century manufacturing. The rise of the Factory coincided with the decline of light industry in Manhattan — and the disappearance of factories in the old industrial centers of the United States. It served as a symbolic substitute for an earlier mode of production and drew significance precisely from its anachronism, a nostalgia for the past through the lens of glittering pop futurism. In a similar way, Eliasson's studio strategically draws upon an anachronism in relation to economy and industry, namely, today's transformation of work in the industrialized

countries and the predominance of what Michael
Hardt and Antonio Negri have called "immaterial
labor." In terms of organization, Eliasson's current
Berlin studio exemplifies the three types of immate-
rial labor that Negri and Hardt discern.[25] Down in
the cellar, the transition from manufacture to "in-
formation" takes place. The main floor is all about
"analytical and symbolic tasks," the flow of informa-
tion, design, and exchange, including the production
of knowledge or culture work. It serves as the prime
hub of what Eliasson refers to as his "extended studio"
— a growing "social network" and "community" of
the academic and curatorial jet set. But how does the
artist's studio relate to another, far more problematic
aspect of the "immaterialization" of work, namely the
visibility of labor? Globalized industry has many ways
of depicting consumption, but it is reluctant to rep-
resent the preceding labor. The latter is either trans-
ferred to places where it is cheap and removed from
the consumer's sight, or else it has become ever more
abstract and invisible.[26] Industrial production is trans-
formed into spectacle — in the Transparent Factory
(Gläserne Manufactur) in Dresden, Volkswagen has
staged the production of luxury cars since 2001 as if
they were assembled by hand — or symbolically in-
tegrated within the process of consumption — as a

24 Caroline A. Jones, Machine in the Studio: Constructing the Postwar
American Artist, Chicago: University of Chicago Press, 1996, p. 263.
25 Michael Hard and Antonio Negri, Empire, Cambridge, MA: Harvard
University Press, 2000, p. 293.
26 See Jeremy Rifkin, The End of Work: The Decline of Global Labor Force and
the Dawn of the Post-Market Era, New York: J.P. Putnam's Sons, 1995.

customer of IKEA, one is invited to actively participate in the assemblage of the product and to mimic the physical work, which adds the necessary emotional value. Eliasson's obvious attention to the studio and its manifold, often spectacular, representations on the one hand, and his continuous attempts to transform artworks into more than objects on the other, show a remarkable similarity to the commercial strategies used to incorporate invisible production into the event of consumption. His 'narcissistic studio' has turned into an image of itself as well as of the transformation of work into research. It epitomizes the way perception is turned into performance. Many of Eliasson's works have titles that directly address the viewer as potential user or active participant, such as *Your certainty still kept* (1996), *Your inverted veto* (1998), *Your blue afterimage exposed* (2000) or *Your spiral view* (2002). We are made to believe that what we are doing in the museum is *more* than consuming commodified works as passive spectators. This process is self-reproducing — in Eliasson's words: "Sometimes it has a life of its own, and sometimes I am very involved personally."[27]

Here one finds, I would argue, a blind spot in Eliasson's construct of the narcissistic studio. The artist intends to overcome the separation of practices that is typical of today's economy and, by consequence, of today's realm of art, art history, design, and architecture. But the studio is not an organic research community, in truth. Notwithstanding the rhetoric of teamwork and its participatory and

collaborative structures, and despite the fact that some publications merely bear the imprint of *Studio Olafur Eliasson*, it remains clear that Eliasson is the sole author.[28] The collaborators are paid employees whose job it is to produce surplus value. Their status cannot be compared to the situation of the loosely-connected researchers — such as myself — who enjoy the studio as a temporary space of experience and exchange, but who do not depend on its existence and economic prosperity. Eliasson successfully exploits the key rule of any bureaucratic power structure, whether it be the Roman Empire or today's globalized economy: *Divide et impera*, divide and rule. As long as every practice is limited to its spatiality and absorbed in its self-reflection, it can be easily controlled and manipulated. The artist strategically incorporates and controls an ever-growing variety of professional skills — borrowing from the blacksmith and the art historian alike

27 Olafur Eliasson, 'It's the journey, not the destination', in Ursprung, Studio Olafur Eliasson, p. 133

28 When, for example, we read an interview that Eliasson and Obrist recorded on board a private jet, a trip which was itself part of the remuneration that Eliasson received for designing a blanket for that same private airline, the collaborators who designed, produced, and handled the blanket remain anonymous, as do the ones who transcribed and edited the conversational interview. (See 'The vessel interview, part I: NetJets Flight from Berlin to Dubrovnik, 2007', pp. 143-144.) The names of the collaborators appear as a group on the back of publications. They are listed in the colophon or in the acknowledgments, but they are not represented as individual authors. This has only very recently changed in the domain of the discourse, where one of his close collaborators, the art historian Anna Engberg-Pedersen, retains her own voice in publications. It is also interesting that, with the exception of the studio journal TYT and Studio Olafur Eliasson: An Encyclopedia, photographs from the studio rarely show collaborators. The studio is typically presented as a site without people, comparable to the unpopulated landscapes in Iceland that feature in his photographs. Whereas we are familiar with Warhol's Factory as a backdrop of innumerable group portraits of the collaborators, we know Eliasson's studio from innumerable detailed or overall views where the workers appear like figures in a landscape.

— and an ever-growing variety of functions — associated with publishing department, school or museum — to remain somewhat independent within the art world. The studio — both as an effective machine and a brand — provides him with a seminal tool to exploit new themes and a dynamic structure to avoid the traps of formalism, combining both utopian idealism and clever economics. Eliasson's *Werkstatt & Büro* is an experiment whose final outcome we cannot yet know. But as Allan Kaprow once hinted, "Experimental art is never tragic. It is a prelude."[29]

29 Allan Kaprow, 'Experimental Art' (1966), in Essays in the Blurring of Art and Life, edited by Jeff Kelley, Berkeley: University of California Press, 1993, pp. 66-80 (80).

Where is the Studio?
Jan De Cock

Jon Wood

Le jour d'après, Jonas sortit très tôt.
Il pleuvait. Quand il rentra, mouillé
comme un champignon, il était chargé
de planches. Chez lui, deux vieux amis,
venus aux nouvelles, prenaient du café
dans la grande pièce. 'Jonas change
de manières. Il va peindre sur bois!'
dirent-ils. Jonas souriait: 'Ce n'est pas
cela. Mais je commence quelque chose
de nouveau.' Il gagna le petit couloir
qui desservait la salle de douches,
les toilettes et la cuisine. Dans l'angle
droit que faisaient les deux couloirs,
il s'arrêta et considéra longuement les
hauts murs qui s'élevaient jusqu'au
plafond obscur. Il fallait un escabeau
qu'il descendait chercher chez le
concierge (...). A mi-hauteur des murs,
il construisit un plancher pour obtenir
une sorte de soupente étroite, quoique
haute et profonde. A la fin de l'après-
midi, tout était terminé.

Albert Camus, 'Jonas ou l'artiste au
travail', 1957

Gilbert Jonas, the artist subject of Albert Camus's
short story, "believed in his star," fated like the biblical

Jonah to be cast sacrificially into the sea and swallowed by a whale, before being returned safely to shore.[1] Camus's tale plots the gradual rise, fall, and potential 'salvation' of Jonas as an artist and as a father. Juggling the demands of a successful career in the art world and the responsibilities of family life in a small, increasingly crowded apartment, Jonas's story is also a parable of time and space, which sees the gradual and simultaneous shrinking of living and working space as the story unfolds.[2] Having tried working in various rooms, experimented with different partitions, and having put up with the constant comings and goings of artists and critics, the painter turns carpenter-cum-architect and builds himself a wooden house-like retreat in the upper reaches of his apartment. Shunning the social engagements of the art world and committed to his work more than ever — despite his subsequent fall from popular favor — Jonas spends

This essay is a reworked version of 'Where is the Studio of Jan De Cock?', published in Jan De Cock. II Denkmal isbn 9080842427, edited by Wouter Davidts and Jan De Cock, Brussels: Atelier Jan De Cock, 2006, pp. 302-413. I wish to thank Jan De Cock for his generous permission to republish the essay and to use the illustration, and Stefanie Callens of Atelier Jan De Cock for her assistance.

1 Albert Camus, 'Jonas ou l'artiste au travail', in L'exil et le royaume, Paris: Editions Gallimard, 1957, reprinted Paris: Harrap, 1981, pp. 103-142. English translation: "The following day Jonas went out very early. It was raining. When he returned, soaked to the skin, he was loaded down with planks. At home, two old friends, who had come to see how he was, were drinking coffee in the big room. 'Jonas is changing his technique. He's going to paint on wood!' they said. Jonas smiled: 'That's not it. But I am beginning something new'. He went into the little hall that led to the shower-room, the lavatory and the kitchen. In the right angle where the two halls joined, he stopped and studied at length the high walls that rose up to the dark ceiling. He needed a ladder, which he went down to get from the concierge (...). Halfway up the walls he built a floor to get a sort of narrow, but high and deep, loft. By the late afternoon, all was finished."

2 For a further account of this combinatory shrinking of space and proliferation of things, see Peter Dunwoodie, Camus: L'Envers et L'Endroit and L'Exil et Le Royaume, London: Grant and Cutler, 1985, pp. 57-62.

endless hours in the darkness of this self-built hide-away. This time allows him to reflect on his work and, subsequently, on his love for his wife and children, whom he can hear living below. Finally, having collapsed as a result of physical and mental exhaustion, Camus concludes his story with Jonas's architect friend Rateau looking at the canvas that the reclusive artist has been working on all this time. On it, in tiny letters, is written merely a word. It is not clear, we are told, whether it spells *solitaire* (solitary) or *solidaire* (interdependent).[3]

By the mid-20th century, the artist's studio had become very well established as a stock subject in European literature.[4] Camus's short story, in which an artist is forced to build a private studio within the increasingly public space of his own studio-home, displays a subtle awareness of this tradition. Since Honoré de Balzac's *Le chef d'oeuvre inconnu*, which was first published in 1831, the artist's studio has been increasingly presented as the unique and private site of creation and artistic production and as the site of individual artistic and imaginative endeavor shut off from the rest of the material world. Subsequently, as demonstrated by the success of Emile Zola's *L'Oeuvre* of 1886 and the tragic-comic downfall of his poverty-stricken sculptor Mahoudeau, a mythology of the studio of the individual sculptor, as opposed to just that of the painter, was also slowly coming into view.[5]

Although by the end of the 19th century the studio of the individual painter, free and independent

from institutional *ateliers* (and often with combined living quarters), was a commonplace, the sculptor's studio was still widely understood as the domain of master and *praticien*, of apprenticeship and divided labor. It was only in the first years of the 20th century that the individual sculptor's studio emerged into significance in the public domain. Two aspects of its construction and characterization are noteworthy here: firstly, the critical appropriation of the model provided by the modern painter's studio at this time, and secondly, the 'spectral' perpetration of the status of the master-sculptor in the master-studio — carried over even in the absence of apprentices and assistants. The sculptor's studio had for so many years been seen as a site of apprenticeship in the presence of a master-teacher, who stood as the figurehead for the production and achievement therein, that sculptors' studios retained this aura of the group *atelier*, whatever their scale, small or large. Through the huge literature surrounding Auguste Rodin, an image of the

3 Camus, 'Jonas ou l'artiste au travail', p. 142.
4 Oskar Bätschmann discusses the studio as a subject in 19th-century French and German literature, but only in terms of the painter's studio, using the examples of Balzac's Chef-d'oeuvre inconnu (1831), Hoffmann's Die Jesuiterkirche in G. (1817), and Zola's L'Oeuvre (1886), where he focuses on the studio of the painter protagonist Claude Lantier. See 'The Cult of the Tragic Artist: Death and Suicide in the Studio', in The Artist in the Modern World: The Conflict Between Market and Self-Expression, Cologne: DuMont, 1997, pp. 97-103. The example of Balzac's Sarrasine (1830) should also not be neglected in its appropriation of Pygmalionism in the context of the sculptor's studio: "It was more than a woman, it was a chef d'oeuvre. There were to be found in this unhoped-for creation, love to ravish all men, and beauty to satisfy a critic. Sarrasine devoured with his eyes the statue of Pygmalion, for him descended from the pedestal." Honoré de Balzac, Scenes of Parisian Life: Volume Nine, The House of Nucingen, La Princesse de Cadignan etc., London: The Lorraine Press, 1926, p. 235.
5 Zola, L'Oeuvre, Paris: Fasquelle, 1978.

successful sculptor's studio developed in the popular imagination in the late 19th and well into the 20th century. It was this sculptor's studio that served as both the model and anti-model for the studios of sculptors such as Emile-Antoine Bourdelle, Constantin Brancusi, Alberto Giacometti, Henri Laurens, Aristide Maillol, Charles Despiau, and many others working in Paris and elsewhere. For all of these sculptors, this ambivalent status was important, making the studio a microcosmic/macrocosmic artistic environment. An *atelier* implied at once a site of particular, individual practice and also of general, collective resonance: the sculptor speaking for the people and taking on the heroic aura of avant-garde collectivity.

Looking back across the literary history of the subject in this period, the material conditions of the individual sculptor's studio emerge as an equally important part of the mythology. These were frequently characterized and caricatured in three main ways.[6] First, the studio was cast as a dark and dusty indoor realm (as opposed to the healthy, outdoor environment of *plein air* painting), entirely taken over by the working materials of the craft (plaster, clay, stone or wood). Since the sculptor didn't need windows in order to look out onto represented views, the sculptor's studio was often window-less or had its windows covered up and white-washed over, creating a highly inward-looking, contained, and enclosed environment. This, in turn, had the effect of overwhelming visitors' senses by providing not only a visual, but also a multi-

sensory experience of sculptural process, since the materials could be smelled and felt in the damp and dusty studio. Second, the atmosphere of the studio was presented as having a melancholic, funerary, tragic, and gothic character, something in part generated by the statuary and figurative sculpture that populated it. Sculptures thus appeared as ghostly actors, and the sculptor's studio was cast as a stage for their spectral, uncanny performances. Third, the sculptor's studio was cast as the magical site of Pygmalionism, of the transformational 'coming to life' of the female figure (Galatea, in Ovid's account) through dream, reverie or prayer.[7] The popularity of this myth in late 19th-century French academic painting, and its pertinence as a conceptual device for the polite negotiation of the model's nudity, is well known.[8] Its power, however, to transform the status and character of the sculptor's

6 The downfall of Zola's sculptor can also be read as an inscription of the traditional fate of sculpture, compared to that of painting, within the paragone. The visit to his sculptor's studio by Claude and Sandoz is important and worth quoting at length since it perfectly illustrates the image of the sculptor's studio I am outlining here: "Ils s'engagèrent tout de suite dans la rue du Cherche-Midi. Le sculpteur Mahoudeau avait loué, à quelques pas du boulevard, la boutique d'une fruiterie tombée en faillite; et il s'y était installé, en se contenant de barbouiller les vitres d'une couche de craie. (...) La boutique, assez grande, était comme emplie par un tas d'argile, une Bacchante colossale, à demi renversée sur une roche. Les madriers qui la portaient, pliaient sous le poids de cette masse encore informe, où l'on ne distinguait que des seins de géante et des cuisses pareilles à des tours. De l'eau avait coulé, des baquets boueux traînaient, un gâchis de plâtre salissait tout un coin; tandis que, sur les planches de l'ancienne fruiterie restées en place, se débandaient quelques moulages d'antiques, que la poussière amassée lentement semblait ourler de cendre fine. Une humidité de buanderie, une odeur fade de glaise mouillée montait du sol. Et cette misère des ateliers de sculpteur, cette saleté du métier s'accusaient davantage, sous la clarté blafarde des vitres barbouillées de la devanture." Zola, L'Oeuvre, pp. 82-83.
7 For the story of Pygmalion, see Ovid, Metamorphosis. Book X. Lines 243-297.
8 See Frances Borzello, 'The Model's Status', in The Artist's Model, London: Junction Books, 1982, pp. 65-85.

studio, and to elevate it beyond its mundane workshop function to the realm of ideas, is less remarked upon. In this way, the sculptor's studio was seen as a timeless domain governed only by the laws of art, a *lieu sacré* of visionary creativity and the stage for an erotic drama in which the roles of the female model and statue were variously caught up and played out.

Camus's short story, which presents not only a painter but also an *artisan*, carpenter and architect, is an intriguing and much overlooked text within this studio literature. On the one hand, it satirizes not only the post-war Parisian art world and its pressures and pretensions, but also the idea perpetuated there, of the artist's studio as a quasi-mystical site of isolated and individual artistic practice. On the other hand, it credits the studio as a space of reflection and transformation, of thought and resolution, where important lessons are learned and decisions reached. This is neatly summed up at the ambiguous end of the story, where Camus presents his character Jonas as advocating something of a riddle: either solitude and individual endeavor, or solidarity and mutually supportive togetherness. The answer to the existential conundrum presented is seemingly a reconciliation of both positions: that being an artist now requires a new, more complicated and combinatory relationship between art and life, between public and private realms, between individual and collective activity, between solitude and solidarity. For Camus, the artist's studio is thus both rejected and accepted: it is still an

important place, but represents only half of the story of an artist's life and practice. The rest must happen elsewhere, beyond its walls, frames, and limits.

Published in 1957, Camus's short story was an acutely timely contribution to the discourse of the artist's studio and to the realities of its practices. 1957 saw the death of Brancusi, one of Europe's most famously studio-based sculptors, and the bequest of the contents of his studio at 11 impasse Ronsin to the French state. With Jean Genet's *L'Atelier d'Alberto Giacometti*, that same year also witnessed the publication of a monograph on (arguably) Europe's second most famously studio-oriented sculptor.[9] Twenty-five years lay between the births of these two sculptors and thus Camus's text appeared at a moment when a younger generation was taking over. (Indeed, Giacometti, though promoted first as a 'surrealist' then an 'existential' artist, was first trained as a sculptor under Bourdelle at his Grande Chaumière studio in the mid-1920s.) Moreover, Camus's text stands intriguingly, in its deliberate ambivalence, at the beginning of a period when the idea of the artist's studio itself, and its relationship to the world outside its walls, was just starting to be profoundly rethought and reformulated. It seems poised, Janus-headed, looking back critically at the pre-war mystification and sanctification of the artist's studio, as well as looking ahead, in an anticipatory way, to the partial physical and intellectual evacuation

9 Jean Genet, L'Atelier d'Alberto Giacometti (1957), Paris: L'Arbalète, 1995.

of the studio in the following decade. In 1966, Alan Kaprow unambiguously outlined his anti-studio position in his 'How to make a Happening' text, declaring: "[t]he romance of the atelier, like that of the gallery and museum, will probably disappear in time. But meanwhile, the rest of the world has become endlessly available."[10] And in 1971, Daniel Buren declared his "distrust of the studio and its simultaneously idealising and ossifying function," preferring to work beyond it, in the site of the artwork's presentation and display.[11] Reading Camus's story today, there also seems something acutely contemporary about Jonas' radical gesture: it might remind us of a Paul Thek construction, a Siah Armajani room, a Mike Nelson log cabin, a Simon Starling rope trick, a Gregor Schneider loft conversion, a Paul McCarthy film set, a Rirkrit Tiravanija reconstructed lodging, or perhaps even a Jan De Cock *Denkmal*.

Jan De Cock is a sculptor for whom this rich, anxious and deeply contested tradition and legacy of the studio, and of the studio of the sculptor in particular, is profoundly important. Not unlike the traditional sculptor's studio, De Cock's *Denkmäler* are themselves well-crafted and well-staged sites of enclosure, performance, and imagination and, as I will show, they owe much to the studio's historical array of narratives, techniques and strategies. Akin to the traditional studio-artist relationship, a *Denkmal* is the result of the activities of the 'Atelier Jan De Cock' as much as it is by the artist 'Jan De Cock' himself.

Moreover, as evidenced by the four books that the artist has published as part of his practice in the past five years, he is an artist who is clearly fascinated as much by the sculpture of Brancusi and Bourdelle, or Georges Vantongerloo and Donald Judd, as he is by the work of Dan Graham, Marcel Broodthaers, and Buren — with whom he made a joint project in the north of Italy in 2006.[12] The status and function of the studio has an interesting role within this duality. Of all the photographs of sculptures that, for example, figure in De Cock's first book in 2004, Brancusi's *Endless Column* and Bourdelle's *Hercules the Archer* are two of the most prominent. Reproduced both inside and outside their respective studio settings, and of different scales, the black and white photographs of both these sculptures remind us that the studio setting — the structure of containment and enclosure that envelops these works — actually also struggles to hold these sculptures. Although it frames and facilitates these sculptures' dynamics, the studio cannot

10 Allan Kaprow, How to Make a Happening, New York: Harry N. Abrams Inc., 1966, p. 183.
11 Daniel Buren, 'The Function of the Studio', translated by Thomas Repensek, in October, 10 (Fall 1979), pp. 51-59 (55).
12 The four books are part of a larger, 12-part encyclopedia project. So far, Jan De Cock has published the following volumes: Jan De Cock: I Denkmal isbn 9080842419, Brussels: Atelier Jan De Cock, 2004; Jan De Cock: II Denkmal isbn 9080842427, edited by Wouter Davidts and Jan De Cock, Brussels/New York: Atelier Jan De Cock/Thea Westreich and Ethan Wagner, 2006; Jan De Cock. III Denkmal isbn 9789080842434, Brussel/New York: Atelier Jan De Cock/Thea Westreich and Ethan Wagner, 2008; Jan De Cock: IV Denkmal isbn 9789080842441, Brussels/New York: Atelier Jan De Cock/Thea Westreich and Ethan Wagner, 2008.
In 2006 Jan De Cock made a joint-installation with Daniel Buren at Giuseppi Terragni's Casa del Fascio in Como and the Galleria Massimo Minini in Brescia (Denkmal 4, Casa del Fascio, Piazza del Popolo, Como, 2006).

195

really sustain or control them. Columns rise up verti-cally with a rhythmic rhomboid movement that will take them, Jack and the Beanstalk-like, through the studio's ceiling and into the clouds, linking heaven and earth. And bow bent to fire an arrow, *Hercules the Archer* is a work that not only dramatizes its immedi-ate spatial environment, but also implicates the space ahead in the archer's sights as an anticipatory part of the story. Both of these sculptures have become outdoor public monuments and, in turn, signature pieces, emblematic of the sculptors who made them. (De Cock's own fascination with *Hercules the Archer* might also, I think, stem from the legibility of his own initials, JDC, monogram-like within the armed ana-tomical composition of Bourdelle's sculpture).[13] These famous sculptures are thus works that bespeak both the studio setting and the departure from it.

The 'Atelier Jan De Cock', based at 15 Auguste Gevaertstraat in Brussels, can be read as an ate-lier haunted by some intriguing precursors. Its high level of craftsmanship and artisanal labor, skill, and expertise places his work within a modernist tradi-tion of the sculptor's studio. But De Cock's ongo-ing *Denkmal* project articulates the sculptor's studio as not only a place where sculptures are physically made and displayed, but as a complex site of conver-gence and dispersal for people, ideas, and things as well. As such, it connects with the work and thinking of post-1960s artists such as Broodthaers, Graham, Buren, and Michael Asher. We are thus faced with

an unusual double-edged way of thinking and working. With Camus's tale in mind, we also encounter a form of artistic reconciliation. The work of De Cock involves no less than a coming together of individual and collaborative practice, an artisanal workshop and a mobile mode of working, a nomadic approach to production, and a site-specific mode of installation, and a complicated appropriation of private and public space that temporarily collapses the space of the studio into the space of the art museum. In this essay, I ask the question 'where is the studio?' and trace the artistic and art historical co-ordinates of De Cock's various 'studio relocations'.

Is a studio really just a room with four walls? How can it be encountered or accessed by outsiders or people other than the artist? What happens to the studio when the artist leaves or dies? Is it maintained in its original state as a monument to the artist and his practice, is it restored in situ or is it reconstructed and relocated elsewhere in closer proximity to an art museum? De Cock's *Denkmal* series displays a subtle awareness of and sensitivity to the question of studio reconstruction, a topical museological question over recent decades. The studios of many modernist sculptors (some included in De Cock's image bank) have experienced different fates. What happens to their walls is crucial; it dictates what kind of reconstruction and what kind of accessibility and experience for

13 Jan De Cock also owns a remade plaster version of Brancusi's 1912 marble Muse, which sits on his desk in his Brussels studio.

the viewer or visitor is at stake. Visiting an artist's studio is generally felt to enable a view 'behind the scenes', an experiential insight into the artist's work in its correct, originary context, prior to the post-studio spaces of the gallery or museum. Studios, especially reconstructed ones, are thus not only seen as the sites of production of art, but as prompts for a further comprehension of the artist's work and persona as well. Some studios, like those of Henri Bouchard and Bourdelle, have kept their original walls intact and have been maintained as museums of their respective artists. Some, like Giacometti's at 46 rue Hippolyte-Maindron, have had their plaster walls removed altogether after the sculptor died.[14] Since they were seen as so integral to his artistic and studio identity, they were redisplayed as works of art in their own right in 1978-79.[15] In some studios, such as those of Maillol, Barbara Hepworth, and Henry Moore, certain rooms have received large, single, glass windows installed in the walls, enabling viewers to overlook the space in its original or reconstructed state, and to get a belated impression of the 'work in progress'. Other studios, like Renzo Piano's 1997 reconstruction of Brancusi's second, later studio at 11 impasse Ronsin, built right outside the Centre Georges Pompidou, have had their walls removed altogether and replaced by floor to ceiling glass. Visitors to L'Atelier Brancusi now come inside the building and walk around the studio (in a clockwise direction) looking in, through the glass, at the studio and its contents. They will never step

over the threshold into the studio, nor be able to walk around the sculptures and grasp their carved scale through the spatial experience of the framing dimensions of the enclosing building. The Brancusi studio is now brighter and whiter than ever, opened up by a kind of democratic transparency. Dislocated from the fabric and contingencies of its previous cul-de-sac life off rue Vaugirard in the 15th arrondissement, it has become an artefact in itself — nonetheless offering an extremely elegant and judicious solution to a very difficult curatorial and museological problem.

De Cock's *Denkmäler* not only display a knowledge of the studio as a historical phenomenon, but also demonstrate a subtle awareness of its museological status and problematic posterity.[16] For De Cock, the relationship between his artistic production and the art museum is an intimate one. "My work is site-specific, it cannot exist without the context of the museum," the artist told an interviewer in 2003.[17] By

14 For a new reading of the status and function of Giacometti's studio, see: Jon Wood, 'From vue d'atelier to vie d'atelier: 46 Hippolyte-Maindron and the beginnings of Giacometti', in Peter Read and Julia Kelly (eds.), Alberto Giacometti: Critical Essays, Aldershot: Ashgate, 2009, pp. 17-42.

15 See Alberto Giacometti: Les murs de l'atelier et de la chambre du 46 Hippolyte-Maindron, Derrière le miroir, Paris: Galerie Maeght, 1979 and the catalogue essay 'Autre heure, autres traces...' by Michel Leiris.

16 This he shares with other contemporary artists, such as Thomas Demand, Jason Rhoades, Mike Nelson, Liesbeth Bik and Jos van der Pol, Richard Venlet or Job Koelewijn, whose Transported Studio (1994) and The World is My Oyster (1996) play out the anxious relationship between studio, gallery, and the world beyond them both. For an excellent account of the work of Bik Van der Pol in relation to the idea of the studio, see Wouter Davidts, 'In the Peripheries of the Studio: The Early Works and Practice of Bik Van der Pol', in Bik Van Der Pol: With Love From the Kitchen, Rotterdam: NAi Publishers, 2005, pp. 61-64. See also Jon Wood, 'The studio in the gallery?', in Suzanne MacLeod (ed.), Reshaping Museum Space: Architecture, Design, Exhibitions, London: Routledge, 2005, pp. 158-169.

17 Jan De Cock interviewed by Milovan Farronato in Tema Celeste (November-December 2003), p. 88.

'work' he could almost be talking about his studio. His declaration of interdependence is also a declaration of independence, evocative of artistic freedom, not of cultural subordination. Like Buren, De Cock transfers much of his physical work and practice into the art museum, transforming the latter into a temporary workshop.[18] But De Cock proceeds to build all around himself — like a hermit crab that builds its own shell within the one it has moved into. As he said himself: "the walls of my studio are for that moment — the moment of an exhibition — where I work. (…) *Denkmal* is a *mould* that is transportable elsewhere."[19] The walls of the studio thus temporarily coincide with the internal walls of the museum, adding a new inner layer that both hides and highlights the original structure and its history. Jan De Cock's *Denkmäler* act as temporary 'second skins' and 'sleeves' within the larger and more permanent outer body and structure of the art museum, but they are also walled interventions into the curated, uncurated, and frequented spaces of the art museum — De Cock initially named his works 'randschade' or 'collateral damage'.[20] They insinuate themselves into the fabric and politics of the place, taking part in and becoming part of its history.[21] The period of installation and habitation has even led some writers to cast the site and installation of a *Denkmal* more as a studio-home than a studio, bringing an added level of intimacy to the proceedings. Rather like Tomoko Takahashi's occupation of the Serpentine Gallery during the making and installa-

tion of her show there in 2005, one critic noted that De Cock's *Denkmal 2*, at Manifesta 5 in Donostia-San Sebastián, "may have doubled as the artist's crash pad" over its nine-week installation period.[22]

In a sense, De Cock makes models. Not small-scale models that people can look down on, peep into and around, but large-scale, life-size models that people can walk around or into, and sometimes experience from the inside. The human scale of the *Denkmäler* is crucial to their efficacy. In a way they emerge as a contemporary blend of Dada and Constructivism — something like a cross between Kurt Schwitters's *Hannover Merzbau* (c. 1933) and Gerrit Rietveld's *Schröderhuis* (1924). They seem to rebuild Cor van Eesteren and Theo van Doesberg's *Model for an Artist's House* (1923) on a large scale, and outside in or inside out within the pre-existent architectural

18 His own Brussels studio, it should be said here, is a large space which not only accommodates offices, a kitchen, and its own 'Bar Gevaert' for post-work socialising and conviviality, but also plenty of storage room and a two floor workshop, which also enables split-level viewing opportunities.
19 Jan De Cock in conversation with Monica Amor, Wouter Davidts, Kirstie Skinner, John Welchman, and Jon Wood at Tate Modern, London, Friday 1st July 2005.
20 Phrases used by Monica Amor and John Welchman in conversation with Jan De Cock at Tate Modern, London, Friday 1st July 2005. Initially, Jan De Cock systematically titled each of his works Randschade, and there were ten in total, numbered in order of production. Within Randschade fig. 7 in the Ghent Museum of Fine Arts, the artist used the term Denkmal for the first time, labelling the different sections of the installation. Since Denkmal 10 in De Appel in Amsterdam (2003), De Cock consistently uses Denkmal as the title for his works, followed by a signature number that correlates with the street address of the specific location.
21 See Wouter Davidts's analysis of Jan De Cock's work in the Brussels Palais des Beaux-Arts; Wouter Davidts, 'Travail de [vi]site: Jan De Cock and the Brussels Palais des Beaux-Arts', in Jan De Cock: Denkmal isbn 9080842419, pp. 5-18.
22 Jordan Kantor, 'Jan De Cock', Artforum XLIII, 5 (January 2005), p. 152. See Rochelle Steiner, 'Tomoko Takahashi', in Tomoko Takahashi (exh. cat.), London: Serpentine Gallery, 2005.

structures of an art museum. De Cock's sculptures turn viewers into visitors by setting up and installing structures that surround, guide or lead them around the work. But what they actually are invited to visit, is a studio, albeit an abandoned one. For when the work is done and the artist and his team have left, a *Denkmal* never stops having been a studio. It will always be a site where things have been visibly and invisibly worked upon. Evidence of the studio is still everywhere; in the brand new immaculate and reflective surfaces, in the smell of recently cut fiberboard, in the immaculate ledges and levels, in the clean angles, neat joins and hidden screws, in the interlocking network of boxes, cabinets, compartments and units, in the new floors, corridors, doorways, and shelves. Any *Denkmal* is haunted by its fabricators and their craftsmanship. This residue of studio energy and sculptural hospitality empowers it, grants it an "inner power," to use a phrase dear to the artist.[23] The studio is still everywhere, as a powerful material presence and reality. As such the work plays upon the material enveloping and encasement that, as I stated at the beginning of this essay, have traditionally been characteristics of the sculptor's studio. Sculptors' studios have often acquired identities and reputations as places based on their material conditions and the practices that they accommodate. In this way, for example, we were presented with the whiteness of Rodin's studio (first promoted by Rainer Maria Rilke), the whiteness of Brancusi's studio (promoted by almost every-

202

one from Tristan Tzara and Mina Loy to Margaret Anderson and Georges Duthuit) to the plaster dustiness of the studios of both Arp and Giacometti (celebrated by Genet).[24] De Cock follows in this modernist tradition with his characteristic use of fiberboard. He and his team work in large sheets of this man-made and synthetic material, like an 'infinite stretcher,' from one *Denkmal* to the next. It has a neutrality, an industrially formatted and international character, that is not evocative of any particular national tradition or locally specific material culture. It also has a reflective skin that gives the fiberboard not only a glossy hardness, a sealed intactness, and a shiny resilience, but also a marble-like translucency that seductively takes us into its inner material depths. Not unlike a museumized sculptor's studio, De Cock's *Denkmäler* harness a heightened, engaged, imaginative and historically alert kind of visitor attention. They serve as three-dimensional invitations, fiberboard gauntlets thrown down to challenge the gallery visitor to be on the lookout. Everything is there to be looked at and into, to be discovered and detected, to be considered and contemplated. Like exhibited studios, you might say, De Cock's *Denkmäler* make the audience captive.

23 Jan De Cock in conversation with Monica Amor, Wouter Davidts, Kirstie Skinner, John Welchman, and Jon Wood at Tate Modern, London, Friday 1st July 2005.
24 For more on this, see Jon Wood, 'Brancusi's white studio', Sculpture Journal, VII (2002), pp. 108-120 and Jon Wood, 'When we are no longer children: Brancusi's wooden sculpture c. 1913-25', in Carmen Giménez and Matthew Gale (eds.), Constantin Brancusi: The Essence of Things, London: Tate, 2004, pp. 60-69.

In *Randschade fig. 3* in the German city of Borken (2001), De Cock's intervention took a powerfully archaeological turn; sections of flooring and ceiling were removed, exposing the cavities and foundations of the building. The 'collateral damage' of this *Denkmal* combined excavation with additive layering and gave the site-specificity of the installation an added poetry, depth, and urgency. The site-specificity of each *Denkmal* is registered through the numbering system employed (which always reflects the street number of the host institution), but such excavation further adds to this dimension, reaching into the belly of the building. In choreographing such play, De Cock encourages the viewer not only to re-imagine spatial relations with the room, but also to reconsider the history, meaning, and function of the place. What is a plinth, what is a pedestal? Might the whole gallery now in fact have become a plinth? Visitors are provided with an uncanny experience — an experience of a new order, but also an awareness of the place underneath the reflective dry lining. This is a deliberate and acutely disorienting strategy, half welcoming and invitational, half about setting traps and obstacles. Views are both afforded and restricted, and made intentionally deceptive. It becomes difficult to judge the distances and spaces between fiberboard layers and to gauge the inner heights and depths of the *Denkmäler*. This experience inadvertently recalls the mood of a Giorgio de Chirico painting, with its unsettling technique of *dépaysement*. This painterly description is ap-

204

propriate, since Jan De Cock clearly thinks through his *Denkmäler* as much in terms of images and scenes as he does in terms of three-dimensional, frequentable circuits. His comment that his works are "off-screen sculptures" confirms that what is at stake is always round the corner, just out of the frame, slightly hidden behind something else.[25] Asymmetry is crucial, and the complete story and overarching compositional strategy is always postponed and anticipated, offered up piece by piece (montage-like), and never fully revealed in its entirety.

The relationship between such compositional display strategies, and the ways in which the *Denkmäler* are accessed and viewed by visitors, is clearly intimately conceived and imagined by the artist. The extraordinary photographs by which De Cock documents all of his installations reveal that he evidently envisions his *Denkmäler* and their visitors as one. Since people make places, these staged installation photographs of people frequenting his *Denkmäler* are highly important and interpretative images, far more than the private documentation shots that they might, at first glance, seem to be. They bring about an image of the *Denkmal* as 'activated' or 'at work'. Here again, De Cock's *Denkmäler* connect with the history of the sculptor's studio. In the studio pictures of Brancusi or an artist such as Brassaï — for whom Paris itself,

25 Jan De Cock in conversation with Monica Amor, Wouter Davidts, Kirstie Skinner, John Welchman, and Jon Wood at Tate Modern, London, Friday 1st July 2005.

inside and out, by day and by night, became one large, highly photogenic film set — the studio emerged as a stage or set on which ambiguities, doublings, and visual puns between statues and models, between inert material and living beings, between stasis and movement were played out.[26] In keeping with this, visitors to De Cock's sculptures often feel watched, invigilated or under surveillance — the artist even likes his *Denkmäler* to be provided with security staff and gallery attendants. Likewise, the large Duratrans lightbox versions of some of these photographs are often incorporated in subsequent *Denkmäler*. They not only keep the sites on the move, or on a loop from one location to the next, but also openly perpetuate a mode of encounter and visitor interaction between subsequent *Denkmäler*. De Cock stated that visitors to his installations "become actors, become self-conscious of their own presence. They see their own mobility in relation to dead material."[27] While this can clearly be seen in the work, there is another possible interpretation; such photographs also have the ability to cast gallery visitors into figurative sculptures — posed models, captured either in states of self-absorption or viewing their surroundings. They thus cast the *Denkmäler* into new relief, emphasizing their status as staged enclosures and bringing greater attention to their forms and surfaces. This staged aspect of De Cock's color installation photographs becomes more apparent when they are seen alongside his extraordinary wide-angled, black and white *Temps Mort* photographs.

These photographs depict figurative sculpture, situated both outdoors as public, monumental sculpture in urban settings, and indoors in the galleries and storerooms of European museum collections.[28] They bespeak De Cock's delight in photographing figurative sculpture and juxtaposing sculptures with people, in ways that make the latter look like sculptures, and bring the former, in Pygmalion-like fashion, to life.

De Cock's *Denkmäler* endeavor to create new and independent spaces for experience, thought, imagination and reflection, thereby revealing the studio as a place where all of these activities find their place and space. This was made strikingly clear in the photographs of *Denkmal 9* at the Henry Van de Velde University library in Ghent in 2004. Library users make particularly good models and these photographs record them both still and in movement, catching them silently in the middle of reading, writing or thinking. *Denkmal 9* deliberately tapped into the 'studio-studiolo' tradition, knowingly incorporating its 'slow time' atmosphere into the resulting photographs. De Cock's *Denkmäler*, like studio spaces, are cast as places of contemplation, conducted alone and in the company of others — *solitaire* and *solidaire*, to use Camus's terms.

Keeping his own workshop photographically

26 For more on Brassaï and studio photography, see Jon Wood, 'Close Encounters: The Sculptor's Studio in the Age of the Camera' in Close Encounters: The Sculptor's Studio in the Age of the Camera, Leeds: Henry Moore Institute, 2001, pp. 8-27.
27 Kantor, 'Jan De Cock', p. 152.
28 Jan De Cock: I Denkmal isbn 9080842419, pp. 269-338.

under surveillance is something De Cock shares with other artists, such as Bruce Nauman and Graham Gussin, whose films, *Mapping the Studio I (Fat Chance Cage)* (2002) and photograph *Studio (Dry Ice)* (1997) respectively, playfully highlight the banality of studio life and send up the idea of the studio as a magical, mystical, and otherworldly venue. For De Cock, however, studios are far from banal places and this comes across particularly strongly in the images of the making of his 2000 work *Vertigo, or the Era of Free Catalogues*, erected in the Felix Hap Park in Brussels. In his 2004 artist's book, De Cock printed twenty color photographs of this structure being constructed (some of which include him at work) and then placed these photographs all on one page next to a large full-page color reproduction of Charles Mertens's canvas entitled *The Painter's Workshop* (1885), from the Museum of Fine Arts in Ghent.[29] If any confirmation were needed, this double-page spread boldly makes the connection between De Cock's mobile *atelier* and the artist's studio. Indeed, in a very real sense, his idea of the studio can be discerned running subtly but powerfully through the series of photographs reproduced in this 2004 book. De Cock has called the book "a museum in itself," but perhaps more importantly it is a studio as well: an image bank, a scrapbook of ideas, mental notes, photographs, and visual records.[30]

It will be interesting to see how Jan De Cock's work develops in the forthcoming years and how the idea of the studio is treated in his future projects. The

studio-museum relationship is here to stay for a while longer in our age of restoration and reconstruction, and De Cock's has already made some highly compelling interventions into this field. Interventions which, as this essay has tried to show, take their bearings from a range of different 20th-century precursors and from a variety of sculptural practices. Far from the usual, humdrum 'artist residencies,' his *Denkmäler* create sculptural and architectural interventions that get under the skin of the studio and the art museum simultaneously, asking that we rethink the coordinates and dimensions of these places. Alongside this, and as shown by his photography and his ongoing series of publications, De Cock's grasp of the studio today also entails an understanding of its material existence as archive and documentation, as well as an intuitive appreciation of both the theater of the studio and the art museum, as places where people come to see and be seen and to take part in the experience of art.

29 Jan De Cock: I Denkmal isbn 9080842419, pp. 248-249.
30 Jan De Cock in conversation with Monica Amor, Wouter Davidts, Kirstie Skinner, John Welchman, and Jon Wood at Tate Modern, London, Friday 1st July 2005.

Biographies

Wouter Davidts (Antwerp, B/Amsterdam, NL) is Professor of Modern and Contemporary Art at VU University in Amsterdam. From 2003 to 2008, he was a postdoctoral researcher in the Department of Architecture & Urban Planning of Ghent University (UGent), where he obtained a PhD in Museum Architecture in 2003. In the fall of 2006, he was a British Academy research fellow at Goldsmiths, University of London. He was a research fellow at the Research Group of Visual Arts, Academie voor Kunst en Vormgeving|St Joost, Avans Hogeschool from 2007 to 2008, and a visiting research fellow at the Henry Moore Institute, Leeds, in the fall of 2008. He is the author of *Bouwen voor de kunst?*, Ghent: A&S/books, 2006, and has published on the museum, contemporary art, and architecture in journals such as *Afterall*, *Archis*, *De Witte Raaf*, *Footprint*, *Kritische Berichten*, *OASE*, and *Parachute*, as well as in books and exhibition catalogues. In 2007, he curated the exhibition *Beginners & Begetters* at the contemporary arts center Extra City in Antwerp.

Julia Gelshorn (Zurich, CH) is Assistant Professor of Art History at the University of Zurich. She was a postdoctoral fellow at the German Centre for the History of Art in Paris from 2006 to 2008. From 2001 to 2005, she was an Assistant Professor at the University of Bern. She is the author of *Strategien der Aneignung: Bilddiskurse im Werk von Gerhard Richter und Sigmar Polke*, München: Fink, 2009, and has published on contemporary art and on issues such as

artistic authorship, and the intermediality of image and text, as well as on artistic identity. She is editor of *Legitimationen. Künstlerinnen und Künstler als Autoritäten der Gegenwartskunst*, Bern: Peter Lang, 2005.

MaryJo Marks (New York, US) is an art historian and writer based in New York, where she teaches art history at the School of Visual Arts. Her most recent project, 'Allan McCollum's Supplements', will be included in a forthcoming monograph on the artist (JRP Ringier). She is currently working on a book that explores the relationship between 1960's Conceptual photography and theoretical writings on the Everyday.

Kim Paice (Cincinnati, US) is Assistant Professor of Art History at the College of Design, Art, Architecture, and Planning (DAAP) of the University of Cincinnati, Ohio (UC). In 2003, she completed her PhD at the Graduate School and University Center of the City University of New York with a doctoral study of process art and pictoriality in the works of Robert Morris, Richard Serra, and Robert Smithson. Her scholarship has appeared in *Art + Text*, *Documenta XII: Journal of Journals*, *Drain: A Journal of Contemporary Art and Culture*, *n.paradoxa: International Feminist Art Journal*, *World Art*. She has also written exhibition catalogues for The Contemporary Arts Center and The Storefront in Cincinnati. In 1994, she put

213

together the exhibition catalogue *Robert Morris: The Mind/Body Problem* after four years of work in the Curatorial Department of the Solomon R. Guggenheim Museum, New York.

Kirsten Swenson (Las Vegas, US) is Assistant Professor of Contemporary Art History, Criticism, and Theory at the University of Nevada, Las Vegas. Prior to joining the faculty at UNLV, she taught courses in Modern Contemporary Art at Case Western Reserve University, New York University, and the State University of New York (SUNY) at Stony Brook. In 2006, she received her PhD from SUNY, Stony Brook, where she completed a dissertation on Eva Hesse and gender politics in the late-1960s New York art world. Swenson was a pre-doctoral research fellow at the Smithsonian American Art Museum, and a teaching fellow at the Whitney Museum of American Art. She writes regularly for *Art in America* and has published academic articles on Eva Hesse, Lee Bontecou, Ruth Vollmer, and Agnes Martin.

Morgan Thomas (Christchurch, NZ) completed her PhD at the University of Sydney in 2003 and is currently a Lecturer in Modern and Contemporary Art at the University of Canterbury (New Zealand). She previously taught at the University of Queensland. She has also worked as a translator and editor and as an art critic and reviewer. Her research focuses on postwar art and criticism, and on contemporary

art and critical theory. Recent publications include 'Slow Dance: Douglas Gordon's 24 Hour Psycho' in *Reading Room: A Journal of Art and Culture* (2008), 'E is for Everything', in Robert Leonard (ed.), *Richard Bell: Positivity*, Brisbane: Institute of Modern Art, 2007, and 'Rothko and the Cinematic Imagination', in *Rothko: The Late Series* (exh. cat.), London: Tate Publishing, 2008. With Robert Leonard, she is co-curating an exhibition of recent work by Australian and New Zealand artists for *White Box*, New York, to be held in 2009-2010.

Philip Ursprung (Zurich, CH) is Professor of Modern and Contemporary Art at the University of Zürich, Switzerland. He has taught History of Art and Architecture at the Swiss Federal Institute of Technology in Zurich, at the University of the Arts in Berlin and the Graduate School of Architecture, Planning and Preservation of Columbia University, New York. He was a visiting curator at the Museum of Contemporary Art in Basel, the Graduate School of Architecture, Planning and Preservation of Columbia University, New York, and the Canadian Centre for Architecture in Montreal, where he curated *Herzog & de Meuron: Archeology of the Mind* and edited the catalogue *Herzog & de Meuron: Natural History*, Montreal/Baden: CCA/Lars Müller, 2002. He is the author of *Grenzen der Kunst: Allan Kaprow und das Happening, Robert Smithson und die Land Art*, Munich: Silke Schreiber, 2003. He wrote the introduction of *Studio*

Olafur Eliasson: An Encyclopedia, Cologne: Taschen, 2008. He is the editor of *Caruso St John: Almost Everything*, Barcelona: Polígrafa, 2008.

J o n W o o d (Leeds, UK) coordinates the research program and curates exhibitions at the Henry Moore Institute in Leeds. He is also an Associate Lecturer at Leeds University, teaching on the MA in Art History. He has written widely on twentieth-century and contemporary sculpture and has had a particular interest in the artist's studio since doing his PhD at the Courtauld Institute of Art in London. He has published on the studios of Brancusi, Moore, Giacometti, and Picasso, and is presently editing a book with Wouter Davidts called *The Studio in the Gallery: Museum, Reconstruction, Exhibition* (Ashgate, forthcoming).

Jon Wood is the co-editor (with Alex Potts and David Hulks) of the *Modern Sculpture Reader*, Leeds, Henry Moore Institute, 2007. He has curated several exhibitions, including *Against Nature: the hybrid forms of modern sculpture* (2008), *Rock Paper Scissors: Manual Thinking in Contemporary Sculpture* (2007), *Freud's Sculpture* (2006), *Shaping Modern Sculpture: Stephen Gilbert and Jocelyn Chewett* (2006), *With Hidden Noise: Sculpture, Video and Ventriloquism* (2004), *Shine: Sculpture and Surface in the 1920s and 1930s* (2002), and *Close Encounters: The Sculptor's Studio in the Age of the Camera* (2001).

Acknowledgments

The majority of the essays herein were first presented during a session that was chaired by the editors and held at the 95th Annual Conference of the College Art Association (CAA) in New York, in February 2007. Having organized a well-received panel, we recognized the value of developing the papers into solid, autonomous essays, and gathering them as a proper body of research into the artist's studio. We are immensely indebted to the authors for their efforts in reworking their papers substantially for this book. It has been a great pleasure for us to team up with them during the conference and throughout the lengthy editorial process that followed. We also wish to thank the artists Daniel Buren, Jan De Cock and Olafur Eliasson for granting us generous permission to use images of their work as illustrations.

This book was made possible through the support of many people and institutions, for which we are immensely grateful. First and foremost it benefited from a generous grant from the Mondriaan Foundation and additional funds for the public presentation from the BAM Institute for Visual, Audiovisual and Media Art, the City of Antwerp and AIR Antwerpen.

Wouter Davidts would like to thank Camiel van Winkel, Rens Holslag, and Jules van de Vijver of the Research Group of Visual Arts of the Academie voor Kunst en Vormgeving|St Joost, Avans Hogeschool, where a research fellowship in 2007 and 2008 allowed him to expand the book project. He wishes to thank them for the stimulating intellectual environment

and the funds they provided for the final publication. He is grateful to the Department of Architecture & Urban Planning of Ghent University, where he was fortunate to work for over a decade in the best of conditions, and where most of the prior work for this book was done. Special thanks go to Bart Verschaffel, Head of Department, who has been both a constant supporter and a critical reader of Davidts's work, and to his many colleagues, who guaranteed a most stimulating life at the university on both an intellectual and a social level.

Kim Paice would like to thank Yvonne Rainer for generously corresponding with her about her own and Robert Morris's works and studios. She thanks Richard Paice for his generous support and for so kindly letting us make his well-appointed abode into our New York 'studio' in August 2008. There we assembled the manuscript and unified the many bytes of work that had shuttled for months between Cincinnati, Ghent, Antwerp, Amsterdam, New York, Leeds, London, Maastricht, Zurich, Las Vegas, and Paris, among other cities in which we found ourselves at work. Paice also offers praise for the unquantifiable contributions of colleagues Mark Harris and Chris Cuomo, and her students, whose intelligence and collective ways of working have made the School of Art of the University of Cincinnati into a valuable site for studying contemporary art and engaging in activism of many kinds.

Together, we wish to express our gratitude to

221

Astrid Vorstermans of Valiz Publishing, who has shared our enthusiasm for this book from the start, and granted all her energy, devotion, and patience to the project. We are proud to have done the first book in the *Antennae* series and wish her all the best with the series in the future. Haydn Kirnon deserves a word of thanks for the careful copy-edit, and Metahaven for providing this book with a great graphic form and a stunningly beautiful design.

Finally, we would like to thank Sophie Berrebi, Bijke Bosmans, Bill Brown, Marshall Brown, Felix Declerck, Koenraad Dedobbeleer, Dirk Dewit, Dennis Elliott, Philip Heylen, Philip Huyghe, Jean-Pierre Le Blanc, Pamela M. Lee, Valerie Mannaerts, James Meyer, Jan Rombouts, and Rosa Vandervost for their kind and insightful comments on our study, and their many different ways of support for this enterprise.

Acknowledgments

223

Index of Names

Index of Names

Index of Subjects

243

Index of Subjects

Colophon

The Fall of the Studio: Artists at Work
Edited by Wouter Davidts and Kim Paice
Antennae Series n°1 by Valiz, Amsterdam

Copy editing Haydn Kirnon
Production Astrid Vorstermans
Design Metahaven
Paper inside Munken Print 100 gr,
hv satinated mc 115 gr
Paper cover Bioset 240 gr
Printer Bariet, Ruinen
Published by Valiz, Amsterdam www.valiz.nl

Library of Congress Cataloging-in-Publication Data
The Fall of the Studio: Artists at Work
edited by Wouter Davidts and Kim Paice.
Includes biographical references and index.
1. Artist's studio
2. Post-studio
3. Mark Rothko
4. Bruce Nauman
5. Daniel Buren
6. Robert Morris
7. Eva Hesse
8. Paul McCarthy
9. Jason Rhoades
10. Martin Kippenberger
11. Matthew Barney
12. Olafur Eliasson
13. Jan De Cock

Colophon

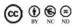
The authors and the publisher have made every effort to secure permission to
reproduce the listed material, illustrations and photographs.
We apologize for any inadvert errors or omissions. Parties who nevertheless believe
they can claim specific legal rights are invited to contact the publisher.

Distribution:
USA: D.A.P., www.artbook.com
GB/IE: Art Data, www.artdata.co.uk
NL/BE/LU: Coen Sligting, www.coensligtingbookimport.nl
Europe/Asia: Idea Books, www.ideabooks.nl

isbn 978-90-78088-29-5
NUR 646
Printed and bound in The Netherlands

This publication was made possible through the generous support of
Mondriaan Foundation
Research Group of Fine Art, AKV I St. Joost, Avans Hogeschool, 's-Hertogenbosch
Department of Architecture and Urban Planning, Ghent University

Mondriaan Stichting
(Mondriaan Foundation)

akv|st joost
avans
hogeschool

ART AND DESIGN

UNIVERSITEIT
GENT

249